W9-AYC-855

LATE 20TH-CENTURY ART

The publication of this catalogue was made possible,
in part, by a production grant from the Best Products Foundation
and a research and editorial grant from the Andrew W. Mellon Foundation.

LATE 2OTH-CENTURY ART

SELECTIONS FROM THE SYDNEY AND FRANCES LEWIS COLLECTION
IN THE VIRGINIA MUSEUM OF FINE ARTS

BY FREDERICK R. BRANDT

VIRGINIA MUSEUM OF FINE ARTS, RICHMOND, VIRGINIA
Distributed by the University of Washington Press, Seattle and London

**Library of Congress
Cataloging-in-Publication Data**

Virginia Museum of Fine Arts.
 Late 20th-Century Art, Selections from the Sydney and Frances Lewis Collection in the Virginia Museum of Fine Arts.
 1. Art, Modern—20th century—Catalogs. 2. Lewis, Sydney—Art collections—Catalogs. 3. Lewis, Frances—Art collections—Catalogs. 4. Art—Private collections—Virginia—Richmond—Catalogs. 5. Virginia Museum of Fine Arts—Catalogs. I. Brandt, Frederick R., 1936–
II. Title.
N6488.5.L49V57 1985 759.06 85-21708

ISBN 0-917046-22-6
ISBN 0-917046-21-8 (pbk.)

Contents

Foreword

An introduction often merely serves the means to fill in missing gaps, to extol the virtues of an artist, the generosity of a donor, the timeliness of an idea. It can also be an opportunity for its author to gild the lily, as it were, and to contribute clever thoughts that may add nothing of substance to the real subject of the book. Not to fall into this fateful trap, therefore, this introduction will be brief.

Fred Brandt, in this thoughtful—indeed loving—exposé of the *modus operandi* and the motivations of the two generous donors whose collections he presents, has said it all, and has done so with the benefit of nearly two decades of intimate contact with them. As a newcomer to the friendship of Sydney and Frances Lewis, and a relatively new discoverer of the results of their acquisitive passion, I can only marvel at what they accomplished and rejoice that they selected this institution to be the permanent safekeeper of their aesthetic vision.

Theirs is the vision of inquiring eyes animated by generous hearts. They are people who intuitively recognize creativity and experimentation. Although objects in a collection may represent acquisitive pursuits resulting from accepting the counsel of others, these objects were acquired as the result of forthright personal responses enriched by deep friendship between creators and collectors. Thus, in this collection we can admire not only the works and the artists but also the personality and spirit of the donors.

May the Lewises' vision continue to enrich not only their fellow citizens of the Commonwealth of Virginia but also that broader, international commonwealth of sentient, thoughtful human beings whom they so superbly exemplify.

Paul N. Perrot
Director
Virginia Museum of Fine Arts

Preface

In 1973 Sydney and Frances Lewis asked me to become curator of their extensive collection of painting, sculpture, and decorative arts, which required professional supervision. For the next dozen years I had the pleasure of working with some of the finest examples of both the decorative arts and contemporary painting and sculpture. It was my responsibility to keep track of these objects, arrange transportation, insure and display them, arrange loans, and, when asked, give my advice toward acquisitions. Unlike many collectors, the Lewises have always relied on their own keen knowledge and judgment. They have never hired outside advisers and thus the collection that is displayed today is truly a personal one. It has been my pleasure to play a small role in the establishment of that collection and to have been able to watch it grow into one of the finest private collections in the world.

Because Sydney and Frances Lewis are modest, they avoid discussion about themselves. They also believe that lengthy discussion of art is unnecessary. To them art is meant for visual experience and not scholarly discussion. With that in mind, I have approached this catalogue as a handbook presenting the background of the Lewis Collection's development.

This catalogue contains brief discussions and illustrations of 100 major works, a small part of a collection that comprises contemporary art primarily from the United States and also from Europe and South America. Although the majority of the paintings and sculpture are from the 1960s and 70s, the Lewis Collection also contains earlier works by the Abstract Expressionists of the 50s and some works of the 80s. It is not encyclopedic and does not include works by every major artist. A criterion for inclusion in the collection was that the Lewises themselves had to respond to a particular artist's work. In other words, because an artist is not represented in the collection does not imply in any way his or her art is not significant or creative but simply means that it was not to the Lewises' personal taste.

Many of the works in the collection have been seen before as the Lewises have made generous loans to major exhibitions throughout the country and the world. In addition, many of these objects have been published frequently and will probably be familiar to those who are acquainted with contemporary painting and sculpture. Other, lesser known works, however, have had little or no exposure because they were acquired directly from the artists.

The dozen years that I have worked with the collection have been significant ones for me. My constant exposure to this vast treasure of contemporary art has deeply enriched my own life, and my contact with Sydney and Frances Lewis has shown me how two caring, intelligent, and loving persons can use their own resources to enhance other people's lives and outlooks both in material and philosophical ways. It is to these two remarkable people, Sydney and Frances Lewis, that I proudly dedicate this catalogue.

Frederick R. Brandt
Curator of 20th-Century Art,
Virginia Museum of Fine Arts

Acknowledgements

During the development of the Lewis collection and the writing of this catalogue, many friends, colleagues, and scholars have helped me. My deep appreciation must be expressed to the artists who have given me insights into their creative processes: Robert Arneson, Richard Artschwager, Jennifer Bartlett, Jack Beal, George Bireline, Deborah Butterfield, John Clem Clarke, John DeAndrea, Richard Estes, Rafael Ferrer, Helen Frankenthaler, Sondra Freckelton, Sam Gilliam, Nancy Grossman, Bryan Hunt, Alex Katz, Nicholas Krushenick, Robert Longo, Edward Paschke, Ed Ruscha, David True, and Christopher Wilmarth.

Many members of the Virginia Museum of Fine Art's staff have contributed to the production of this catalogue and to research on the entries. I am particularly indebted to Ashley Kistler, gallery assistant, and to museum intern, Mary Ann Kearns, both of whom spent a great deal of time doing research on the artists and doing other preliminary research and organizing which has been extremely helpful to me in writing the catalogue entries.

Other members of the museum staff have contributed extensively to the production of the catalogue. Paul Perrot, director, supported the publication from its beginning and has provided necessary encouragement throughout its development. Dennis McWaters, former Museum photographer, provided the majority of the color photographs, with the remainder from Ronald Jennings, chief photographer, and Lorna Clark, assistant photographer. William Flynn, graphic designer, designed the book; Lisa Hummel, registrar; Bruce Young, associate registrar; Diane Hart, assistant registrar and Kathy Morris, assistant registrar, were responsible along with their skilled and always cooperative team of art handlers for making the objects available to the photographers. Polly Bozorth, secretary to the collections division, typed and retyped the manuscript.

I extend special thanks to Jay Barrows and Stephen B. Holcomb of Best Products Company, Incorporated, who have aided me in storing, transporting, and installing it, as well as making works available to the Museum for photography and research. I have been indebted to them for their continual cooperation and willingness to attack and solve many problems. For many years they have professionally and generously aided me in working with the collection.

I also wish to thank my colleague Susan L. Butler who co-authored with me the catalogue *Late Twentieth Century Art from the Sydney and Frances Lewis Foundation Collection*. She has generously allowed me access to her files and correspondence with various artists included in this catalogue.

During my work with the Lewis Collections, I have had the constant support and cooperation of my wife, Carol, and my two children, Fritz and Karen. They have aided me in keeping records, measuring, and in the many other small but necessary duties.

The final and most sincere expression of gratitude must be extended to Sydney and Frances Lewis who have made all of this possible. Through their discerning eyes all of our lives have been enriched and will continue to be. As their personal curator, I am deeply indebted to them for the opportunity to experience the growth of this remarkable collection and to enjoy their friendship and knowledge. It is to them that all Virginians should extend their deepest thanks and recognition.

Introduction

The Sydney and Frances Lewis Collection of twentieth-century painting and sculpture is without question one of the great private collections of contemporary art in the world. It did not originate as a collection, however, but as the desire of two intelligent people to acquire objects that were meaningful to them in terms of aesthetics and that reflected their interests in the cultural life of their own time.

When asked at what point these works became a true collection rather than a gathering of objects, the Lewises found it impossible to reply. As private individuals, they bought objects that appealed to them but did not buy the paintings and sculptures in a curatorial sense. That is, they did not purposefully look for objects to fill in certain gaps as one might do for a museum collection. Only in more recent years, when they realized that the collection would indeed be going to a museum, did they think of it as a collection that could be expanded or have more meaning if certain objects were included. Those objects, however, still had to be ones acceptable and equal in quality to specimens already in the collection.

Neither Sydney nor Frances Lewis have a background associated with the arts. Sydney Lewis was born and raised in Richmond. Frances Lewis was born in New York but spent her adolescent years in Washington, D.C. They founded their Richmond-based store, Best Products Company Incorporated, in 1957. Because it was a small business, they did much of the buying for the company, traveling often to New York and Chicago. Pressures of schedule demanded spending one day in New York doing what would have otherwise required several days. In the early 1960s, however, they enjoyed a more leisurely pace. The extra time was spent in visits to galleries and auction houses.

Their change in schedule was felicitous. The early 1960s was explosive for the arts, particularly on the East Coast and especially in New York. Many new galleries appeared, with innovative works that had evolved from a reaction to Abstract Expressionism (the product of the so-called "New York School"), which had dominated the arts since World War II. The Lewises' new interest in the visual arts coincided exactly with the rise of the Pop Art Movement. A classified advertisement in the *Village Voice* led to a meeting with Andy Warhol. Warhol had proclaimed in the newspaper ad that he would trade his paintings for almost anything. The Lewises made an appointment to see him and started a friendship that has lasted over two decades. Warhol was one of the first artists with whom the Lewises established a relationship.

They met other Pop artists such as Roy Lichtenstein and Tom Wesselmann and still others who continued to paint in an abstract style, such as Theodore Stamos and Robert Goodnough. All these artists became the Lewises' friends. Stamos introduced the Lewises to the decorative arts, which have figured so prominently in their collecting. They admired his collection of Tiffany glass and other Art Nouveau objects. Stamos introduced the Lewises to the dealer Lillian Nassau and accompanied them to major Art Nouveau auctions.

The Lewises had no intention of forming a large collection. They simply bought what they liked for their house in Richmond. Both avant-garde and traditional works found their way to Richmond. Among the latter group were drawings by Modigliani and Henry Moore, a Flemish painting, and some early European prints and drawings. The Lewises later sold their more traditional works as their interest in contemporary art increased.

As often as possible, the Lewises tried to meet the artists whose works they bought. Their new friends were exceptional people with whom they could discuss politics, films, and farming with as much ease as they could talk about art. Some of these friendships contained surprises. When they met Jack Beal, they found in his studio a yearbook from Richmond's Thomas Jefferson High School, from which both Beal and Sydney Lewis had graduated.

It is difficult today to imagine the art world of New York in the early 1960s. Such styles as Pop Art, Minimalism, and, a little later, Photo-Realism, were dominant. Many artists who later became famous were then unknown and sold their works directly to customers. Compared to today, galleries were relatively few, particularly those with contemporary painting and sculpture. Prices had not reached the heights attained today. New collectors were thus able to buy good paintings and sculptures on a moderate income. Today, it would probably be quite difficult to build such a collection without unlimited means.

As the Lewises purchased more, they read more about the contemporary art scene. Believing that nothing should take the place of looking at art, they endeavored to see as much as possible of an artist's work to make comparisons for selecting the best piece. Another important factor in buying contemporary American painting and sculpture at this time was its greater availability than objects from earlier periods.

Not all of their acquisitions came from New York. They bought works by Virginia artists and by many others. Upon seeing the work of George Bireline at the André Emmerich Gallery in New York, they found that the artist lived in North Carolina. They visited Bireline in Raleigh to see more of his painting. This experience again resulted in a lasting friendship and purchases.

The Lewises' home was soon crowded with art. Therefore, they began to hang art in the showrooms and corporate offices of Best Products. In addition, under Sydney Lewis's direction, the company established a barter program whereby the company traded merchandise from its sales catalogue for paintings or sculptures. These objects were placed in Best Products showrooms throughout the country, thus fulfilling the Lewises' desire to bring contemporary art to the public and to give younger artists recognition and exposure.

Best Products has also been responsible for several architectural commissions. Since 1972, the architectural group SITE (Sculpture in the Environment), under the direction of James Wines, has designed and created several Best Products showrooms across the country. In addition, the firm Venturi, Rauch and Scott Brown created a showroom in northern Philadelphia, and Hardy, Holzmann, Pfeiffer and Associates created Richmond's award-winning Best Products corporate headquarters. The company also has made significant contributions to art projects throughout the United States, particularly in Virginia, including patronage of various exhibitions at the Virginia Museum of Fine Arts, contributions to arts centers and cultural projects throughout the state, sponsorship of dance performances, and the general support of concerts, theater, preservation programs, and public television. Although the Lewises themselves have not commissioned many works, they have had several portraits made. When they gave funds to build the Law School at Washington and Lee University, Jack Beal did their portrait.

By 1969 the Lewises' collection had overwhelmed their home. They consequently purchased the Robert Cabell house on Monument Avenue, near the Virginia Museum. Designed and built between 1922 and 1924 by William Lawrence Bottomley, a leading East Coast residential architect, this fine house eventually became an important center for students and scholars of both the decorative arts of 1890 to 1930 and painting and sculpture of the last three decades.

In 1978, concerned for the public's opportunity to see the best in contemporary painting and sculpture, the Lewises established The Sydney and Frances Lewis Foundation to provide a traveling exhibition of contemporary art for smaller museums and galleries, especially those at universities throughout the country. In its seven years' existence, this collection has circulated and grown continually. Traveling shows, catalogues, and posters, are all made available free by the Foundation to circumvent the all-too-common problem of limited finances at museums and galleries. Many of the works from both the Foundation and the Lewises' private collection are on view in the West Wing of the Virginia Museum of Fine Arts and are discussed below.

At the end of the 1970s, the Lewises finally acknowledged that they indeed had a collection of national significance. Because the earliest works were from the 1960s, the Lewises acquired still earlier works, particularly those of the first generation New York School or Abstract Expressionists of the 40s and 50s to make their collection more comprehensive. They acquired significant works by Willem de Kooning, Ad Reinhardt, Franz Kline, Helen Frankenthaler, Mark Rothko, and other masters of American painting and sculpture who had changed the course of the history of art in the 1950s. The Lewises also made commitments to the future of the collection. Many museums wished to acquire it in whole or in part. In 1979 the Lewises announced that they would give their entire collections of contemporary work and decorative arts to the Virginia Museum of Fine Arts as a gift to the Commonwealth of Virginia. In addition, they shared with Mr. and Mrs. Paul Mellon the costs of design and building of the Museum's new West Wing in which both

families' collections are now exhibited.

As mentioned in the preface, Sydney and Frances Lewis have revealed little about themselves. Nor do they approve of lengthy discussions of art, recognizing the validity of the viewer's individual interpretation from direct experience of the work itself or from an illustration thereof. To them the prime importance belongs to the object as a manifestation of the artist's creative ability.

In accordance with the Lewises' beliefs, therefore, neither this essay nor the following entries contain extended discussions about the Lewises' background, their collecting habits, or the art historical context into which the various works fit. Instead, this catalogue is an overview of an outstanding and remarkable collection presented to the public by two remarkable people, who through genuine understanding, love, respect for the creative impulse, integrity, and keen personal insight have assembled a collection of the best contemporary American and European art.

As Sydney and Frances Lewis said when asked about their collection, "One day we saw a picture, liked it and bought it. Woe unto us! Soon we had an incurable passion that demands all our time, energy, and spare cash. The passion has opened our eyes, our hearts, our minds, our ideas, to new views of the universe; to new ways of looking at the world. Lucky us!"*

*As quoted by Charles L. Wyrick, Jr. in *Contemporary American Paintings from the Lewis Collection* (Wilmington, Delaware: Delaware Art Museum, 1974), preface (unpaginated).

Catalogue

The one hundred works illustrated and described herein have been selected as a representative cross-section of the Lewis Collection and the Lewis Foundation Collection. Although many of the artists whose works are discussed are represented by more than one work in the collection, the selection has been limited to singular paintings or sculptures by each artist. A more complete listing of the total works in the collection will be published sometime in the future.

The following abbreviations are used for publications cited frequently in the text: Wyrick, *Contemporary American Paintings* =Charles L. Wyrick, Jr., *Contemporary American Paintings from the Lewis Collection* (Wilmington, Delaware: Delaware Art Museum, 1974); Brandt and Butler, *Late Twentieth Century Art*=Frederick R. Brandt and Susan L. Butler, *Late Twentieth Century Art from The Sydney and Frances Lewis Foundation* (Richmond: The Sydney and Frances Lewis Foundation, 1981). Many of the entries in this catalogue are altered from those in the latter publication.

All measurements are shown in centimeters and inches; height precedes width.

Arman (born Armand Fernandez)
American (born in France), 1928-

1. *Great Nails Fetish*, 1978
Welded steel picks, 127.0 × 83.8 × 63.5 (50 × 33 × 25)
Unsigned
Virginia Museum of Fine Arts, The Sydney and Frances
 Lewis Foundation Collection, 79014

Arman has been called the "Magician of Form" and the "Magician of Gesture."[1] For more than two decades he has taken commonplace, manmade objects and assembled them into compositions that take on new forms and meanings. In addition, he has dismembered them or partially destroyed other objects and preserved the remains in polyester resin or cement. Most recently, he burned a suite of Louis XV reproduction furniture. He then had the burned remnants cast in bronze, resulting in a haunting, apocalyptic reminder of the fragility of life in the nuclear age.[2]

In 1956 Arman had his first one-man show. At that time he was painting abstract pictures and creating *cachets*, images made with rubber stamps. By 1959 he had exhibited accumulations of miscellaneous objects he found in the Paris flea markets and elsewhere. In that same year he co-founded with Yves Klein the *Nouveaux Réalistes*, an avant-garde group of French artists who banded together as a reaction to the abstract art of the School of Paris. During the following years, he destroyed every-day objects, including cars and musical instruments, with the final form being the art object.

Arman's "accumulations" of the 1960s, which reached their pinnacle in 1964, were held in place by polyester resin to ensure their permanence. He later abandoned the resin because of its health hazards and substituted cement. In the past few years, Arman has used welding, a technique he learned in 1962, to join the carefully selected elements of his sculpture.

Great Nails Fetish is a logical continuation of his process of accumulating objects and repeating them to form images directed not only by the artist but also often by the form of the object itself. The pickaxes that make up *Great Nails Fetish* were selected for their individual shapes as well as the form they would take when assembled. It is part of a series of works based on free-standing accumulations of tools and utensils. "When interested by a tool, I buy from a hardware store the suitable quantity. I . . . weld and assemble the objects only when I have a complete vision of the finished work."[3]

No matter what the technique—welding, dismemberment, destruction and recreation, or accumulation—the result of Arman's sculpture is often brutal, aggressive, humorous, melancholic, or touching, but always capable of stirring emotion.

In the accumulation and combining of similar objects, Arman creates a critical moment of transcendence in which the objects are no longer important as an individual entities but become significant parts of the total mass.

Provenance: André Emmerich Gallery, New York, 1979.
Published: Daniel Abadie, *Arman* (Paris: Galerie Beauborg, n.d.), p. 10; Brandt and Butler, *Late Twentieth Century Art*, pp. 4-5, no. 2 (illus.).

1. Jan van der Marck, "Magician of Form/Magician of Gesture," *Arman: Selected Works 1958-1974* (La Jolla, California: La Jolla Museum of Contemporary Art, 1974), unpaginated.
2. For a complete description and photographs of the process of this piece, see *Arman: The Day After* (New York: Marisa del Re Gallery, 1984).
3. Letter, dated May, 1980, from the artist to Susan L. Butler, former vice-president of the Sydney and Frances Lewis Foundation. The letter is part of the Lewis Foundation archives in the Department of 20th-Century Art, Virginia Museum of Fine Arts.

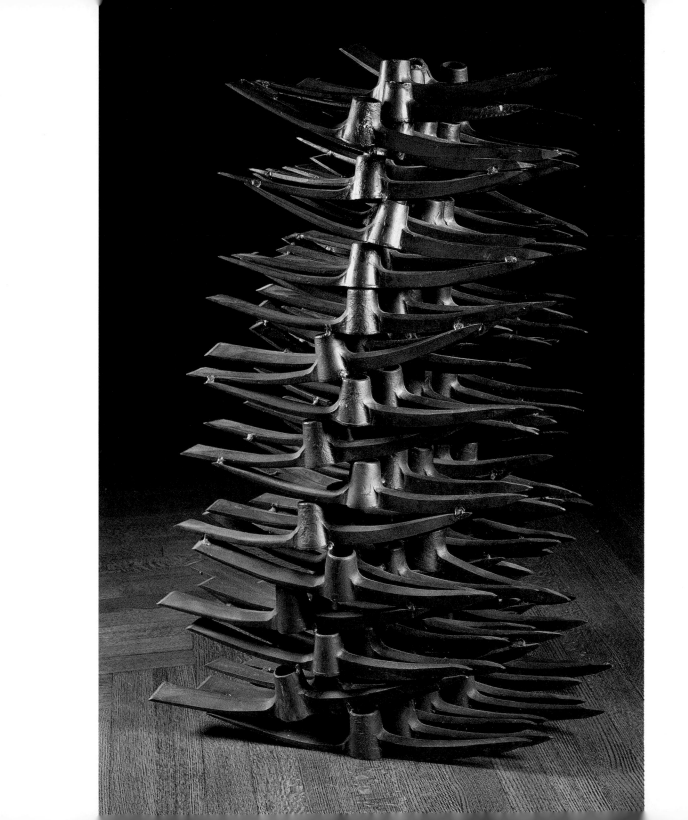

Robert Arneson
American, 1930-

2. *A Likeness of Francis B.*, 1981
Glazed ceramic, 190.5 × 66.0 × 49.5 (75 × 26 × 19½)
Signed on back: *Arneson 1981*
Virginia Museum of Fine Arts, Gift of
 Sydney and Frances Lewis, 85.357 a/b

Robert Arneson has taken clay from its traditional utilitarian role to the realm of sculpture. Since 1965, when he made his first full-scale bust, *Self-Portrait of the Artist Losing His Marbles*, Arneson has been engrossed in the creation of portrait sculptures in clay. The vast majority of these have been portraits of himself in various humorous guises and attitudes. Arneson believes that these portrait sculptures are "an expression . . . a focal point . . . the outer part of ourselves that reveals the inner."[4] In the same manner as the self-portraits, the portraits of his artist, patron, and dealer friends—as well as those of more famous historical subjects which he calls "heroes and other strange types"—often capture a humorous moment or anecdote that relates to that person's life. For example, his portrait of Vincent Van Gogh, which he calls *Vince*, shows the artist moments after he has sliced off his ear. Van Gogh shifts his eyes to the now bleeding side of his head. His bloodied ear lies at the base of the sculpture. The entire sculpture is painted in glazes that resemble the colors and particular quality of paint Van Gogh himself used.

Another one of his "heroes" is the portrait bust *Elvis*. Wearing a classical cuirass emblazoned with a guitar flying upward on wings, the rock-and-roll star sports his familiar sneer. A rock balanced on his shoulder may be a generic symbol of his music or a "chip" of defiance for some parent to knock off. As with other Arneson portrait busts, this one of Elvis bears resemblance to the busts of antiquity. In the case of *Elvis*, Arneson was inspired by Cellini's marble bust of Cosimo de Medici in the De Young Museum of Art in San Francisco.[5]

Other portrait busts and more recent works have not been created in such a humorous vein. *A Likeness of Francis B.* is a large-scale bust depicting the well-known contemporary British artist Francis Bacon. Of the artist Arneson says, "Francis Bacon I like a lot—the plastic distortions, rapid brushstrokes—the directness of idea and execution."[6] In this case Arneson depicts the artist in a realistic manner when viewed from the front. However, to show the inner turmoil of this controversial painter in relationship to his work, Arneson has created a Dr. Jekyll-Mr. Hyde portrait. To appreciate the image fully, the viewer must circumambulate the pedestal bust to see that the portrait of the artist is transformed into one of Bacon's familiar horrific and distorted faces.

A controversial person in recent years, Arneson has lately depicted the ghastly images of people killed or mutilated in a nuclear explosion. He is very deeply affected by current events and the foolishness of governments as they threaten the total existence of life itself. His images are black in humor and make powerful statements of the artist's wishes and desires for a more peaceful world. He often masks his anxieties with subtle and not-so-subtle humor. He also has the ability to poke fun at himself and at others to show that everyone is part of the human comedy.

To create these busts, Arneson uses a blank mold into which he press-molds the clay. He then adds to this blank to create the exact likeness he is seeking. Other parts are hollow-built with slab, coil, and wheel-thrown techniques. The piece is then bisque-fired at 1690° F, glaze-fired at 2100° F, and luster-fired at 1320° F.

Provenance: Alan Frumkin Gallery, New York, 1981.
Published: *Robert Arneson—New Ceramic Sculpture* (New York: Alan Frumkin Gallery, May 1981), no. 5 (illus.).
Exhibited: *Robert Arneson—New Ceramic Sculpture*: Alan Frumkin Gallery, New York, May 1981.

4. Letter (1980) from the artist to Susan L. Butler, former vice-president of the Sydney and Frances Lewis Foundation. The letter is part of the Lewis Foundation archives in the Department of 20th-Century Art, the Virginia Museum of Fine Arts.
5. Ibid.
6. Letter, dated September 28, 1984, from the artist to the author. The letter is part of the Lewis Collection archives in the Department of 20th-Century Art, Virginia Museum of Fine Arts.

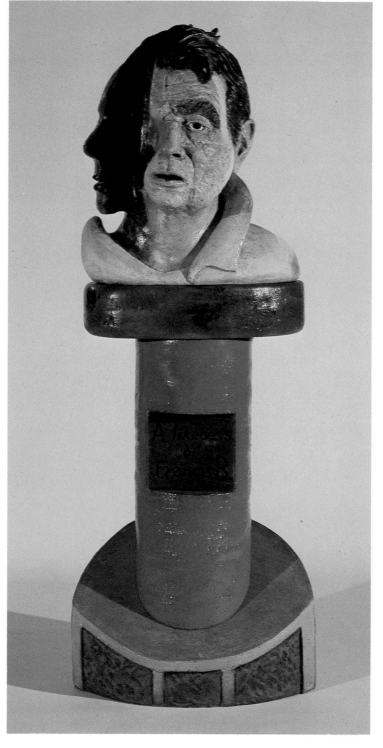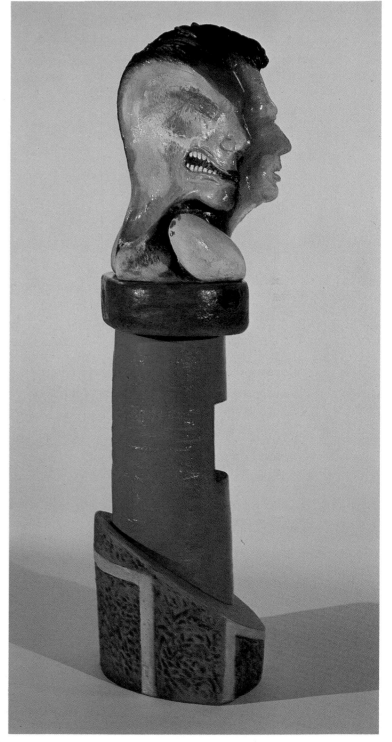

Richard Artschwager
American, 1923-

3. *Williamsburg Pagoda*, 1981
Acrylic and charcoal on textured fiberboard, Formica,
 painted wood, 221.0 × 187.3 × 20.3 (87 × 73¾ × 8)
Unsigned
Virginia Museum of Fine Arts, Gift of
 The Sydney and Frances Lewis Foundation, 85.358

It is a typical contradiction for Richard Artschwager to depict an eighteenth-century colonial building in fiberboard and Formica, two very mid-twentieth-century materials. But, then again, even though the Williamsburg Magazine or Arsenal is an actual 1715 building, Colonial Williamsburg is mostly a reconstruction or replica of an original in the same way that Formica is a reproduction or replica of a real, natural material.

Artschwager's "paintings and objects mirror and, at the same time, contradict both illusion and reality—the very stuff of which they are made. In his hybrid realm he sets us apart from these two worlds and holds us in tension between them.... He makes ordinary forms extraordinary to counter the general with the particular."[7]

Artschwager denies that his use of mundane, middle-class subject matter or his use of Formica is social commentary. Instead, he says that he "tries to look around with an unjaundiced eye, i.e., tries to get out from under received taste."[8] His use of modern materials such as Formica and fibreboard relates directly to the use of crude natural substances by the primitive artist. Both subject matter and material were "ready-at-hand."

Artschwager came to a career in art relatively late. After serving in the army during World War II, he finished his education at Cornell University, from which he received a degree in chemistry. He then studied with the French painter Amedée Ozenfant, who had emigrated to New York. Artschwager worked at various jobs, finally becoming a cabinetmaker and mass producer of articles of furniture. In 1962 he utilized Formica in his furniture and fiberboard in his paintings. His furniture, at first functional, evolved into minimalist, non-functional objects. Even though they often looked like furniture, they did not function as such and instead became aesthetic objects. For the past ten years Artschwager has continued painting, drawing, and creating his "furniture" objects.

Artschwager chose the Williamsburg Magazine as a subject because of its hexagonal form and the parallelism between the roofline and some of his invented landscapes. The tip of the roof becomes a vanishing point for the rows of "bushes" that sprout out of the foreground of his painting. This vegetation is very similar to the type that appeared in his painting *Bushes II* (1977).

The routed Formica that forms the "ceiling" of the painting contains lines that at first appear to converge on a singular vanishing point, but, in fact, do not. This perspective was not done scientifically but intuitively, by laying out the pattern first. This upper part imitates changing viewpoints as the body or head moves. The lower Formica paneling, imitating wood, forms a wainscotting or frame defining the frontal space of the work.

Although Artschwager's work has been described as surrealist, it is really more related to the work of collage. His oeuvre, especially the furniture pieces, "are insertions into the common space, belonging to it, but also of various kinds and degrees of disjunct. And the same applies to the paintings, especially if you see it all as furniture under which is posted Special Case Sculpture and Special Case Painting. A collage is a Pandora's box which spreads its disjuncts beyond the confines of its frame."[9]

Provenance: Leo Castelli Gallery, New York, 1981.
Exhibited: *Late Twentieth-Century Art From The Sydney and Frances Lewis Foundation Collection*: Mississippi Museum of Art, Jackson, January 31-March 14, 1982; University Memorial Gallery, University of Rochester, Rochester, January 30-March 13, 1983; Muscarelle Museum, College of William and Mary, Williamsburg, February 4-April 14, 1984; Huntington Galleries, Huntington, West Virginia, June 2-August 19, 1984; The Athenaeum, Alexandria, Virginia, May 7-June 2, 1985.

7. Suzanne Delehanty, "Transformations of Illusion and Reality," *Richard Artschwager's Theme(s)* (Buffalo, New York: Albright-Knox Art Gallery, 1979), pp. 10-11.
8. Letter, dated June 28, 1982, from the artist to the author. The letter is part of the Lewis Foundation archives in the Department of 20th-Century Art, Virginia Museum of Fine Arts.
9. Ibid.

Jennifer Bartlett
American, 1941-

4. *237 Lafayette St.*, 1978
Enamel and baked enamel on silkscreened steel plate,
 27 plates: 96.5 × 360.7 overall, 30.5 × 30.5 each,
 (38 × 142, 12 × 12)
Unsigned
Virginia Museum of Fine Arts, Gift of
 Sydney and Frances Lewis, 85.360.1/27

It is not surprising in this age of the computer to find an artist whose work appears to be programmed systematically in terms of repetitive shapes and serial progressions of form. Jennifer Bartlett's work, however, transcends the machine-age aspect of the computer through a sensitivity, improvisation, resourcefulness, and organization based on rhythms such as those in a complex musical composition. Although undoubtedly owing a debt to her predecessors of the late nineteenth century, such as Seurat, as well as her more immediate forerunners such as Sol LeWitt, Bartlett at the same time creates images comprised of a wide range of styles resulting in work that bears her own personality.

Born in California, Bartlett studied at Mills College in Oakland and later at Yale University School of Art and Architecture, where she received a B.F.A. and an M.F.A. She moved to New York in 1965. Her early work was done on large monumental canvases. In 1968, however, Bartlett abandoned the traditional canvas for plates of cold-rolled steel whose surfaces were enameled in white and silk-screened with a light grid. Bartlett says that she made this change because "I wanted my paintings to change. I felt if I could restrict all the physical decisions about the work, maybe something would happen with the content. I decided to work on the plates for five years no matter what I felt about what was coming out on them."[10]

In *237 Lafayette Street*, the title deriving from an address in New York, as do the titles of many of her works, Bartlett used twenty-seven plates, repeating the basic theme of "house" three times. She treats the composition, however, in a totally different stylistic manner. The first set of plates depicts the house through a series of dots, one dot per grid square. The second set depicts the same composition in basically flat planes of colors, and the third allows her to use an expressionistic brush stroke in vivid enamel colors.

To change further and to complicate the rhythm of the composition, however, Bartlett displaces the central panel of each set by removing it from the first set and substituting it as the central panel in the second. She then repeats this by taking the central panel from the second set and substituting it in the third. The third displaced central panel then exists in solitude to the right of the composition, surrounded by negative space. Our eyes complete the composition around it and relate that panel to the more positive shapes of the rest of the work.

Bartlett is prolific. Her composition *Rhapsody* (collection of Sidney Singer), based on a swimming pool outside a villa in Nice, consists of 988 enamel metal plates and encompasses a space 7½ feet high by 160 feet wide. More recently she has done a series of 200 studies of the same pool. Although she has returned to more traditional techniques, these works were created in a serial manner similar to her earlier steel plates, making us well aware not only of the image itself but also of the process by which that image gradually evolves.

Provenance: from the artist, 1978.

10. Grace Glueck, "Painting a Cosmic Conversation," *The New York Times*, 23 May 1976.

13

Jack Beal
American, 1931-

5. *Fortitude*, 1978
Oil on canvas, 152.4 × 137.2 (60 × 54½)
Signed lower left: *Jack Beal*
Virginia Museum of Fine Arts, Gift of
 The Sydney and Frances Lewis Foundation, 85.361

Jack Beal is a narrative painter and is probably the most important Social Realist painter in America in the past half-century. A "Life Artist" rather than a "Realist," Beal expresses his moral beliefs through his paintings of friends, patrons, fellow artists, and other people whom he admires. His work relates directly to real life and does not simply exist as icons or pictures. Beal believes that artists who distort the human figure are violating the dignity of humanity.[11]

Fortitude is one of a series of paintings Beal completed in 1977-78 depicting virtues and vices, which comprise themes that fit all the criteria that Beal believes to be crucial to the Life Artist. "Depicting a subject implies approval/certification of the subject and it is vital to choose someone/something worthy of approbation. Communication with the audience has become, for me, as necessary a factor as the aesthetics of the picture. Because it takes me so long to make a picture, I find it mandatory to choose a subject that will engage me *fully* during the course of making; easy subjects will no longer suffice—I want to be challenged so I might do my best."[12] The subjects for *Fortitude* are Phyllis and Donald Schriver, who live on a

dairy farm near Beal's home. Having turned their farm over to their grown son, they now work hard at other occupations. Mr. Schriver is an excellent carpenter whose work is much in demand. Beal feels they typify "courage in everyday life."

Beal studied at William and Mary College in Norfolk and later at the School of the Art Institute of Chicago. A competent abstract painter at first, he later rejected this mode for Realism. Since the early 1960s, Beal and a number of other artists have been responsible for the revival of the popularity not only of Realist painting but also of narrative painting as well.

"My whole painting career I've searched for an equitable balance between human needs and aesthetics needs. It is a very exciting conflict. Clearly I'm a modern painter, but my interests are extremely varied and I try to draw stimulation from all kinds of sources. . . . I'm making twentieth-century pictures, but I've learned a lot from my sixteenth- and seventeenth-century colleagues. I'm trying to paint people and things the way I think most people see people and things. And I'm trying to paint them as they are."[13]

Provenance: Alan Frumkin Gallery, New York, 1979.
Published: Brandt and Butler, *Late Twentieth Century Art*, p. 7, no. 4 (illus.); Margaret Miller, *Realism and Metaphor* (Tampa: University of Southern Florida Art Galleries, 1981), p. 13 (illus.).
Exhibited: *Realism and Metaphor*: SVC/Fine Arts Gallery, University of Florida, Tampa, April 14-May 24, 1980; Visual Arts Gallery, Florida International University, Miami, July 25-August 15, 1980; Jacksonville Art Museum, Jacksonville, Florida, September 4-October 18, 1980. *Late Twentieth-Century Art From The Sydney and Frances Lewis Foundation Collection*: Allen Priebe Art Gallery, University of Wisconsin-Oshkosh, Oshkosh, January 27-March 15, 1981; Morehead State University, Morehead, Kentucky, August 31-October 16, 1981; Columbia Museum of Art, Columbia, South Carolina, November 15-January 10, 1982; Mississippi Museum of Art, Jackson, January 31-March 14, 1982; University of Tennessee, Knoxville, March 28-May 30, 1982; Allentown Art Museum, Allentown, Pennsylvania, November 14, 1982-January 16, 1983; University Memorial Gallery, University of Rochester, Rochester, January 30-March 13, 1983; Everson Museum of Art, Syracuse, New York, March 25-May 29, 1983; Muscarelle Museum, College of William and Mary, Williamsburg, February 4-April 14, 1984; Huntington Galleries, Huntington, West Virginia, June 2-August 19, 1984; The Athenaeum, Alexandria, Virginia, May 7-June 2, 1985.

11. Gerrit Henry, "Jack Beal: A Commitment to Realism," *ARTnews* 83/10 (December 1984): 97.
12. Letter, dated April 24, 1981, from the artist to the author. The letter is part of the Lewis Foundation archives in the Department of 20th-Century Art, Virginia Museum of Fine Arts.
13. Judd Tully, "The Art of Labor," *The Washington Post*, 20 March 1977.

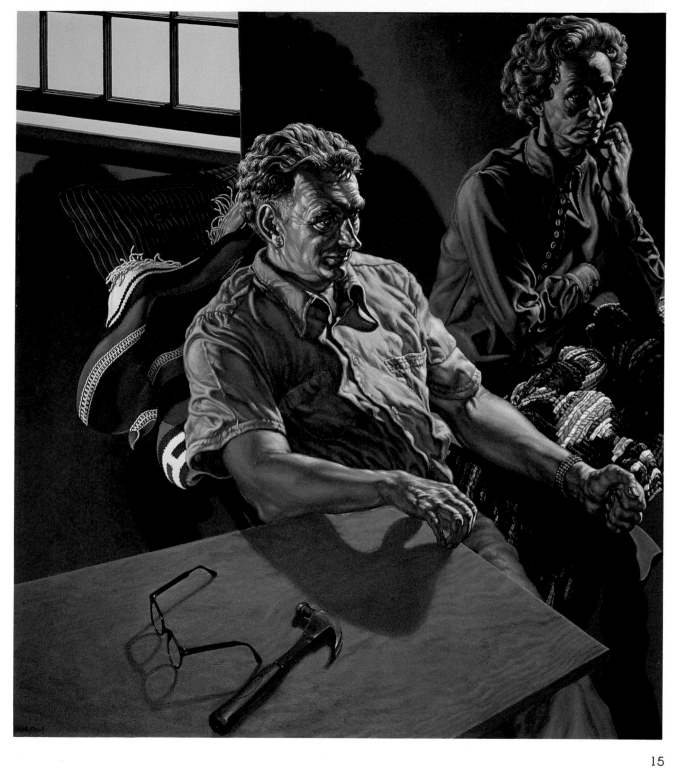

Robert Bechtle
American, 1932-

6. *Berkeley Stucco*, 1977
Oil on canvas, 123.8 × 176.5 (48¾ × 69½)
Signed on reverse upper left: *R Bechtle 1977*
Virginia Museum of Fine Arts, Gift of
 The Sydney and Frances Lewis Foundation, 85.362

Although painters have long used the camera as an aid, they have admitted to using it only in recent years. One of the definitions set down by Louis Meisel in his book *Photo-Realism* is that the true Photo-Realist "uses the camera and photograph to gather information."[14] He further states that Bechtle "was the first of the West Coast painters to execute a true Photo-Realist work, '*56 Chrysler* (1964).[15] As is typical of Photo-Realist paintings, Bechtle portrays ordinary people in everyday, unexciting, situations.

Born in San Francisco and educated at the California College of Arts and Crafts, Oakland, and the University of California at Berkeley, Bechtle draws upon the subjects that are part of his own life and that surround him on a daily basis. He works from photographs of friends, relatives, family, and various sun-drenched suburban streets and houses.

He paints these subjects with no romanticism or drama but instead instills a sense of neutrality into the pictures. He tries not to influence the viewer's reaction to his paintings. "It is in part a preference I have for subtle art which does not shout its meaning. Neutrality is in many ways central to the idea of Realism. The marks which give information and make reference to the visual world in a Realist painting are presented without hierarchy as simply signifying things which exist, presenting the look and texture of the everyday world in a way that gives equal importance to the seemingly insignificant. In making a choice of what to paint I am, of course, saying what might be important to me. But in what way important? Different viewers will have different answers."[16]

Because of his use of photography, his figures often are "arrested" or "frozen." To maintain his neutrality again, Bechtle approaches the subjects of his paintings as if they were parts of a still life. He is more concerned with balance, shape, color, and tension than with the personalities of his sitters. People did not play a role in his earlier paintings, which were primarily images of automobiles parked in front of surburban homes. Gradually he included figures with the automobiles until the figure became the dominant focus of the image, as in *Berkeley Stucco*.

Unlike many of the other Photo-Realists, Bechtle does not try to eliminate the hand of the painter but actually allows his brushstrokes to remain apparent without interfering with the precise execution of his images. *Berkeley Stucco* shows a keen affinity for the work of Edward Hopper in its concentration on sun reflected off city walls. Bechtle's subjects, like Hopper's, are drawn from everyday middle-class people that one sees everywhere in our environment. "I see them (the people acting as subjects in Bechtle's paintings) as particular embodiments of a general American experience. My interest has nothing to do with satire or social comment though I am aware of the interpretations others might give. I am interested in their ordinariness—their invisibility through familiarity—and in the challenge of trying to make art from such commonplace fare."[17]

Provenance: O.K. Harris Works of Art, New York, 1978.
Published: John Arthur, *Realism/Photorealism* (Tulsa, Oklahoma: Philbrook Art Center, 1980), no. 91 (illus.); Louis K. Meisel, *Photo-Realism* (New York: Harry N. Abrams, 1980), p. 42, no. 48 (illus.), p. 48, no. 98 (illus.); "The Lonely Look of American Realism," *Life* (October 1980): 76-77 (illus.); Brandt and Butler, *Late Twentieth Century Art*, p. 8, no. 5 (illus.).
Exhibited: *Realism/Photorealism*: Philbrook Art Center, Tulsa, October 5-November 23, 1980. *Late Twentieth-Century Art From The Sydney and Frances Lewis Foundation Collection*: The Anderson Gallery, Virginia Commonwealth University, Richmond, December 5, 1978-January 8, 1979; Institute of Contemporary Art, University of Pennsylvania, Philadelphia, March 22-May 2, 1979; The Dayton Art Institute, Dayton, Ohio, September 13-November 4, 1979; Brooks Memorial Art Gallery, Memphis, December 2, 1979-January 27, 1980; Dupont Gallery, Washington and Lee University, Lexington, Virginia, February 18-March 21, 1980; The Toledo Museum of Art, Toledo, September 21-November 9, 1980; Madison Art Center, Madison, Wisconsin, November 23, 1980-January 18, 1981; Allen Priebe Art Gallery, University of Wisconsin-Oshkosh, Oshkosh, January 27-March 15, 1981; Ulrich Museum, Wichita State University, Wichita, April 1-May 31, 1981; Morehead State University, Morehead, Kentucky, August 31-October 16, 1981; Columbia Museum of Art, Columbia, South Carolina, November 15-January 10, 1982; Mississippi Museum of Art, Jackson, January 31-March 14, 1982; University of Tennessee, Knoxville, March 28-May 30, 1982; Worcester Art Museum, Worcester, Massachusetts, September 10-October 31, 1982; Allentown Art Museum, Allentown, Pennsylvania, November 14, 1982-January 16, 1983; University Memorial Gallery, University of Rochester, Rochester, January 30-March 13, 1983; Everson Museum of Art, Syracuse, New York, March 25-May 29, 1983; Muscarelle Museum, College of William and Mary, Williamsburg, February 4-April 14, 1984; Huntington Galleries, Huntington, West Virginia, June 2-August 19, 1984; Piedmont Arts Association, Martinsville, Virginia, February 27-March 27, 1985; The Athenaeum, Alexandria, Virginia, May 7-June 2, 1985.

14. Louis K. Meisel, *Photo-Realism* (New York: Harry N. Abrams, 1981), p. 12.
15. Meisel, *Photo-Realism*, p. 13.
16. Letter, dated May 1978, from the artist to Susan L. Butler, former vice-president of the Sydney and Frances Lewis Foundation. The letter is part of the Lewis Foundation archives in the Department of 20th-Century Art, Virginia Museum of Fine Arts.
17. Meisel, *Photo-Realism*, p. 27.

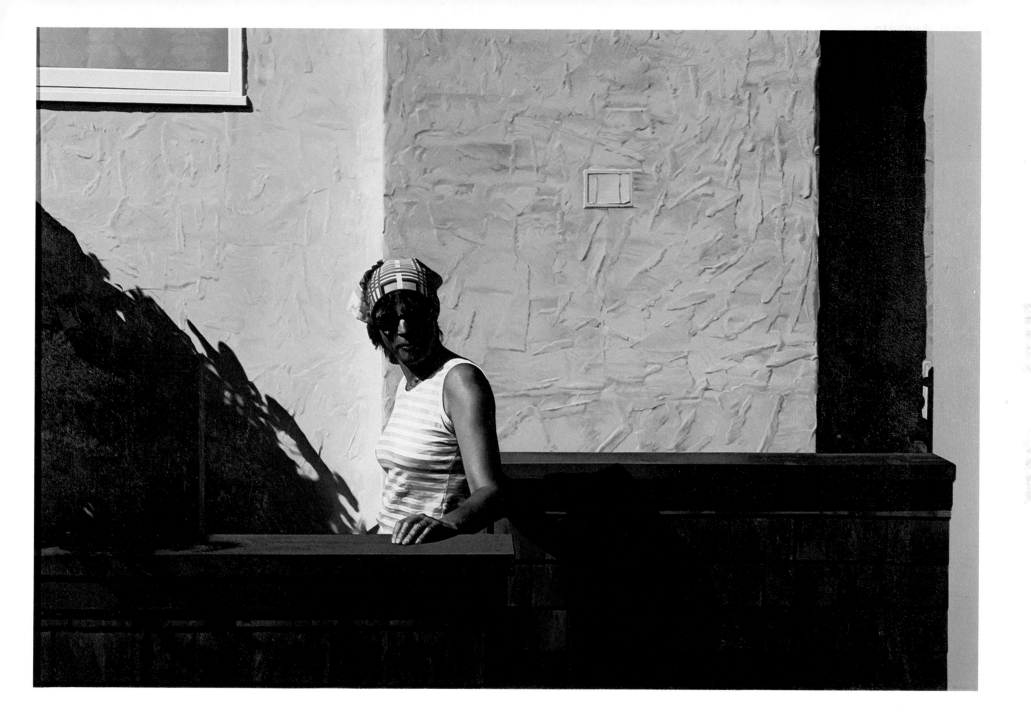

17

George Bireline
American, 1923-

7. *San Quentin Blues*, 1965-66
Acrylic on canvas, 183.0 × 243.8 (72 × 96)
Signed on stretchers: *George Bireline*
Virginia Museum of Fine Arts, Gift of
 Sydney and Frances Lewis, 85.363

George Bireline's paintings, whether totally abstract or illusionistically realistic, challenge the viewer's perception. Interested in the viewer's active participation, Bireline believes that "an active viewer completes the work. His response to what he views may enrich his perception of my work in that things are and are not what they seem, and the mystery that results can be a delightful wonderment."[18]

San Quentin Blues is part of a series of abstract paintings that Bireline created over almost two decades before turning to a more illusionistic and realistic style. In spite of their abstraction and relationship to Abstract Expressionism and Color Field painting, the paintings often contain allusions to recognizable images, as confirmed by their titles. For example, the images in the works of this period are similar to architectural elements. *San Quentin Blues* seems to have a window covered with bars set into a field of color. Others paintings relate to other windows, doorways, and further building details.

Slightly before this period, Bireline's work was recognized by the critic Clement Greenberg, who had seen his paintings on a visit to Raleigh, North Carolina. As a result, Bireline exhibited in 1964 and 1965 in New York where he received highly favorable reviews. Bireline continued to live in Raleigh. After a brief period in New York, Bireline moved to North Carolina where he had received a graduate degree from the University of North Carolina at Chapel Hill.

Bireline's early paintings bear a strong relationship to those of the Abstract Expressionists, particularly Hans Hofmann. His large, expansive, and colorful paintings of the 60s first drew attention to his work. His early colorful and geometric images and his recent realist paintings are equally expressive.

Of *San Quentin Blues*, Bireline has remarked that it "was in the series of paintings that looked critically at (his) preceding work. The previous work had gotten too precise for me; they lost an element I enjoyed in the earlier work, the drawing—the gestural content—they became in some way associated with geometric abstraction and I had very little interest in that....

"All of the color field paintings used color organization to describe certain spatial attributes-interior, exterior, window, wall, completed, coming, contained, flowing, etc. So it is appropriate to read the barred window in *San Quentin Blues* as spatial metaphor that refers to aspects of our lives, desirable but unobtainable, something like that."[19]

Provenance: from the artist, 1965.
Published: Wyrick, *Contemporary American Paintings*, p. 19 (illus.); *Original Bireline* (Raleigh: North Carolina Museum of Art, 1976), no. 41 (illus.).
Exhibited: *Selections from the Lewis Collection*: Richmond Artists Association Carillon Show, March 1969. *Contemporary American Paintings from the Lewis Collection*: Delaware Art Museum, Wilmington, September 13-October 27, 1974. *Original Bireline*: North Carolina Museum of Art, Raleigh, March 7-April 11, 1976; Southeastern Center for Contemporary Art, Winston-Salem, North Carolina, May 7-30, 1976.

18. Letter, dated July 13, 1978, from the artist to Susan L. Butler, former vice-president of the Sydney and Frances Lewis Foundation. The letter is part of the Lewis Foundation archives in the Department of 20th-Century Art, Virginia Museum of Fine Arts.
19. Letter, dated January 1985, from the artist to the author. The letter is part of the Lewis Collection archives in the Department of 20th-Century Art, Virginia Museum of Fine Arts.

Lee Bontecou
American, 1931-

8. *Untitled (No. 25)*, 1960
Welded steel, canvas, 183.0 × 142.3 × 50.8 (72 × 56 × 20)
Unsigned
Virginia·Museum of Fine Arts, Gift of
 Sydney and Frances Lewis, 85.364

In 1959 Lee Bontecou switched from representative sculptures of animals and birds to welded and fabricated abstract sculptures. In so doing she became one of the most sought-after young sculptors of the sixties.

The writer and artist Don Judd put her work into the category of "specific objects" in that they were sculptures that had painterly attributes and thus fell somewhere into that category of art that was neither painting nor sculpture.[20] In 1960 Bontecou said of her art: "My concern is to build things that express our relation to this country—to other countries—to this world—to other worlds—in terms of myself. To glimpse some of the fear, hope, ugliness, beauty and mystery that exist in us all and which hangs over all the young people today. The individual is welcome to see and feel in them what he wishes in terms of himself."[21]

Wanting to make sculpture that did not stand on the floor but hung on the wall, Bontecou welded together steel rods to which she wired canvas. Much of this canvas was fabric from various sources. Because of its diverse origins, it had several differing textures, colors, and other natural nuances. In addition, she treated the canvas in various ways with sizing, blow torches, and soot.

A common motif in Bontecou's work of this period is a single hole or orifice. Where more than one hole appears, a major orifice placed asymmetrically usually dominates the composition, as in this 1960 untitled sculpture. The multi-layered topography of the wall relief seems to lead up to and recede from this orifice, which entices us to look deep into this frontal composition. The black backing to the piece gives an infinite void to the opening, in sharp contrast to the tactile surface of the rest of the composition.

The openings, with their black voids, give a sense of terror or impending danger. They combine the machine with natural form. In addition to their mystery and danger, they also become erotic in their illusion to female forms. Bontecou does not want to make the introduction of the work easy. She likes the mystery and does not wish to explain the works. The complexity of their solids and voids, negative and positive spaces as content, produce an aggressive quality that is not apparent in her later works. By 1967 she had changed both the form of her work and the media, ending a period of dynamic sculpture that merits her a place of honor in the history of American art.

Provenance: Robert C. Scull, New York; Sotheby Parke-Bernet, New York, 1973.
Published: William C. Seitz, *The Art of Assemblage* (New York: Museum of Modern Art, 1961), no. 18, pl. 139; *Documenta III* (Kassel, West Germany: Paul Dierichs, 1964), p. 325 (illus.); *A Selection of Fifty Works from the Collection of Robert C. Scull.* Sale catalogue, Sotheby Parke-Bernet, New York, October 18, 1973, no. 1 (illus.).
Exhibited: *Leo Castelli Ten Years*: Leo Castelli Gallery, New York, 1961. *The Art of Assemblage*: Museum of Modern Art, New York; Dallas Museum for Contemporary Arts, Dallas; San Francisco Museum of Art, San Francisco, 1961-1962. *Documenta III*: Kassel, West Germany, 1964. *Current Trends in Painting*: West Hartford, Connecticut, Hartford Art School of the University of Hartford, March-April 1967. *Lee Bontecou*: Städtische Museum, Leverkusen; Museum Boymans-van-Beunigen, Rotterdam; Gesellschaft für Bildende Kunst, March-July 1968. *Selections from the Sydney and Frances Lewis Collection*: Richmond Public Library, Richmond, February 1976.

20. For a more complete definition of "specific objects," see Donald Judd, "Specific Objects," in *Contemporary Sculpture*, ed. Joseph J. Akston (New York: The Art Digest, Inc., 1965), pp. 74-82.
21. As quoted in *Americans 1963*, ed. Dorothy C. Miller (New York: The Museum of Modern Art, 1963), p. 12.

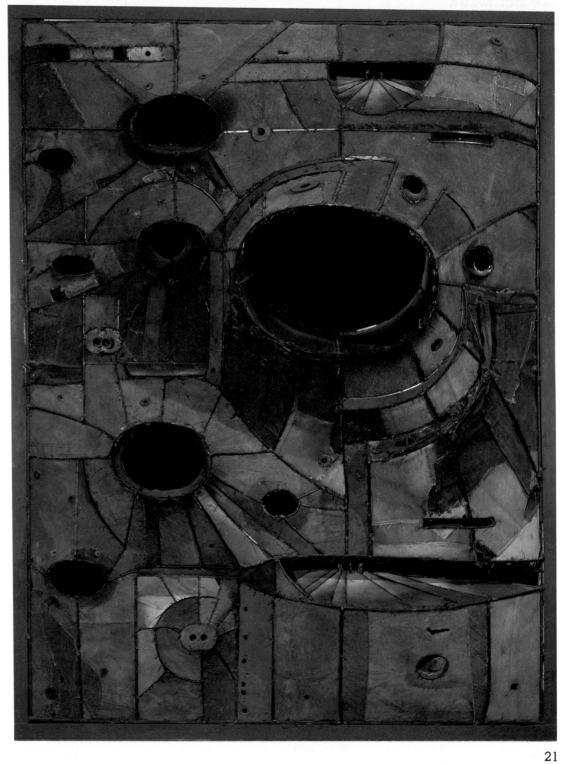

Fernando Botero
Colombian, 1932-

9. *La Estufa*, 1970
Oil on canvas, 188.0 × 149.0 (72½ × 58½)
Signed lower right: *Botero 70*
Virginia Museum of Fine Arts, Gift of
 Sydney and Frances Lewis, 85.365

Fernando Botero is a twentieth-century Manner-ist. Like El Greco and Parmigianino before him, Botero willfully distorts his figures. Since the mid-1950s, he has created a large body of work representing fat, bulbous, obese, or inflated fig-ures, as well as still lifes in which the inanimate objects take on the same characteristics as his people.

Having received little formal education in the arts, Botero became an illustrator in 1948 for the newspaper *El Colombiano*. In 1951 he moved to Bogota, where he had his first one-man show. His early paintings reflect the influence of the Mexican muralists. By 1956 he began to estab-lish the style of inflating figures and objects that has become his well-known trademark for al-most three decades. This painting, *La Estufa*, painted in his studio on Stephen's Hand Pass Road in East Hampton, Long Island, during his stay in this country from 1964 to 1972, contains both inanimate and animate objects. The stove (*la estufa*) takes on the same inflated character-istics of his people. In its size and volume, the stove becomes an animate object and takes on an almost human personality. Likewise, the cat, with its oversized body, contains an almost hu-man face. In typical Botero fashion, the cat has a frontal gaze. Seldom, if ever, do Botero's figures relate visually to one another within the canvas. Instead, he prefers to have them in direct confrontation with the viewer.

Although his style is unique, Botero was un-doubtedly influenced by his fellow Latin Ameri-can artists, particularly the Mexican painters, and by pre-Columbian art.

Provenance: Levy Gallery, Milan; Marlborough Galleria d'Art, Rome; Sotheby Parke-Bernet New York, 1975.
Published: *Important Post War and Contemporary Art.* Sale catalogue, Sotheby Parke-Bernet, New York, October 24, 1975, no. 421 (illus.); Germán Arciniegas, *Fernando Botero* (New York: Harry N. Abrams, 1977), pl. 131; Cynthia Jaffee McCabe, *Fernando Botero* (Washington, D.C.: Smithsonian Institution/Hirshhorn Museum and Sculpture Garden, 1979), p. 71, pl. 28.

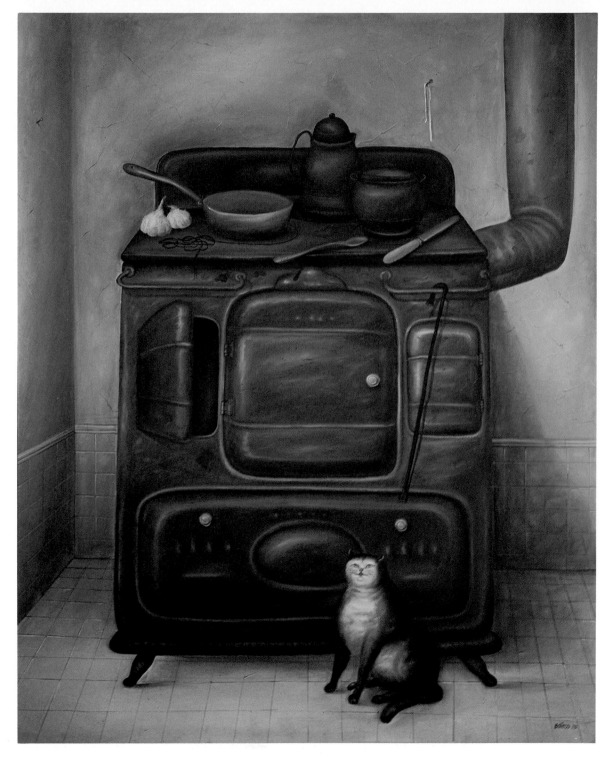

Roger Brown
American, 1941-

10. *Adam and Eve (Expulsion from the Garden)*, 1982
Oil on canvas 121.9 × 182.8 (48 × 72)
Unsigned
Virginia Museum of Fine Arts, Gift of
 Sydney and Frances Lewis, 85.366

Roger Brown's painted world is a stage whereon he depicts the dramas of contemporary life. He derives his images from history and the Bible and depicts them in a unique style in which starkly silhouetted figures are set amidst the buildings of Chicago or fantastic and impenetrable jungles are covered by skies filled with aggressive clouds.

Brown studied at the American Academy of Art, Chicago, and later received his undergraduate and graduate degrees at the School of the Art Institute of Chicago. He has lived in Chicago since 1970 and has often been associated with the Imagist painters there.

In his characteristic style, Brown arranges figures as if they appear on a stage. They often make theatrical gestures, which draw our attention to the part of the composition Brown feels should be emphasized. Narrative and often humorous, the scenes take on an ominous, even threatening atmosphere as the backlighted figures are silhouetted against foreboding skies. The pictures illustrate the American scene but not in the manner of works from the 1930s. Little wholesomeness or patriotism appears. Brown instead creates tensions among the figures as well as between them and the viewer. His picture planes are shallow, the depth being created through the odd perspective we often associate with primitivism or naive art.

Despite their complex and sophisticated nature, Brown's compositions can be associated with the naive work of Henri Rousseau, particularly in his use of junglelike flora. The simplification of forms into repetitive symbols is important in Brown's oeuvre. Although Brown has depicted a traditional Biblical subject here, the expulsion of Adam and Eve from the Garden of Eden, he gives us the feeling that we are witnessing a contemporary event set not in Paradise but perhaps in the Florida everglades. Despite the angel's flaming sword, no threat menaces Adam and Eve, who leave calmly. As in so many of his other recent paintings, Brown presents a stage set, the low horizon line with the miniature palm trees serving as footlights. The aggressive sky could be a painted theatrical backdrop. The sky and the hissing snake are the two truly menacing elements of the painting. It is more of a confrontation between the angel and the snake. Brown does not condemn Adam and Eve for their fall, but instead chronicles the event as if it might appear on the six o'clock news.

Provenance: Phyllis Kind Gallery, New York, 1982.
Published: Judd Tully, "MoMA's Eye: Aerial and Bloodshot," *Art World* 8/9 (June 1984): 1 (illus.).
Exhibited: *An International Survey of Realist Painting and Sculpture*: Museum of Modern Art, New York, May-August, 1984.

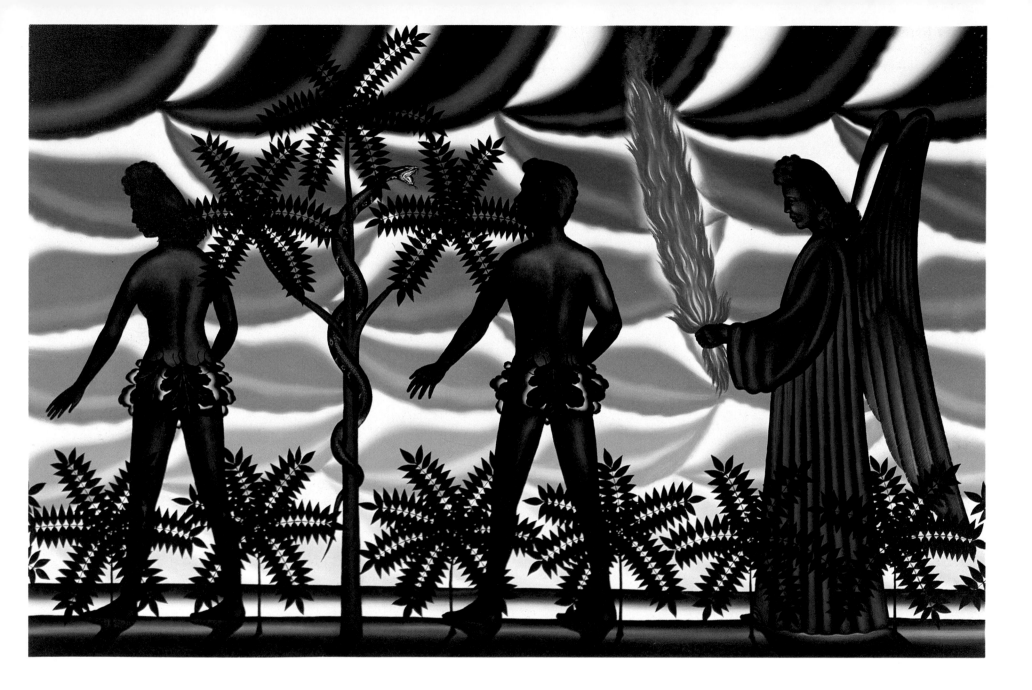

Deborah Butterfield
American, 1949-

11. *Large Horse*, 1978
Earth, wood, wire, 137.2 × 254.0 × 134.6 (54 × 100 × 53)
Unsigned
Virginia Museum of Fine Arts, Gift of
 Sydney and Frances Lewis, 85.367

For Deborah Butterfield, the horse is in effect her empty canvas. This large assemblage continues her equine theme. All of her horses have very personal connections to the artist. For instance, she uses the measurement of her own body to relate the measurements of the horses to each other. The distance from her head to her chest may become the distance from the mane to the shoulder of a horse she is creating. These horses are both self-portraits and portraits of the horses.

Born in San Diego, Butterfield studied at the University of California at Davis. Since 1979 she has lived and worked in Montana, raising the very animals that she depicts.

Her earliest horse sculptures were of poly-chromed plaster on steel armatures. Her later work reveals a greater selectivity in materials and ideas. For example, to her mud-and-stick horses, seemingly made from the debris left after a flood, Butterfield added such man-made objects as rusty metal and old bottles. She succeeded in giving more depth and breadth to the materials she used and to the presence of the horse.

Basing her compositions on three of her own horses, Butterfield begins by welding an armature, which defines the basic form. Over the armature she applies the materials, in this case mud and sticks. As Butterfield remarks, the medium is a pun on "figure/ground" relationships. "They are both. The horse *is* its environment. For me they mimicked the giant clots of mud and sticks left over in river beds after a flood/thaw—a direct relation to my own thoughts taking form and direction after a 'flood' of emotion. The mud implies flesh, the sticks bone and muscle—they also function gesturally."[22]

The posture of this horse relates to the reclining female nude. "Since most people think only of horses as a standing, upright symbols, I wanted to use this posture. It took on more meaning because horses can sleep standing up and will only lie down in a safe environment. Since art galleries are not 'safe,' I thought it showed great strength and confidence to allow the mare to lie down and be vulnerable in the formal situation of a gallery."[23]

Each sculpture has an individual identity. Butterfield has remarked, "I always work to make the personality of each horse dominate and overrule the identity of its sum parts. These horses are rarely hollow shells, but are built up from within and reveal the interior space. The gesture is contained and internalized while the posture is quiet and still. Action becomes antici-pated rather than captured. Each horse represents a framework or presence which defines a specific energy at a precise moment."[24]

Provenance: O.K. Harris Works of Art, New York, 1978.

22. Letter, dated March 20, 1985, from the artist to the author. The letter is part of the Lewis Collection archives in the Department of 20th-Century Art, Virginia Museum of Fine Arts.
23. Ibid.
24. The artist as quoted by Kay Larson in *Deborah Butterfield* (Winston Salem, North Carolina: Southeastern Center for Contemporary Art, 1983), unpaginated.

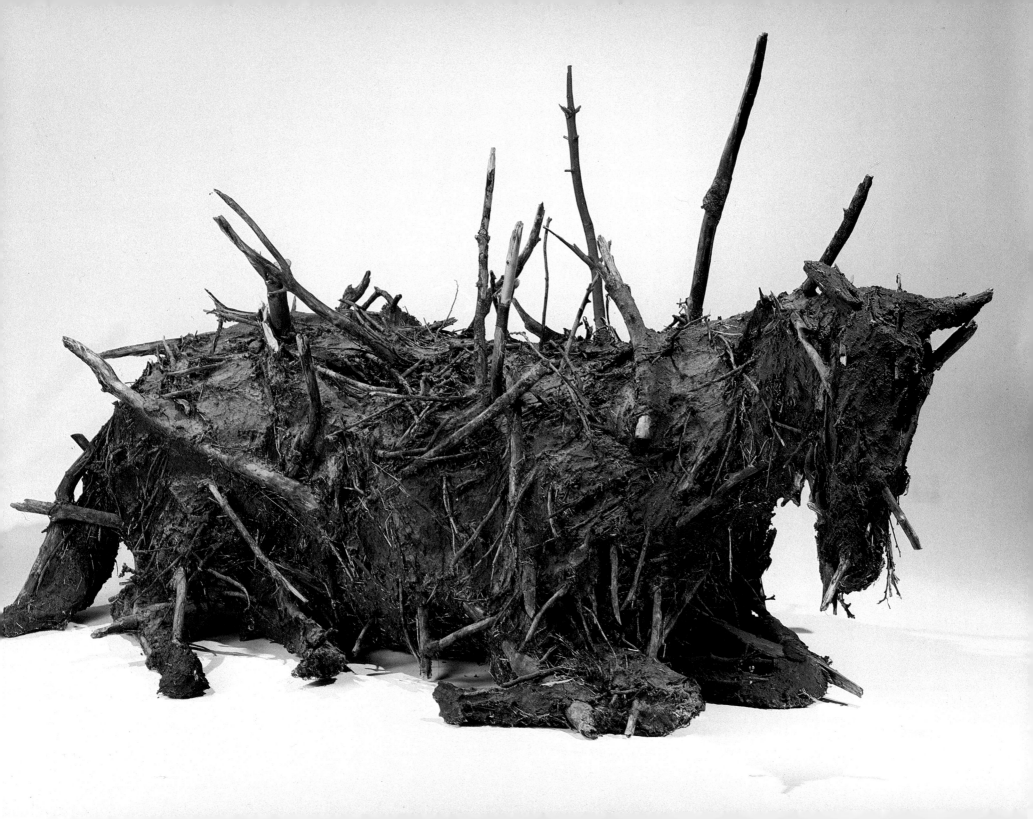

Anthony Caro
English, 1924-

12. *Writing Piece: Cease*, 1979
Wood and steel, 56.0 × 143.5 × 59.7 (22 × 56½ × 23½)
Unsigned
Virginia Museum of Fine Arts, Gift of
 The Sydney and Frances Lewis Foundation, 85.368

Since 1960 Anthony Caro has been making steel sculptures, which recall David Smith's and Henry Moore's technique and attest to Picasso's enduring legacy of constructed sculpture.

After studying at Regent Street Polytechnic School and then at the Royal Academy School in London, Caro was an assistant to Moore from 1951 to 1953. In 1959 he had made his first trip to the United States, and the following year he completed his first constructed steel sculptures.

Many of his early pieces were painted, at first with blacks and browns and then with bright colors, to avoid patination or rust, both of which would convey the notion of age. In 1974, however, he did allow such natural coloration. The majority of his work is horizontal. Caro welds I-beams, Z-shapes, and boiler plates with a low center of gravity in perfect balance. He does not include bases, which would impart an unwanted theatrical quality to invade his work and, therefore, does not put bases on them. His monumental pieces have a floating quality and weightlessness.

Writing Piece: Cease is part of a series begun in 1978. "Whereas in the past I had used some anonymous unit as parts of my work, in this series I intentionally chose units such as tools. It is as if I was prepared to remake their history."[25]

Concerning his technique, Caro writes:

I work on smaller steel sculptures in my garage, adjoining my house, and try to work very immediately and spontaneously, tacking the metal units together. I then leave them where I can't see them for several months until they have been properly welded together by my assistant Pat Cunningham, who is a full-time welder.

I then see the sculptures afresh in my studio in Camden Town and they are revealed as objects with the umbilical cord to me quite severed so that I feel free to make drastic changes, cutting out pieces, destroying them altogether, adding totally different units, completely rearranging the intent of a sculpture and even, very occasionally, finding that my first choice was the one that I still wanted to go with. In the event of changes, Pat will work further on the sculptures and then I will have yet another look. This is why works often take up to a year from first to last.[26]

Provenance: André Emmerich Gallery, New York, 1979.

Published: Brandt and Butler, *Late Twentieth Century Art*, p. 13, no. 9 (illus.); *Anthony Caro* (New York: André Emmerich Gallery, 1979), end plate.

Exhibited: *Late Twentieth-Century Art From The Sydney and Frances Lewis Foundation Collection:* Allen Priebe Art Gallery, University of Wisconsin-Oshkosh, Oshkosh, January 27-March 15, 1981; Morehead State University, Morehead, Kentucky, August 31-October 16, 1981; Columbia Museum of Art, Columbia, South Carolina, November 15, 1981-January 10, 1982; Mississippi Museum of Art, Jackson, January 31-March 14, 1982; University of Tennessee, Knoxville, March 28-May 30, 1982; Worcester Art Museum, Worcester, Massachusetts, September 10-October 31, 1982; Allentown Art Museum, Allentown, Pennsylvania, November 14, 1982-January 16, 1983; University Memorial Gallery, University of Rochester, Rochester, January 30-March 13, 1983; Everson Museum of Art, Syracuse, New York, March 25-May 29, 1983; Randolph-Macon Woman's College, Lynchburg, Virginia, November 6-December 17, 1983; Muscarelle Museum of Art, College of William and Mary, Williamsburg, February 4-April 14, 1984; Huntington Galleries, Huntington, West Virginia, June 2-August 19, 1984; Martinsville, Virginia, February 27-March 27, 1985; The Athenaeum, Alexandria, Virginia, May 7-June 2, 1985; Piedmont Arts Association, Martinsville, Virginia, February 27-March 27, 1985; The Athenaeum, Alexandria, Virginia, May 7-June 2, 1985.

25. Letter, dated June 13, 1980, from the artist to Susan L. Butler, former vice-president of the Sydney and Frances Lewis Foundation. The letter is part of the Lewis Foundation archives in the Department of 20th-Century Art, Virginia Museum of Fine Arts.
26. Ibid.

Patrick Caulfield
English, 1936-

13. *The Mysterious Suspicion: After Magritte*, 1974
Acrylic on canvas, 274.3 × 152.4 (108 × 60)
Signed on reverse on lower stretcher: *Caulfield/The Mysterious
 Suspicion: After Magritte 1974*
Virginia Museum of Fine Arts, Gift of
 Sydney and Frances Lewis, 85.369

For over two decades, Patrick Caulfield has painted bland, familiar objects in a direct, linear, deadpan fashion. His subjects have ranged from loaves of bread, candles, and vases of flowers to 1950s studio and house interiors and complex still lifes. He has depicted settings so familiar to our eyes that we feel a sense of *déjà vu.*

Caulfield may seem comparable to the Pop artists, particularly to Roy Lichtenstein. This comparison is superficially true in the relationship of his black outlines to his large areas of flat colors. The comparison with Pop Art is not valid, however, because Caulfield does not monumentalize everyday objects. Instead he records them in his unique style by placing them in context to everyday life. His style does not derive from the comic book but from his own world.

In *The Mysterious Suspicion: After Magritte*, the subject matter derives both from his own world (a room of his house) and from René Magritte's painting *The Mysterious Suspicion* (1928). Magritte had depicted his brother looking at his hand. Caulfield has a figure dressed in contemporary clothes and standing in a contemporary room. "I must have been influenced by Magritte quite early on. He seemed to be a quite novel artist and seemingly easy to grasp. He doesn't demand a knowledge of the history of painting the way that other artists do. I have always liked Magritte but what struck me remarkably about this particular image was that it didn't have any of Magritte's trickery and space, and yet had all the power that his imagery has. If you describe the painting to someone, a man looking at his hand, one wouldn't think that was remarkable, would you? I thought it was a great achievement to use such a simple image and give it such impact. I thought as I couldn't own the painting, I'd like to do a version of it. It *was* about the figure. I added all the other trappings, simply to confuse the simplicity of the image, which is what makes the Magritte marvelous."[27]

The Mysterious Suspicion: After Magritte is a complex composition of deep pictorial space emphasized not only by the distinctive linear pattern of the black outlines but also by the planes of solid color setting off the individual planes as they recede into the background. The overlapping images—the orange butterfly chair, the figure, the blue coffee table, the second butterfly chair, and finally the yellow dining room/kitchen—strengthen and emphasize this receding depth.

Caulfield has not sought the public spotlight, and thus his work is not as well known in this country as is that of his countryman, David Hockney, for example. He has quietly and consistently produced paintings that deal with his world and by so doing has created a body of significant work that chronicles his time.

Provenance: O.K. Harris Works of Art, New York, 1974.
Published: Marco Livingstone, *Patrick Caulfield: Paintings 1963-81* (London: The Tate Gallery, 1981), p. 65 (illus.).
Exhibited: *Patrick Caulfield*: F&M Gallery, Richmond, July 1976. *Patrick Caulfield: Paintings 1963-81*: Walker Art Center, Minneapolis, August 22-October 4, 1981; The Tate Gallery, London, October 27, 1981-January 3, 1982.

27. The artist as quoted by Marco Livingstone in *Patrick Caulfield: Paintings 1963-81* (London: The Tate Gallery, London, 1981), p. 26.

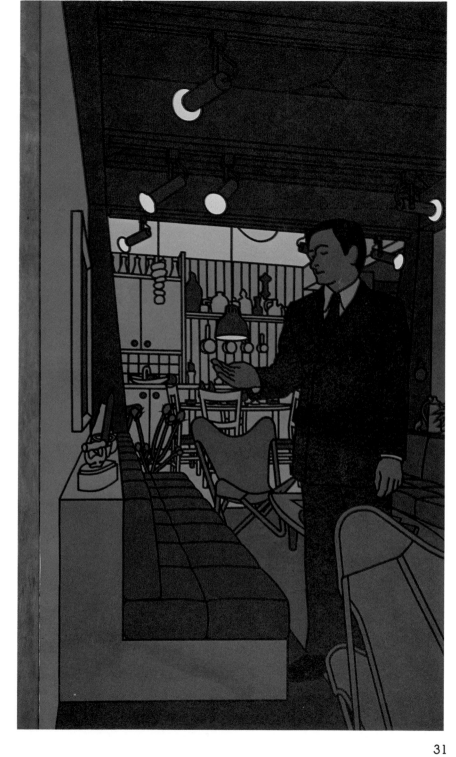

John Chamberlain
American, 1927-

14. *Johnny Bird*, 1959
Enameled steel 150.0 × 134.7 × 115.6 (59 × 53 × 45½)
Unsigned
Virginia Museum of Fine Arts, Gift of
 Sydney and Frances Lewis, 85.370

In 1957 John Chamberlain made his first piece of sculpture, using auto parts found in Larry Rivers's house in Southampton. Because of his use of bent and twisted painted metal welded into a packed and dense mass exclusive of narrative content, revealing instead the artist's intuitive manipulation of color, form, and composition, he became linked to the Abstract Expressionists.

Welded sculpture and found objects are not original to Chamberlain. Prototypes exist in the art of Picasso, Braque, and Gonzalez. More recently the sculptures of David Smith and Richard Stankiewicz closely parallel Chamberlain's use of industrial materials. Chamberlain, however, recognized the usefulness of the car part. Everywhere available and already painted, car parts can be welded, shaped, and transformed into unique compositions. Indeed, when first seen, sculptures such as *Johnny Bird* are recognized not for the identity of their components, which have been purposefully twisted and fastened into place and enriched with color, but for their new abstract volumes. Although not large, *Johnny Bird* has the feeling of monumentality. The small, thin elements add to the composition a linear aspect which in turn defines the mass of the volume. Although each unit is defined by its color, the artist has delicately balanced one section upon the other so that they form a homogeneous assembly, imparting balance and delicacy around a central axis. In establishing the delicate equilibrium of the respective parts, Chamberlain goes beyond his material to transform the dirty, rusting hulks into unified compositions bordering upon beauty. In 1982 Chamberlain wrote:

> The definition of sculpture *for me* is stance and attitude. All sculpture takes a stance. If it dances on one foot, or, even if it dances while sitting down, it has a light-on-its-feet stance. What I do doesn't look like heavy car parts laid up against a wall.

> Sophisticated materials and complex systems are not necessarily good media for art because art is a simple thing, and, the more simple the medium, the less you have to get over to get to the fact of the piece.

> I try to make the object the liaison to everyone who comes and looks at it. I must unleash something that they've probably locked up. Then, occasionally, I have to explain it to them and, all of a sudden, they have the right to an opinion—to counteract and to say, 'that doesn't work.'[28]

Provenance: Parke-Bernet Galleries, New York, 1970.
Published: Diane Waldman, *John Chamberlain: A Retrospective Exhibition* (New York: The Solomon R. Guggenheim Museum, 1971), p. 39, pl. 11; Lisa Phillips, *The Third Dimension: Sculpture of The New York School* (New York: The Whitney Museum of American Art, 1984), p. 52, fig. 53 (illus.).
Exhibited: *14th Festival of Contemporary Art*: Cornell University, A. D. White Gallery, Ithaca, New York, 1960. *John Chamberlain*: Solomon R. Guggenheim Museum, New York, December 23, 1971-February 20, 1972. *The Third Dimension: Sculpture of the New York School*: Whitney Museum of American Art, New York, December 5, 1984-March 3, 1985.

28. John Chamberlain, "A Statement," in *John Chamberlain Sculpture: An Extended Exhibition* (New York: Dia Art Foundation, 1982), unpaginated.

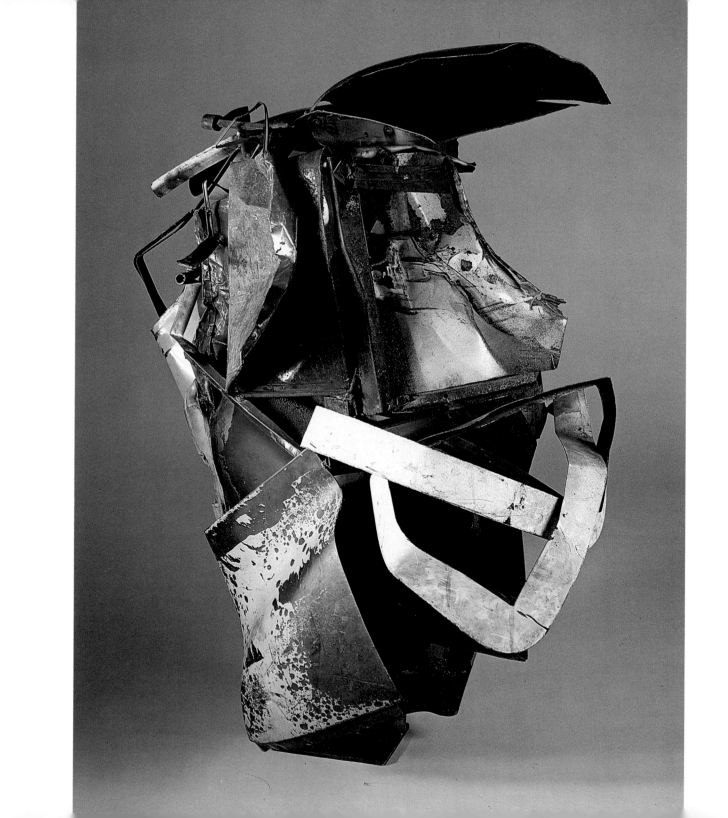

Sandro Chia
Italian, 1946-

15. *Man and Vegetation*, 1983
Bronze, 251.5 × 177.8 × 170.2 (99 × 70 × 67)
Signed on right foot: *Modern Art Foundry*
Virginia Museum of Fine Arts, Gift of
 The Sydney and Frances Lewis Foundation, 85.371

Sandro Chia received a degree in 1969 from the Accademia di Belle Arti in Florence and then, before settling in Rome, spent the following year traveling through Europe and India. He had his first one-man show in 1971 and moved to New York in 1980.

Chia's work is deeply influenced by Italian history and art. His monumental figures have often been compared to the heroic sculptures and paintings created in Italy under the reign of Mussolini.[29] The Italian Mannerist tradition of painting and sculpture, however, had the greatest influence on his work. Willfully distorted figures dominating landscapes, often set in ambiguous relationships to one another, characterize Chia's art.

Chia is accomplished both as a painter and a sculptor. In *Man and Vegetation*, the monumental figure undergoes a metamorphosis. It is difficult to tell at what stage or period the change is taking place. Parts of the figure are depicted as brick and vegetation, but the figure is completely human. The vines are so articulated that they become veins of the body. The face looks upward in either hope or despair. The aspects here have vague mythological and surrealistic origins.

The sources of Chia's images are drawn from both the past and the present. "The sources are many—newspapers, dailies, etc. The images are pretext for painting. It functions two times—first to begin the work of painting, and then later it is the result of the work. In the end the image of the painting is not only the image—it is the painting itself."[30]

Provenance: Leo Castelli Gallery, New York, 1983.
Exhibited: *Sandro Chia*: Leo Castelli Gallery, New York, April-May 1983.

29. For a comparison between the work of Sandro Chia and that produced under Mussolini, see Robert Hughes, "Doing History as Light Opera," *Time*, 16 May 1983, 79.
30. As quoted by Danny Berger, in "Sandro Chia in His Studio: An Interview," *The Print Collectors' Newsletter*, January-February 1982, 168.

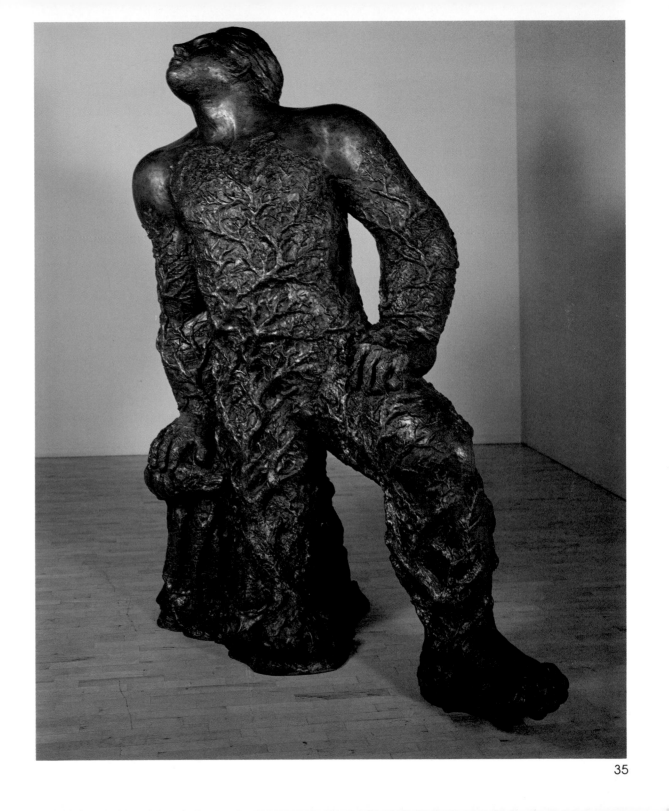

John Clem Clarke
American, 1937-

16. *Bacchanal I,* 1970
Oil on canvas, 188.0 x 226.0 (74 x 89)
 Signed on reverse, upper left: *Bacchanal I/*
 John Clem Clarke 70
Virginia Museum of Fine Arts, Gift of
 Sydney and Frances Lewis, 85.372

Interested in mechanical printing processes and their applications to the fine arts, John Clem Clarke has created paintings since the 1960s that involve a spray technique and stenciling and convey the effect of a mechanically reproduced image. He first photographs his subject, then projects it onto transparent stiff paper, and cuts stencils of the colors and tonal values of the painting. Laying these stencils on the canvas and spraying paint, Clarke builds up the colors from dark to light. The spray gun is an ordinary household "flit" gun, and not a more sophisticated airbrush.

The first works to achieve recognition consisted of a series based on old master paintings by such artists as David, Seurat, and Delacroix. Clarke used the stencil and spray-paint method for a scale larger than the originals; a white border around the painting was included to show that the image was related to mechanical art reproduction.

This series was followed by a group of similar paintings based on Clarke's own photographs. *Bacchanal I* (1970), part of this second series, shows some of Clarke's friends posed in Roman garb as if they had been painted by Caravaggio. The composition and the tonalities reinforce this parallel, even if there is no Caravaggio prototype. As in his earlier work, Clarke made stencils and used a spray gun. Close examination reveals an overall dot or pointillist effect that visually blends in the eye of the viewer. Although the content may evoke a response, it is not of primary importance to the artist. As Clarke has said, "Subject matter doesn't concern me much. Visual code holds the lasting interest for me."[31]

Provenance: O.K. Harris Works of Art, New York, 1970.
Published: Udo Kultermann, *New Realism* (Greenwich, Connecticut: New York Graphic Society, 1972), p. 50 (illus.); Wyrick, *Contemporary American Painting,* p. 23 (illus.); Edward Lucie Smith, *Art Now* (New York: William Morrow & Co., 1977), p. 462, no. 369 (illus.).

31. Letter, dated May 4, 1981, from the artist to the author. The letter is part of the Lewis Collection archives in the Department of 20th-Century Art, Virginia Museum of Fine Arts.

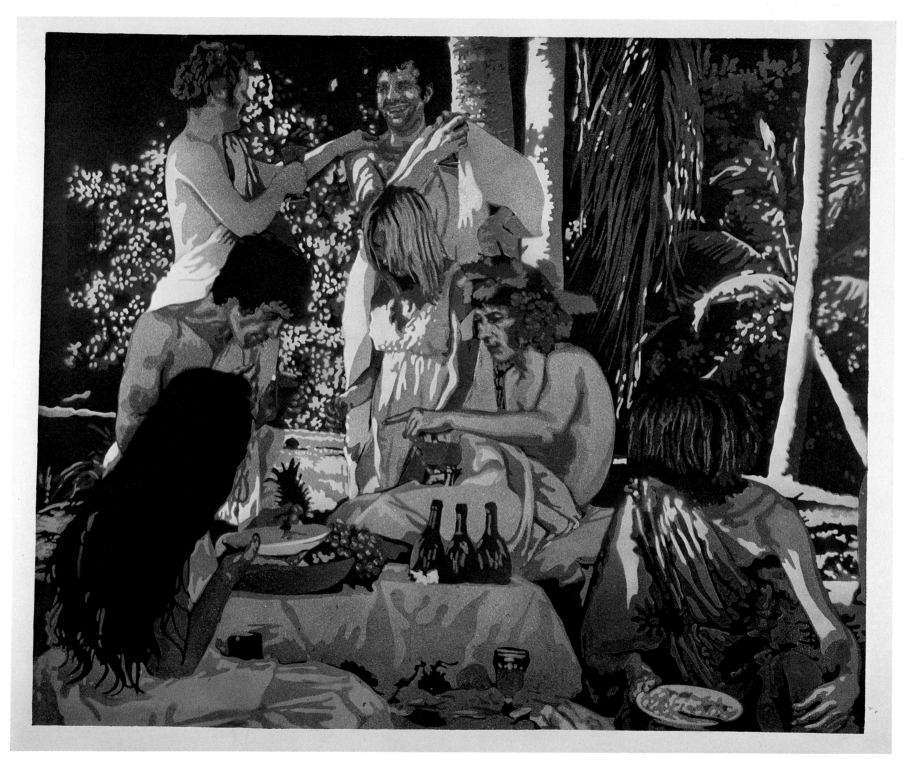

Francesco Clemente
Italian, 1952-

17. *Francesco Clemente Pinxit*, 1981
Natural pigment on paper, 24 miniatures,
 each 22.2 × 15.2 (8¾ × 6)
Signed on first panel: *Francesco Clemente Pinxit*
Virginia Museum of Fine Arts, Gift of
 Sydney and Frances Lewis, 85.373.1/24

Francesco Clemente combines the old and the new. He paints highly unusual scenes on sixteenth-century manuscripts. On close examination, we find evidence of the twentieth century—a soccer field and people wearing headphones. This visual play is typical of Clemente, one of the New Wave or *la transavanguardia* of Italy.

Born in Naples, Clemente now lives in Rome and Madras, India. His first one-man show was in Rome in 1971, and he received international acclaim when he was included in the 1980 Venice Biennale. Diverse, irreverent, steeped in Italian tradition and history, Clemente's works are endowed with a private imagery and symbolism that does not encourage understanding or participation.

Perhaps because of Clemente's lack of formal education, his drawing has a naiveté and an inconsistent style and medium. In fact, the artist delights in his ability to work in a variety of media and to change and adapt his work. He is as much at home in printmaking as he is in drawing, painting, or fresco.

Provenance: Sperone Westwater Fischer Gallery, New York, 1981.
Published: Jeff Perrone, "Boy Do I Love Art or What?" *Arts Magazine* 56/1 (September 1981): 74 (illus.); Paul Gardner, "Gargoyles, Goddesses and Faces in the Crowd," *ARTnews* 85 (March 1985): 55 (illus.).
Exhibited: *Francesco Clemente*: Sperone Westwater Fischer Gallery, New York, May 2-30, 1981. *Image Innovations: The Europeans*: Institute of Contemporary Art, Virginia Museum of Fine Arts, Richmond, May 10-June 12, 1983. *Issues I—New Allegory*: Institute of Contemporary Art, Boston, January 12-December 28, 1982. *New Painting*: Krannert Art Museum, Champaign, Illinois, January 27, 1984-March 11, 1984. *Content—A Contemporary Focus*: Hirshhorn Museum and Sculpture Garden, Smithsonian Institution, Washington, D.C., October 4, 1984-January 6, 1985.

Chuck Close
American, 1940-

18. *Jud*, 1982
Pulp paper collage on canvas, 243.8 × 182.8 (96 × 72)
Unsigned
Virginia Museum of Fine Arts, Gift of
 The Sydney and Frances Lewis Foundation, 85.374

Portraiture, a traditional subject for centuries, took on a new aspect in the late 60s when Chuck Close produced his first major paintings. In 1967, using a closeup photograph of his own face and head, Close painted a self-portrait on a nine- by seven-foot canvas.

In the tradition of Renaissance painters, he laid a grid on the canvas to match a corresponding grid on the photograph as an aid in enlargement and then used an airbrush and very thin, black acrylic paint to produce a self-portrait that, to say the least, was not a flattering representation. "It's difficult to deal with an image of yourself that size. I refer to it as 'him.' I couldn't deal with the fact that it was me. Things I didn't like about myself, the way I look, were enlarged there to such an extent that they were impossible to ignore."[32]

For the next several years Close continued to paint portraits of his friends using the same grid technique and completing one section at a time as he slowly painted the portrait from top to bottom. He restricted himself to black paint and airbrush to avoid brushstrokes. Any highlights were the result of allowing the gessoed canvas or paper to show through.

By 1971 Close was incorporating color into his portraits. Again defying tradition, he did not build up glazes or mix the colors on his palette. Using the airbrush technique, he overlaid the primary colors, red, yellow, and blue, in much the same manner as a printer would produce a color reproduction. Red was applied first, then blue, then yellow. The "mixture" creates the effect of a full-color portrait. Like the earlier black-and-white paintings, these portraits were also done on a large scale.

Jud (1982) represents a radical departure from Close's earlier work. Again, the traditional tools of the portrait painter have been replaced, this time by pieces of handmade paper of various sizes, intensities, and tonalities, from white to black. He applies the pieces to the canvas, thus sending information to our eye that is translated into an astounding realistic portrait in black and white. As with all of his other work, *Jud* results not from Close's desire to produce "realist" portraits but from his investigation of technique and production. Through his techniques, Close breaks down the visual image into its component parts of information which must be re-assembled.

Close has been likened to both Pop artists and Photo-Realists. Neither comparison is correct. His cool, detached approach to portraiture is actually more similar to that of the Minimalist painters and sculptors. The image is always secondary to the technique. The paintings could just as easily be closeup details of an inanimate object or a scene. By using unfamiliar faces, Close removes the viewer from any psychological association with that image. In addition, in works such as *Jud*, Close has added a new layer of information, that of texture. He forces examination of his paintings by sections, not by the entirety. In addition, confronting his portraits is often uncomfortable because of the proximity to the sharp-focused details, sometimes revealing facial flaws.

Close's work is indeed outstanding in the long history of portraiture.

Provenance: Pace Gallery, New York, 1983.
Published: *Chuck Close*, (New York: Pace Gallery, 1983), unpaginated.
Exhibited: *Chuck Close*: Pace Gallery, New York, February 25-March 26, 1983.

32. Martin Friedman, "Facing Reality," *Close Portraits* (Minneapolis: Walker Art Center, 1980), p. 14.

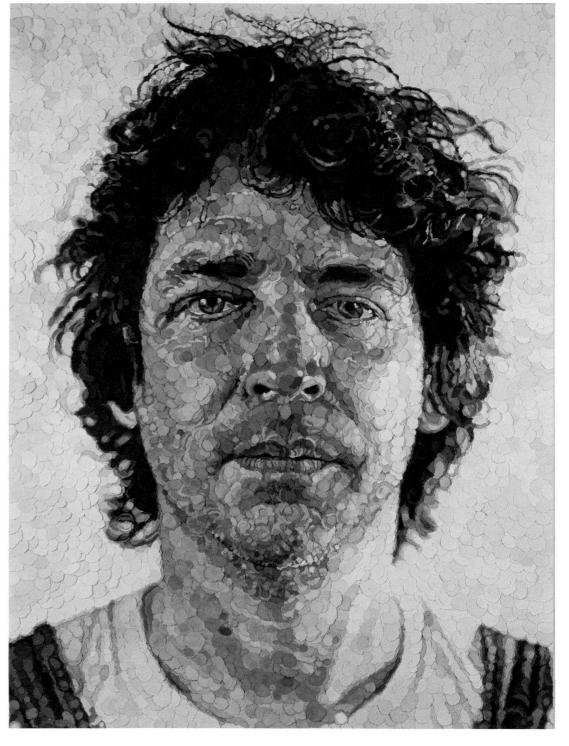

Robert Cottingham
American, 1935-

19. *Pool*, 1973
Oil on canvas, 198.1 × 198.1 (78 × 78)
Signed on reverse: *Pool/1973/Cottingham*
Virginia Museum of Fine Arts, Gift of
 Sydney and Frances Lewis, 85.375

Robert Cottingham is an observer of details, not of landscapes but of cities, particularly an aspect of cities familiar to all of us—neon signs. Cottingham photographs details of signs from many different angles, selecting and editing the angles and images necessary for a series of sketches. After varying the composition, he translates the final sketch into a large, tightly detailed façade.

His use of photography has led some to label Cottingham a Photo-Realist. Having worked for an advertising agency, Cottingham has an affinity for commercial scenes and lettering, which is understandable. Although his façades are comparable to signs from the golden age of neon in the 1930s and 40s, nostalgia is not at issue. He is more interested in the play of light and shadow; the reflective qualities of light on glass, stone, and other materials; the role of each element in forming a cohesive and interesting composition; and the interplay of various brilliant colors created by the electric signs. He avoids indications of the specific locality, favoring signs that have anonymity.

Cottingham also avoids the appearance of the painter's hand. Although he uses a brush, he diminishes the texture, thereby imparting the feel of a vastly enlarged color photograph. The only elements of drama, allegory, or narrative implicit in Cottingham's works are whatever, if any, messages underlie such word fragments such as "ode," "art," or "rat."

Provenance: O.K. Harris Works of Art, New York,1973.
Published: Wyrick, *Contemporary American Paintings*, p. 25 (illus.); Toni del Renzio, "Robert Cottingham: The Capers of the Signscape," *Arts and Artists* 9/11 (February 1975): 8 (illus.); Louis K. Meisel, *Photo-Realism* (New York: Harry N. Abrams, 1980), p. 150, no. 286 (illus.).
Exhibited: *Selections from the Lewis Collection*: Richmond Public Library, June-December 1974. *Contemporary American Paintings from the Lewis Collection*: Delaware Art Museum, Wilmington, September 13-October 27, 1974. *A Bicentennial Exhibition: American Art Today*: University of Virginia Art Museum, Charlottesville, March 9-April 30, 1976.

Allan D'Arcangelo
American, 1930-

20. *Highway US 1, Panel 3*, 1963
Acrylic on canvas, 177.0 × 206.0 (69½ × 81)
Unsigned
Virginia Museum of Fine Arts, Gift of
 Sydney and Frances Lewis, 85.376

For over two decades Allan D'Arcangelo has been reducing the elements of landscapes surrounding highways and industries to their simplest components and basic colors to create images of America.

In 1963 D'Arcangelo had his first one-man show at the Thibaut Gallery in New York, where he showed a series of paintings depicting the highway—familiar images that imply movement and the passage of time. *Highway U.S.#1, Panel 3* is one of a series of five paintings included in this first exhibition. Each painting is dominated by a familiar broken white line dividing the gray surface of the highway. This line and the highway recedes sharply to a vanishing point in the upper central section of the painting. In the first panel a Sunoco sign and a U.S. Highway 1 marker are seen in the distance very close to the vanishing point. By panel 2 these same two images are about halfway from the vanishing point to the frontal plane of the painting. Panel 3, the painting included in the Lewis Collection, depicts a fragment of the Sunoco sign and a closeup of the highway marker as if we were traveling past the two signs. Only a small portion of the highway marker appears in panel 4 and then panel 5 almost repeats panel 1, the Sunoco sign replaced by one for Texaco. Together the series of panels projects a sense of motion and suggests the experience of the familiar American landscape as if seen from a car.

D'Arcangelo's use of advertising signs and flat, solid colors, placed him in the company of the Pop artists who were emerging at the time of his first show. He did not evoke nostalgia, however, but simply employed already familiar images. A series such as *Highway U.S. 1* has not only a sense of movement but also a change in time. This is only true, however, when all five canvases are viewed together. An individual work such as this panel has a static quality, revealing only a fragment of time, not a complete passage.

D'Arcangelo uses color in a direct fashion. To reinforce his belief that paintings should create moods, he uses flat planes of color, stark silhouettes, and familiar emblems to set both the context and the tone. By silhouetting such natural features as trees and clouds, D'Arcangelo reduces them to their simplest components. The hard-edge linear quality of D'Arcangelo's work is entirely appropriate for the highways and industrial landscapes which he depicts.

Provenance: Kimiko and John Powers Collection, New York; Sotheby Parke-Bernet, New York, 1977.
Published: *Allan D'Arcangelo Paintings 1963-1970:* (Philadelphia: Institute of Contemporary Art, University of Pennsylvania, 1971), unpaginated (illus.); *Modern and Contemporary Paintings, Drawings and Sculpture.* Sale catalogue, Sotheby Parke-Bernet, New York, March 24, 1977, no. 134 (illus.); *Allan D'Arcangelo,* (Richmond: Institute of Contemporary Art, Virginia Museum of Fine Arts, 1979), p. 10 (illus.); Gerald Silk, *Automobile and Culture* (New York: Harry N. Abrams, 1984), p. 140 (illus.); *Domus* 655 (November 1984): 87 (illus.).
Exhibited: *Allan D'Arcangelo Paintings 1963-1970:* Institute of Contemporary Art, University of Pennsylvania, Philadelphia, 1971. *Allan D'Arcangelo:* Institute of Contemporary Art, Virginia Museum of Fine Arts, May 8-July 2, 1979. *Autoscape: The Automobile in the American Landscape:* The Whitney Museum of American Art, Stamford, Connecticut, March 30-May 30, 1984. *Automobile and Culture:* Los Angeles: Museum of Contemporary Art, Los Angeles, July 21, 1984–January 6, 1985.

45

John DeAndrea
American, 1941-

21. *Red-Haired Woman on Green Velvet Chair*, 1979
ethylene-vinyl acetate, oil paint, hair, wood, velvet,
116.8 × 91.4 × 104.1 (46 × 36 × 41)
Unsigned
Virginia Museum of Fine Arts, Gift of
Sydney and Frances Lewis, 85.377

Unlike many artists, John DeAndrea sculpts only figures representing ideal feminine beauty. His models are never fat, old, skinny, or ugly. They are always well-proportioned, comely, and have no obvious deformities.

DeAndrea has made sculptures from casts since he was an undergraduate at the University of Colorado. At first he used plaster molds of the figures to cast fiber-glass sculptures. More recently he has used casting in ethylene-vinyl acetate, which he believes gives him even more detail. He finishes the figures with oil paint.

Many of his figures have no accoutrements. Other works, such as this one, are accompanied by complementary objects such as chairs and beds. Until 1978 DeAndrea painted his works in extraordinarily skillful gradations of natural flesh colors. In that year he achieved what he considered a breakthrough, when he began painting his figures in tonalities of blacks and grays instead of flesh colors. The black-and-white values and the shadows on the figures and often on the accompanying walls force the viewers to look at the lifelike figure in a conceptually different way.

"Coming up through the Realist movement, I was trying to make a figure through the eyes of a fictional third realist sculptor, not myself or Duane Hanson. I was trying to imagine a way a . . . different person might see the figure.

"That was my primary aim. At the same time, I wanted a sculpture that was real, but kept the viewer at bay. The figures and natural colors invite curiosity. I want to make the figure real, but through the black and white composition, keep the viewer back when looking at it, rather than feeling obligated to handle the piece."[33]

DeAndrea has since reverted to realistic painting of the figures. *Red-Haired Woman on Green Velvet Chair*, created in 1979, is an example. Unlike Hanson, DeAndrea has always portrayed his models naked to focus concentration on the figure and not on any symbol or narration implied by particular clothing. To enhance the veracity of his work, DeAndrea has the model pose in a natural, unforced fashion. Tampering little or not at all with the mold, De-Andrea presents a wealth of information.

Provenance: O.K. Harris Works of Art, New York, 1980.
Published: Frank Goodyear, *Contemporary American Realism Since 1960* (Boston: New York Graphic Art Society, 1981), frontispiece.
Exhibited: *Contemporary American Realism Since 1960*: Pennsylvania Academy of Fine Arts, Philadelphia, September 18, 1981-July 25, 1982; Virginia Museum of Fine Arts, Richmond, February 3-March 28, 1982; Oakland Museum, Oakland, California, May 6-July 25, 1982; Gulbenkian Foundation, Lisbon, September 10-October 24, 1982; Salas de Exposciones, Madrid, November 17-December 27, 1982; Kunsthalle, Nuremberg, West Germany, February 11-April 10, 1983.

33. Letter, dated February 28, 1981, from the artist to the author. The letter is part of the Lewis Foundation archives in the Department of 20th-Century Art, Virginia Museum of Fine Arts.

Roy DeForest
American, 1930-

22. *Out West*, 1977
Polymer on canvas, 183.8 × 183.5 (72⅜ × 2¼)
Signed on reverse upper center: *Roy DeForest 1977 Polymer
Acy. BM67MT-VAR* "Out West"
Virginia Museum of Fine Arts, Gift of
The Sydney and Frances Lewis Foundation, 85.378

Dogs have played an important role in Roy DeForest's weird, absurd, eccentric, and highly imaginative paintings. His densely populated pointillist landscapes have delighted viewers not only by their narrative aspect but also by their humor and farcical attitude. DeForest studied at San Francisco State College and the California School of Fine Arts, also in San Francisco. He lives and works on the West Coast, producing on average about twelve paintings per year. Although working in California, he does not think of himself as a regional artist but he does admit that in a loose way his work reflects some general West Coast attitudes.[34]

Out West was the first painting in a series of western works derived from drawings for a show in Santa Fe. It has all the vocabulary typical of his painting, including frontal composition and humans and dogs juxtaposed in a fantastic, tranquil landscape. Earth, sky, and some of the dogs have been rendered with a series of dots of paint applied directly out of the tube. In other areas the brushstrokes supply the texture to a painting that is already very busy in both composition and surface. These paintings are a logical outgrowth of De Forest's earlier

work. Coming from the tradition of Abstract Expressionism, his first paintings were in a non-representational style. Later, they evolved into narrative works expressed in bold colors, but by the late 1960s he had created his unique fantasy world filled with unlikely beasts and humans.

DeForest's art is personal. He does not discuss matters such as the prominence of dogs in his work or the configuration of his landscapes. Preferring a simple and direct approach, he believes that an understanding of art history is unnecessary for evaluation of his paintings. His works reflect a poetic vision of the world in which his creatures exist in peace. "It has been my ambition for quite some time now to be able to construct, paint, sculpt, or draw something that would have the ability to fuse itself on the observer and allow him to witness and experience its performance, an activity not unlike that of a trained dog, elephant, or acrobat."[35] To accomplish this he has created a magical, fantastic world.

Provenance: Allan Frumkin Gallery, New York, 1978.
Published: Brandt and Butler, *Late Twentieth Century Art*, p. 20, no. 16 (illus.).
Exhibited: *Late Twentieth-Century Art From The Sydney and Frances Lewis Foundation Collection*: The Anderson Gallery,

Virginia Commonwealth University, Richmond, December 5, 1978-January 8, 1979; Institute of Contemporary Art, University of Pennsylvania, Philadelphia, March 22-May 2, 1979; The Dayton Art Institute, Dayton, Ohio, September 13-November 4, 1979; Brooks Memorial Art Gallery, Memphis, December 2, 1979-January 27, 1980; Dupont Gallery, Washington and Lee University, Lexington, Virginia, February 18-March 21, 1980; The Toledo Museum of Art, Toledo, September 21-November 9, 1980; Madison Art Center, Madison, Wisconsin, November 23, 1980-January 18, 1981; Ulrich Museum, Wichita State University, Wichita, April 1-May 31, 1981; Edna Carlsten Gallery, University of Wisconsin-Stephens Point, Stephens Point, January 27-March 15, 1981; Gibbes Art Gallery, Charleston, South Carolina, October 15, 1981-January 10, 1982; Mississippi Museum of Art, Jackson, January 31-March 14, 1982; University of Tennessee, Knoxville, March 28-May 30, 1982; Worcester Art Museum, Worcester, Massachusetts, September 10-October 31, 1982; Allentown Art Museum, Allentown, Pennsylvania, November 14, 1982-January 16, 1983; University Memorial Gallery, University of Rochester, Rochester, January 30-March 13, 1983; Everson Museum of Art, Syracuse, New York, March 25-May 29, 1983; Randolph-Macon Woman's College, Lynchburg, Virginia, November 6-December 17, 1983; Huntington Galleries, Huntington, West Virginia, June 2-August 18, 1984; Piedmont Arts Association, Martinsville, Virginia, February 27-March 27, 1985; Peninsula Fine Arts Center, Newport News, Virginia, April 5-May 1, 1985; The Athenaeum, Alexandria, Virginia, May 7-June 2, 1985.

34. "DeForest on DeForest", in *Roy DeForest* (Sacramento: Crocker Art Museum, 1980), unpaginated.
35. Ibid.

Willem de Kooning
American (born in The Netherlands), 1904-

23. *Lisbeth's Painting*, 1958
Oil on canvas, 126.5 × 159.5 (49¾ × 63¾)
Signed lower left: *de Kooning*
Virginia Museum of Fine Arts, Gift of
 Sydney and Frances Lewis, 85.379

Willem de Kooning is one of the great masters of twentieth-century art. Born in Rotterdam, he studied at the Rotterdam Academy of Fine Arts and Techniques. In 1926 he emigrated to America where he worked as a house painter in Hoboken, New Jersey. The following year he moved to New York, setting up a studio and supporting himself through various commercial art jobs. In the ensuing years he designed an exterior mural for the 1939 New York World's Fair and various projects for the Works Progress Administration. In 1948 he had his first one-person show, at the Charles Egan Gallery in New York. This was followed by a series of important solo and group exhibitions, culminating in retrospective exhibitions at the Museum of Modern Art, the Whitney Museum of American Art, and several other important American museums.

De Kooning is considered the leading figure of Abstract Expressionism, also known as "The New York School" or "Action Painting." In the late 40s and early 50s a group of artists working primarily in New York abandoned representa-tional painting for an emotionally charged style in which the execution and gesture of the artist were highly important. In so doing they created a body of work that vastly influenced artists both in the United States and abroad and promoted American painting to the forefront of interna-tional art.

Although it was basically abstract, de Koon-ing's early work retained some representational imagery, culminating about 1953 in a series of paintings of women. Later works were based on landscapes and highways and became totally abstract and non-representational. *Lisbeth's Painting* was completed during the later period.

De Kooning recalls that he completed the painting late one evening and on the following morning his two-year-old daughter, Lisbeth, rose early and proceeded to play in his studio. "During the course of her activities, she appar-ently rubbed her hands in the pale beige color on the palette, walked up to the painting, and added her inimitable contribution."[36] Although furious when he discovered what his daughter had done, he eventually decided to let her "improvements" remain and named the work after her. This incident underscores both the importance of gesture and accident to the Ab-stract Expressionist painters.

De Kooning's paintings of the 50s are totally abstract and emotive. Through color and brush-work the artist conveys emotions without re-course to representational content. In this man-ner de Kooning establishes a purely painterly link between himself and his audience.

Provenance: Sidney Janis Gallery, New York; Mr. and Mrs. S. J. Levin Collection; Christie, Manson & Woods, New York, 1979.
Published: Harriet Janis and Rudi Blesh, *de Kooning* (New York: Grove Press, Inc., 1959), p. 56, no. 37 (illus.); F. Steegmuller, "A Stroll in the Art Galleries," *Holiday* (October 1959): 90-1 (illus.); *Contemporary Art*. Sale catalogue, Christie, Manson & Woods, New York, November 9, 1979, no. 38 (illus.); Harry T. Gaugh, *De Kooning* (New York: Abbeville Press, 1983), p. 68, no. 58 (illus.).
Exhibited: *Willem de Kooning*: Sidney Janis Gallery, New York, May 1959. *18th, 19th, and 20th Century Paintings*: Joe and Emily Lowe Art Gallery, Coral Gables, Florida, July-September 1962.

36. Letter, dated February 24, 1984, from Edvard Lieber to the author, quoting de Kooning's thoughts about the painting. The letter is part of the Lewis Collection archives in the Department of 20th-Century Art, Virginia Museum of Fine Arts.

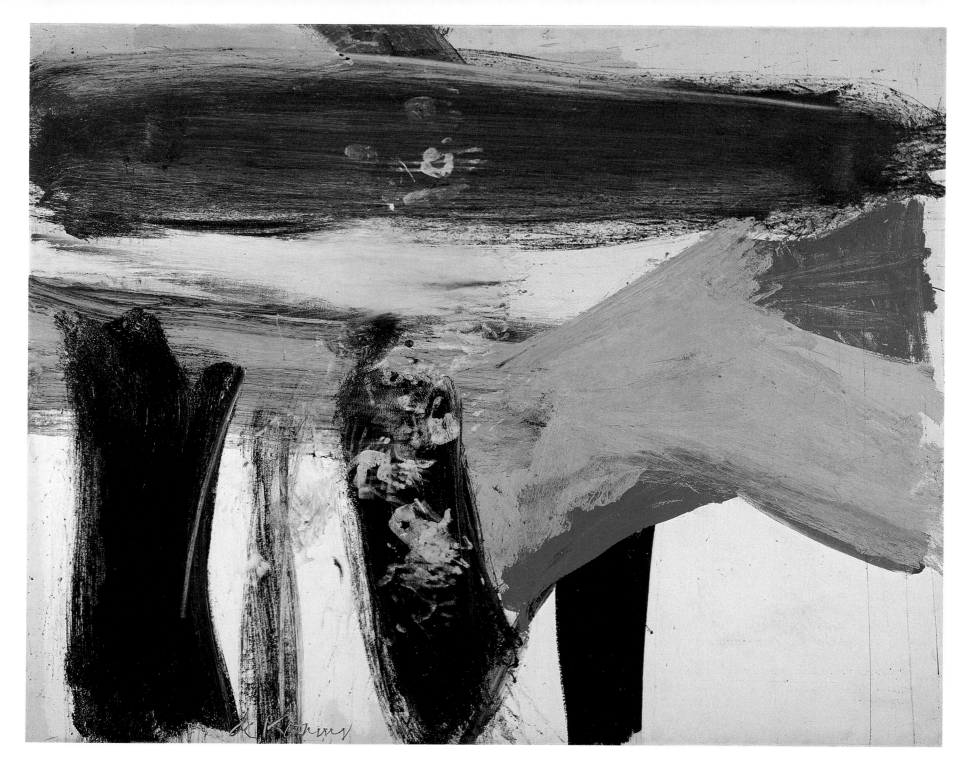

51

Richard Diebenkorn
American, 1922-

24. *Ocean Park No. 22*, 1969
Oil on canvas, 236.2 × 205.7 (93 × 81)
Signed lower right: *RD 1969*; also *Diebenkorn 1969* on reverse
Virginia Museum of Fine Arts, Gift of
 Sydney and Frances Lewis, 85.380

Richard Diebenkorn has been painting his *Ocean Park* series since 1967. Although each painting in the series relates to the others, each also stands on its own. The title and content of the series derive from the beach architecture of Ocean Park in Santa Monica. Through this series of paintings, Diebenkorn has become established as one of the major twentieth-century American artists.

Diebenkorn studied at Stanford University where he had his first exposure to early French modern painters. His own paintings of the time, however, showed a direct relationship to American scene painters such as Sheeler and Hopper. After a semester at the University of California at Berkeley, Diebenkorn, then a member of the Marines Corps, was transferred to the suburbs of Washington, D.C. where he explored its great museums. At the Phillips Collection, he admired the work of Matisse, who had a great impact on him.[37] After World War II, Diebenkorn enrolled at the California School of Fine Arts in San Francisco where he studied under David Park. In the

mid 50s, influenced by Park and his friend Elmer Bischoff, Diebenkorn abandoned abstract painting for figure painting. These three artists are often credited with the return to representational painting that began around this time. Abstract painting was still the major force on the East Coast.

Diebenkorn did a series of both still lifes and figurative paintings, the latter primarily involved with women and with the dynamics of pictorial space. He always considered himself a landscape painter, however, and in 1967 he began *Ocean Park*, the series of paintings for which he is perhaps best known.

Built of luminous colors on a rectangular format, the *Ocean Park* paintings not only capture the special light and richness of the Santa Monica beach front but also show Matisse's and Mondrian's continuing influence, particularly in their compositional devices.

As in many of the other *Ocean Park* paintings, *Ocean Park No. 22* has a vertical format dominated by several loosely painted broad white

bands that give an almost topological effect to the composition. They not only serve to segregate the major planes of color but also act as a unifying force within the painting. They also give an edge to the painting, particularly at the bottom left where a light blue vertical strip serves that function. The resolution of the edge is very important to Diebenkorn. He often solves this problem with vertical passages such as are apparent here. The development of the composition is indicated by the presence of delicate charcoal lines and the reworking of the surface area.

Provenance: Marlborough Gallery, New York; Private collection, Chicago; Sotheby Parke-Bernet, New York, 1980.
Published: *Contemporary Paintings, Drawings and Sculpture.* Sale catalogue, Sotheby Parke-Bernet, New York, November 13, 1980, no. 69 (illus.); Rita Reif, "Auctions: Sales Records Set at Houses," *New York Times*, December 26, 1980 (illus.).

37. Robert T. Buck, Jr., Linda L. Cathcart, Gerald Nordland, Maurice Tuchman, *Richard Diebenkorn: Paintings and Drawings, 1943-1976* (Buffalo: Albright-Knox Art Gallery, 1976), p. 6.

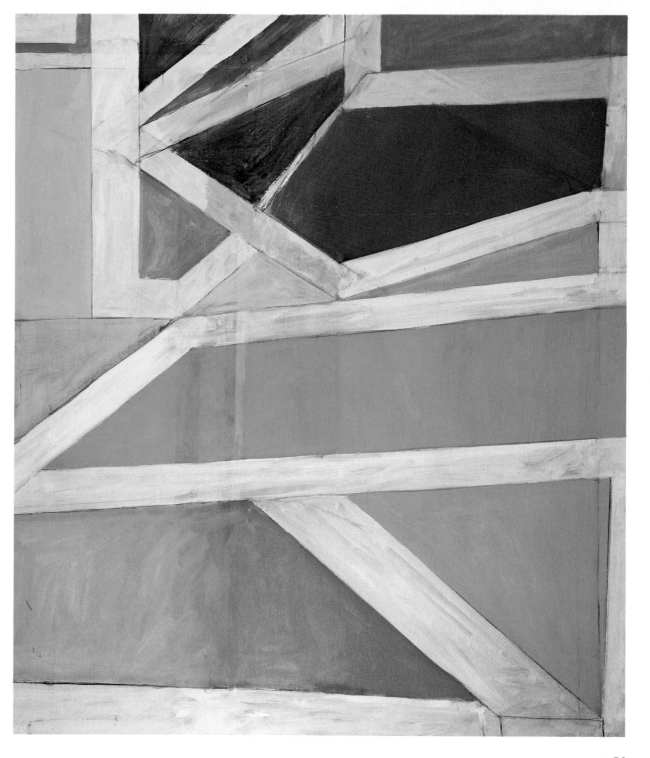

Jim Dine
American, 1935-

25. *Red Robe With Hatchet (Self-Portrait)*, 1964
Oil, metal, canvas, wood, 221.0 × 152.4 × 61.0 (87 × 60 × 24)
Signed on reverse, upper right: *Red Robe With Hatchet*
 (Self-Portrait) /1964/ Jim Dine
Virginia Museum of Fine Arts, Gift of
 Sydney and Frances Lewis, 85.381.1/3

Jim Dine was educated at the Cincinnati Art Academy and Ohio University. In 1958 he moved to New York where he immediately became involved in the active art world emerging at that time. Dine was considered an avant-garde artist with connections to the fledgling Pop movement, a comparison that he has continually refuted.[38] His work incorporated clothing, tools, and other ordinary objects assembled and attached to painted canvases, in the tradition of Marcel Duchamp's found objects and other Dada works.

In 1964, Jim Dine saw an advertisement in the *New York Times* that included a bathrobe worn by a figure who had been airbrushed out. Feeling an immediate response to this "portrait," Dine adopted the motif as a personal symbol.[39]

He considers *Red Robe with Hatchet* to be a self-portrait. It was painted in East Hampton, Long Island in the summer of 1964, "when I began working on my first show of Robe pictures, but I wasn't free enough then to improvise, so it's quite rigid in its definition. I probably visualized the axe, the log, and the bathrobe as an extension of myself—a self-portrait.

"Actually, I never wear a bathrobe. I began to draw from a real one only in 1979 in Jerusalem when Nancy (the artist's wife) photographed me in it so I could get the folds right. There's some sort of primitive abstraction in the painting of it that is slightly embarrassing to me now. The log was found in a lumber yard; it had been there a long time and was used for cutting other logs.

"If the picture has to do with anything it might be about cutting, which is implicit in using an axe. I've always loved them, the way they look, what they can do, their menacing quality ('I'd like to sharpen my axe') and see them as a metaphor for many things."[40]

Although the robe image recurs in his paintings of the past two decades, no two are alike. In each case, the robe is an entirely new object, lovingly drawn with the skill of a master draftsman. In Dine's recent works, the robe takes on a brilliant Abstract Expressionist look.

His exhibition of robe paintings at Pace Gallery in 1977 received wide praise, as did a 1980 exhibition there. Critics continually admired the paintings. These works were a far cry from the emotion and passion evident in Dine's robe flat imagery of *Red Robe with Hatchet*.

Provenance: Mr. and Mrs. Robert B. Mayer Collection, Winnetka, Illinois; Sidney Janis Gallery, New York; Sotheby Parke-Bernet, New York.
Published: John Gordon, *Jim Dine Retrospective* (New York: Whitney Museum of American Art, 1969) no. 66; *Important Post War and Contemporary Art*. Sale catalogue, Sotheby Parke-Bernet, New York, October 26, 1972, no. 40 (illus.); Lawrence Alloway, *American Pop Art* (New York: Whitney Museum of American Art, 1974), p. 44, pl. 38; Wyrick, *Contemporary American Paintings*, p. 8 (illus.); Graham W. J. Beal, *Jim Dine: Five Themes* (Minneapolis: Walker Art Center, 1984), p. 73 (illus.).
Exhibited: *Jim Dine Retrospective*: Whitney Museum of American Art, New York, 1969. *Dine/Kitaj*: Cincinnati Art Museum, Cincinnati, April-May 1973. *American Pop Art*: Whitney Museum of American Art, New York, April 6-June 16, 1974. *Contemporary American Paintings from the Lewis Collection*: Delaware Art Museum, Wilmington, September 13-October 27, 1974. *Jim Dine: Five Themes*: Walker Art Center, Minneapolis, February 15-April 15, 1984; Phoenix Art Museum, Phoenix, May 13-June 24, 1984; The Saint Louis Art Museum, July 22-September 3, 1984; Akron Art Museum, Akron, Ohio, September 22-November 11, 1984; Albright-Knox Art Gallery, Buffalo, December 7, 1984-January 20, 1985; Hirshhorn Museum and Sculpture Garden, Washington, D.C., February 20-April 28, 1985.

38. For a brief account of Dine's early relationship to the New York art world, see Graham W. J. Beal, *Jim Dine: Five Themes* (Minneapolis: Walker Art Center, 1984), pp. 7-9.
39. Robert Hughes, "Self-Portraits in Empty Robes," *Time* 14 February 1977, 65.
40. Beal, *Jim Dine: Five Themes*, p. 72.

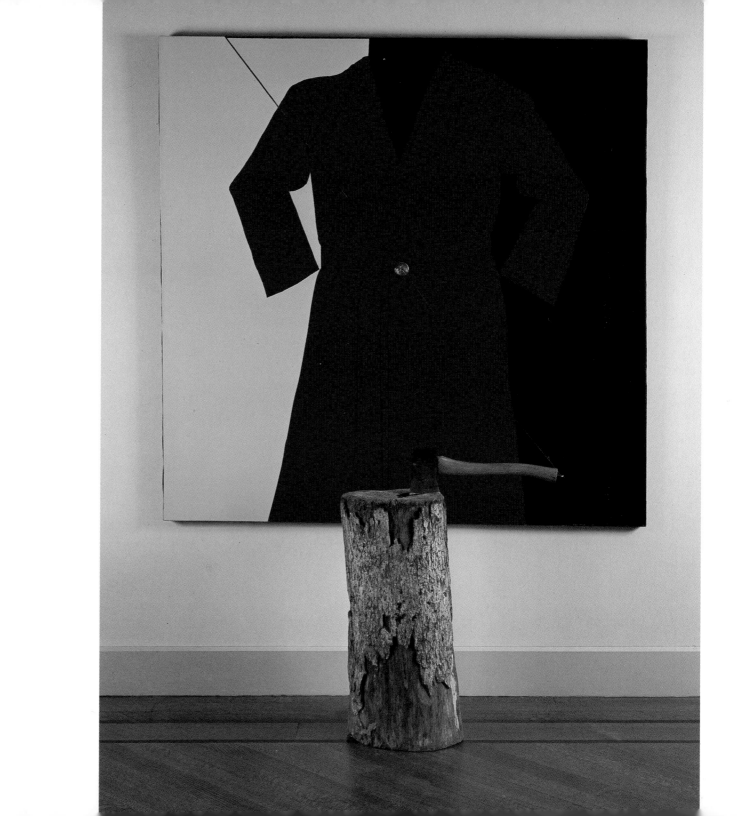

Richard Estes
American, 1936-

26. *Paris Street Scene*, 1972
Oil on canvas, 101.6 × 152.4 (40 × 60)
Signed on license plate: *19 ESTES 72*
Virginia Museum of Fine Arts, Gift of
 Sydney and Frances Lewis, 85.382

As for Robert Cottingham and Robert Bechtle, the camera is an essential tool for Richard Estes. In the production of his "urban landscapes," Estes relies upon the camera to record and store more information than he could gather otherwise. It would not be possible for the present-day artist to sit sketching in the middle of a major city without being mugged or falling victim to air pollution.

Estes has been a realist painter for all of his career. He studied at the Art Institute of Chicago and upon graduation in 1956 worked for ten years as an advertising artist. In 1959 he moved to New York and in 1966 he began painting full time, having his first one-man show at the Allan Stone Gallery in 1968.

Estes records a scene with a 4- by 5-inch large-format camera but does not necessarily use all the details that are visible in the resulting print. He paints in a grisaille on primed canvas and then roughs out the composition in an acrylic underpaint. Using oil paint, Estes completes the precisely painted details of the finished scene over a two- to three-month period.

A major figure in the long tradition of American realism, Estes champions the cityscape. Despite the appearance of the figures in his earlier works, they do not recur later. Figures

romanticize the painting, he feels, and add an unwanted emotional impact to the painting. Pure paintings, "drawings with color," have no narrative and are more important to him. He imposes order upon these scenes with a myriad of details in the super-realist tradition. His paintings go beyond mere detail, beyond the mere reproduction of the subject originally recorded through photographs. He is particularly interested in the complexity of spaces and planes as they occur within a given scene or canvas, and therefore edits the elements of his compositions until he achieves a perfect balance.

Reflections and multiple imagery have an important interrelationship in *Paris Street Scene*, a rare painting in Estes's oeuvre because it does not depict a New York scene, the subject of most of his works. Instead, it shows a quiet side street in Paris where he lived and worked for two months in 1972. The painting is dominated by a severe and abrupt vertical line that divides the canvas into two sections. This is a very strong and daring compositional motif which brings to mind Gustave Caillebotte's *Paris, A Rainy Day* (1877, Art Institute of Chicago) in which a lamp-post sharply divides a Parisian intersection. Estes interjects additional complexities of space by reflecting the left side off the right.

As in so many of his other paintings, Estes has signed this one in a playful manner, the license plate on the car nearest the center of the painting bears his name and the date.

Provenance: Allan Stone Gallery, New York, 1973.
Published: Salme Sarajas-Korte, *ARS 74* (Helsinki: Fine Arts Academy of Finland, 1974), no. 34 (illus.); William Gaines, *Twelve American Painters* (Richmond: Virginia Museum of Fine Arts, 1974), p. 21 (illus.); *Art Actuel Skira Annuel 75* (Geneva: Editions Skira et Cosmopress, 1975), p. 22 (illus.); John Arthur, *Richard Estes: The Urban Landscape* (Boston: Museum of Fine Arts and New York Graphic Society, 1978), p. 14, no. 13 (illus.); Harry F. Gaugh, "The Urban Vision of Richard Estes," *Art in America* 66/6 (November-December 1978): 136 (illus.); "Richard Estes: A New Reality," *Art & Man* 10/4 (February 1980): 10 (illus.); Louis K. Meisel, *Photo-Realism* (New York: Harry N. Abrams, 1980), p. 226, no. 468 (illus.); Judith Stein, "The State of American Realism," *The Connoisseur* (September 1981): 48 (illus.); Gerald Silk, *Automobile and Culture* (New York: Harry N. Abrams, 1984), p. 146 (illus.).
Exhibited: *25 Years of American Painting*: Des Moines Art Center, Des Moines, March 5-April 22, 1973; *ARS 74*: Fine Arts Academy of Finland, Helsinki, February 15-March 31, 1974. *Twelve American Painters*: Virginia Museum of Fine Arts, Richmond, September 30-October 27, 1974. *American Art Since 1950*: Seibu Department Store, Tokyo, Japan, June-July 1976. *Richard Estes*: Allan Stone Gallery, New York, May 1977. *Richard Estes: The Urban Landscape*: Museum of Fine Arts, Boston, May 31-August 6, 1978; The Toledo Museum of Art, Toledo, September 10-October 22, 1978; Nelson Gallery of Art, Atkins Museum of Fine Arts, Kansas City, Missouri, November 9-December 31, 1978; Hirshhorn Museum and Sculpture Garden, Washington, D.C., January 25-April 1, 1979. *The Automobile and Culture*: The Museum of Contemporary Art, Los Angeles, July 21, 1984-January 6, 1985

Rafael Ferrer
American, 1933-

27. *Andean Kayak: for Pablo Neruda*, 1973
Welded steel, 241.3 × 31.8 × 26.7 (95 × 12½ × 10½),
 oar length 143.5 (56½)
Unsigned
Virginia Museum of Fine Arts, Gift of
 Sydney and Frances Lewis, 85.383.1/2

The element of adventure in Rafael Ferrer's art is analogous to his own journeys. A frequent traveler between his home in Philadelphia and his birthplace in Puerto Rico, he often utilizes in his works such motifs of exploration as the kayak or the map.

Ferrer spent four years at Virginia Military Academy in Staunton. In 1951 he entered Syracuse University, where he began to paint. After a brief stay in California, he returned to his homeland where he enrolled at the University of Puerto Rico to study under the Spanish painter E. F. Granell, who introduced him to the great traditions of Spanish literature. In 1953 he traveled to Europe where he met André Breton, Wilfredo Lam, and other French Surrealists. He returned to New York where he painted and occasionally worked for Broadway productions. During the early 1960s Ferrer returned to Puerto Rico where he was accorded two one-man shows. Dissatisfied with the artistic atmosphere of the island, however, he moved to Philadelphia in 1966. The following years were highlighted by his inclusion in a number of exhibitions, such as *When Attitude becomes Form*,

Anti-illusions/Procedures/Materials, and several one-person shows, both in this country and abroad.

Although he had originally experimented with minimalist art, Ferrer later turned to projects that better reflected his Puerto Rican heritage. He felt that minimalism had "stifling academic dictates" with which he could not deal comfortably. He began to construct environmental tents made of painted canvas and containing objects and neon lighting. These tents became part of an invented primitive culture, which included masks, maps, kayaks, neon, paint, and other symbols defining his explorations and voyages.

In the early 1970s Ferrer began his kayak series, of which *Andean Kayak for Pablo Neruda* represents the middle period. In these fantasy boats the artist continued his voyages into the land of his dreams. Austere and elegant, the *Andean Kayak* is made of corrugated and unpainted galvanized steel. The title comes from the poetry and memoirs of the Chilean poet and Nobel Prize winner Pablo Neruda, who died at the time of the overthrow of the

Allende government. For Ferrer, the kayak is "a gray swallow or perhaps a condor. A bird to carry the soul of the poet, a vessel for a spirit."[41]

Ferrer's work is the result of a fertile, active mind. All of his art has been characterized by a thread of energy and the constant exploration of his media, his cultural background, his literary sources, and his world. He is truly a twentieth-century explorer of the mind, and the results of his explorations have greatly helped his viewers to examine and appreciate their own world.

Provenance: Nancy Hoffman Gallery, New York, 1974.
Exhibited: *Rafael Ferrer—Impassioned Rhythms*: Laguna Gloria Art Museum, Austin, Texas, September 3-October 24, 1982; Gibbes Art Gallery, Charleston, South Carolina, November 10-December 31, 1982; El Museo del Barrio, New York, May 15-August 10, 1983; University of South Florida Art Galleries, Tampa, August 29-October 8, 1983.

41. Letter, dated October 19, 1984, from the artist to the author. The letter is part of the Lewis Collection archives in the Department of 20th-Century Art, Virginia Museum of Fine Arts.

59

Rainer Fetting
German, 1949-

28. *Red Square Face*, 1984
Oil on canvas and wood, 238.8 × 216.5 (94 × 85¼)
Signed on the reverse upper left: *Fetting '84 Red Square Face*
Virginia Museum of Fine Arts, Gift of
 The Sydney and Frances Lewis Foundation, 85.385

Although he denies any influence from the great masters of German Expressionism, Rainer Fetting undoubtedly owes much in color and content to the work of Kirchner, Beckmann, Nolde, and Schmidt-Rotluff. For this reason Fetting and other members of his circle of German painters have been called Neo-Expressionists.

Like so many of Fetting's paintings, *Red Square Face* is one of a series, in this case, a series of *Holzbilder* (wood paintings), in which pieces of wood are attached to the canvas and overpainted in the same tonalities and vibrant palette as the rest of the painting. Fetting began this series in 1983 upon his move from Berlin to New York, where he salvaged materials from the abandoned piers of the west side.

Fetting studied at the Berlin State College of Art and later received a German academic exchange fellowship, which allowed him to study in New York. He has exhibited his vibrant, often luridly colored paintings since 1974, but it was probably the 1981 exposition at the Royal Academy of Art in London that brought international recognition to Fetting and his colleagues.

Most of Fetting's work is dominated by the male figure, which is painted in a rich palette of vibrant brush strokes. As in many of his other paintings, the subject in *Red Square Face* commands our attention by its intense frontal stare, which is broken only by the overlaying rectangle form of the applied wood. By extending the rectangle beyond the top and side of the canvas, Fetting adds an additional dimension and lends an expansive quality to the composition, which is further enhanced by the vibrant reds that dominate the painting. His colors have no special significance or psychological overtones. He paints and repaints until the painting is exactly what he wants it to be: "There are lots of things together that create a subject in my paintings. Psychological feelings, something I am experiencing and want to express in a visual way....The picture is a kind of symbol, the result of visual imagination."[42]

Provenance: Marlborough Gallery, New York, 1984.
Published: Richard Sarnoff, *Fetting* (New York: Marlborough Gallery, 1984), p. 9, no. 9 (illus.).
Exhibited: *Rainer Fetting*: Marlborough Gallery, New York, June 9-July 6, 1984.

42. Helena Kontova, "Rainer Fetting," *Flash Art* 115 (January 1984): 18-19.

Barry Flanagan
Welsh, 1941-

29. *Large Leaping Hare*, 1982
Gilded bronze (edition of 4), 243.8 × 274.3 × 200.0
(96 × 108 × 78¾)
Unsigned
Virginia Museum of Fine Arts, Gift of
 Sydney and Frances Lewis, 85.385 a/b

The Welsh sculptor Barry Flanagan has combined the tradition of heroic bronze sculpture and the legacy of British fantasy and combined them to create one of the most illogical yet captivating monumental images of the twentieth century—the leaping hare.

This image evolved out of two decades of making sculpture. During this time Flanagan experimented with several media in an equally diverse range of styles. Always highly inventive, nontraditional, and inquisitive, Flanagan explores the history of monumental sculpture. In addition to his interest in British history, Flanagan responded to twentieth-century English and European literature. His "concrete poetry" was published in the mid to late 60s and shows in its personal manner of expression its parallels to what he was doing in a more tangible three-dimensional form. In both, he is concerned with modeling in form, not in construction, in spite of the influence of his early teachers at St. Martin's School of Art in London, Anthony Caro, Phillip King, and Izaak Witken, all known for their additive techniques.

Flanagan has dealt primarily with abstract images related to the earth and to natural materials. He has carved stone, poured sand, and assembled branches and tree limbs, but it was in the late 70s that the image of the hare first appeared, culminating in the *Large Leaping Hare* of 1982. Leaping through the air, this magnificent figure soars above the earth yet it is tied to it by the stacked pyramidal beams of iron. As Flanagan has stated, "The stone carvings tend to be abstract, dealing in form and the bronze tends to be figurative. And the chosen subject, the surrogate figure is the hare. . . . The themes are evocative of a human situation or activity. These beasts are always doing something, sporting in one way or another. Thematically the choice of the hare is really quite a rich and expressive sort of mode; the conventions of the cartoon and the investment of human attributes into the animal world is a very well practised device, in literative and film, etc., and is really quite poignant, and on a practical level, if you consider what conveys situation and meaning and feeling in a human figure, the range of expression is in fact far more limited than the device of investing an animal—a hare especially—with the expressive attributes of a human being. The ears, for instance, are really able to convey far more than a squint in an eye of a figure or a grimace on the face of a model."[43]

Provenance: Waddington Galleries, London, 1982.
Published: *Sculpture* (London: Waddington Galleries, 1982), unpaginated.
Exhibited: *Sculpture*: Waddington Galleries, London, September 9-October 23, 1982.

43. As quoted by Tim Hilton and Michael Compton in *Barry Flanagan: Sculpture* (London: British Council, 1982), p. 93.

Mary Frank
American, 1933-

30. *Chant*, 1984
Ceramic, 111.8 × 96.5 × 152.4 (44 × 38 × 60)
Unsigned
Virginia Museum of Fine Arts, Gift of
 The Sydney and Frances Lewis Foundation, 85.385.1/4

In the tradition of mythological metamorphoses, Mary Frank transforms the ancient material of clay into vibrant, sensual, seemingly living images of women that often evoke archaeological images. Frank's fragmented figures symbolize female sexuality and sensibilities as she explores the typography of the body, patination, line, and form. She gives concrete form to the abstract qualities of ecstasy.

Frank moved to the United States in 1940. She had no formal training in sculpture but studied painting with Hans Hofmann and, perhaps more importantly, studied dance with Martha Graham. Frank acknowledges the contribution that Graham made to her work in giving her an appreciation of bodily movement and gesture. She began carving in wood, and later worked in plaster, casting some of the results in bronze. She finally turned to clay in the early 70s. Working with clay sheets, she created both monumental figures (such as *Chant*) and smaller and more intimate reliefs and figures of women and animals, all revealing her knowledge and love of nature. Clay allowed her to draw lines and to embed fingerprints and objects as part of her linear approach to a three-dimensional problem. Alluding to archaeology and to ancient mythology, the dimensions of her figures come about through necessity. The size of her kiln dictates the number and size of the stoneware forms that can be adequately fired at one time.

Despite the apparent influence of the art of the Cyclades, Egypt, pre-Columbian cultures, and classical Greece, Frank's style is not slavishly imitative but uniquely gestural and quite apart from the mainstream of twentieth-century art. The figures emerge out of material implying a sense of growth. They are the primordial earth-woman emerging from the landscape, her lover often becoming part of her through line, shadow, and gesture.

Provenance: Zabriskie Gallery, New York, 1984.
Exhibited: *Mary Frank*: Zabriskie Gallery, New York, November-December 1984.

Helen Frankenthaler
American, 1928-

31. *Mother Goose Melody*, 1959
Oil on canvas, 208.2 × 264.1 (82 × 104)
Signed, lower right: *Frankenthaler '59*
Virginia Museum of Fine Arts, Gift of
 Sydney and Frances Lewis, 85.387

Soon after her graduation from Bennington College in Vermont in 1949, Helen Frankenthaler moved to New York where she was exposed to the excitement that was then beginning to dominate American painting. This was the time of the work of Pollock, de Kooning, Kline, and the other first generation Abstract Expressionists. In 1950 she also met Clement Greenberg, the critic and writer who was the major advocate of "Action Painting," and whose theories of formalism greatly impressed the young artist. Always concerned with drawing and especially with the "drawing of color," Frankenthaler gradually began to develop her own style.

The seminal painting in her oeuvre is the 1952 oil on canvas *Mountains and Sea*. In this work she used unprimed canvas onto which she had roughly sketched in charcoal some of her basic forms and shapes. Having just returned to New York from a summer vacation in Nova Scotia, she retained impressions of what she had recently seen and tried to formalize them into her picture concept. She painted by pouring, sponging, rubbing, and brushing colors onto sized canvases. For *Mountains and Sea* however, she used an unprimed canvas and thinner paint. "I put in the charcoal line gestures first, because I wanted to *draw* in with color and shape totally abstract memories of the landscape. I spilled on the drawing in paint from the coffee cans. The charcoal lines were original guideposts that eventually became unnecessary."[44]

Frankenthaler immediately began a series of other paintings based on her new technique, refining the lines and colors. *Mother Goose Melody* is but one strand in a continuous thread of aesthetic development traceable in her work from 1949 to the present. Other related pictures are *Eden* (1957), *Venus and the Mirror* (1957), *Nude* (1959), *Alassio* (1960), and *Swan Lake* of 1961.[45] In all of these works, the use of large areas of paint are stained into the unprimed canvas and are combined with gestural line. Although each color is applied separately through various methods, each work is to be seen in its entirety, not in its components or individual gestures, thus differing from early works of the other Abstract Expressionists.

Although *Mountains and Sea* conveys impressions from her trip to Nova Scotia, Frankenthaler's works are not landscapes but instead represent explorations of color and line. In her lyrical yet dazzling paintings, she has focused on the exploration of shape, form, and color which become part of the very surface of the painting. It is not so much a question of a figure-on-ground relationship as figure-becoming-ground.

Provenance: André Emmerich Gallery, New York, 1980.
Published: Carl Belz, *Frankenthaler: The 1950's* (Waltham, Massachusetts: Rose Art Museum, Brandeis University, 1981), pl. 52; John Elderfield, "Specific Incidents," *Art in America* (February 1982): 104 (illus.); Tom Styron, *Andrew Wyeth: A Trojan Horse Modernist* (Greenville, South Carolina: Greenville County Museum of Art, 1984), p. 17 (illus).
Exhibited: *Frankenthaler: The 1950's*: Rose Art Museum, Brandeis University, May 10-June 28, 1981. *Andrew Wyeth: A Trojan Horse Modernist*: Greenville County Museum of Art, Greenville, South Carolina, March 9-April 15, 1984.

44. As quoted by Gene Baro in "The Achievement of Helen Frankenthaler," *Art International* 11/7 (September 20, 1967): 36.
45. The relationship of these six paintings as part of the development of this continuous thread was suggested by the artist in a letter to the author dated October 15, 1984. This letter is part of the Lewis Collection archives in the Department of 20th-Century Art in the Virginia Museum of Fine Arts.

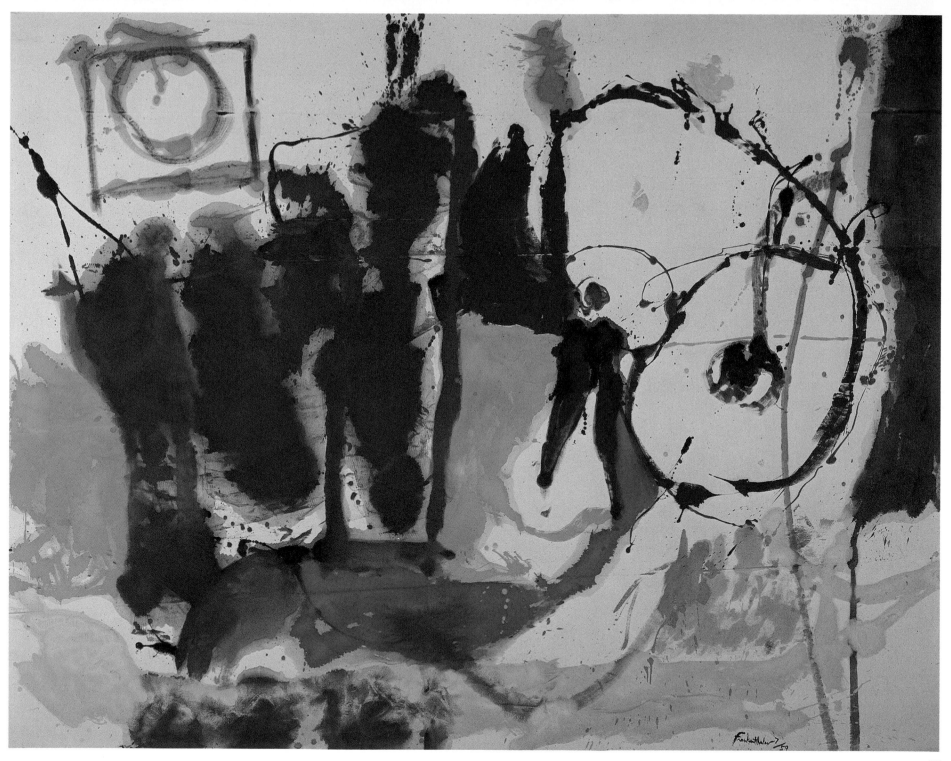

Sondra Freckelton
American, 1936-

32. *Winter Melon with Quilt and Basket*, 1977
Watercolor on paper, 117.5 × 112.0 (46⅛ × 44¹/₁₆)
Signed lower right: *Freckelton 77*
Virginia Museum of Fine Arts, Gift of
 Sydney and Frances Lewis, 85.388

Sondra Freckelton's works reflect the idyllic, pastoral setting of her upstate New York farm, to which she retreats periodically from her home in Manhattan. Her depictions of handwoven crafts, home-grown fruits and vegetables, and furniture evoke a quieter and gentler past, and delineate the abundance of the good life that reflects the history of our country.

Freckelton's images are neither commercial nor pedestrian but lively, vibrant, and exciting. They reveal daring compositional devices that immediately draw our eye to the various juxtaposed textures. She paints in watercolor in precise fashion, demonstrating exquisite control of line and color. In her hand, watercolor becomes the perfect medium for depicting the abundance of life.

In arranging her own still lifes, Freckelton selects freely from her household and garden. *Winter Melon with Quilt and Basket* shows a dramatic diagonal composition based on the line of the quilt as it strikes upward to the left and then reverses its direction, culminating in the top center of the painting. The sliced melon, however, directs our gaze back into the center of the composition and establishes a strong vertical element in line with the basket and the lower folds of the quilt. The colors of the quilt and the produce complement one another, and indicate the artist's complete control over her medium. Although her watercolors are homages to nature's abundance, the human hand is apparent in the craftsmanship of the quilt and basket, as well as the careful slicing of the melon. In some of her works Freckelton includes the human figure, usually self-portraits or portraits of her friends or husband, Jack Beal. But it is always nature that has the starring role.

Provenance: Brooke Alexander Gallery, New York, 1977.
Published: William C. Landwehr, *Watercolor U.S.A. 1977* (Springfield, Missouri: Springfield Art Museum, 1977), p. 6, no. 40 (illus.).
Exhibited: *Watercolor U.S.A. 1977*: Springfield Art Museum, Springfield, Missouri, April 24-June 19, 1977.

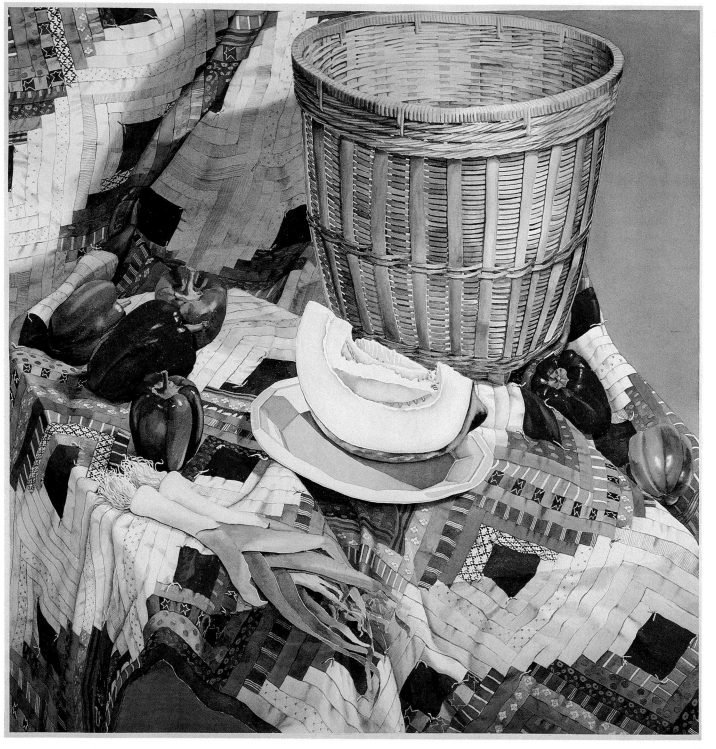

Paul Georges
American, 1923-

33. *Back Yard,* 1976
Oil on canvas, 152.4 × 205.7 (60 × 81)
Unsigned
Virginia Museum of Fine Arts, Gift of
 Sydney and Frances Lewis, 85.389

Paul Georges studied with Hans Hofmann in Provincetown on Cape Cod and later at the Académie de la Grande Chaumière and the Léger School in Paris. Since 1952, he has worked and lived in New York. Although his early work was abstract, Georges emerged as a leading figurative painter in 1961.

Georges draws upon his circle of friends and relatives for his subject matter. In *Back Yard* he depicts himself on one side of the canvas, balanced by his wife and two daughters on the other. At times, he illustrates moral dramas, which are usually in New York and acted out by fellow artists and other friends. They document dramatic events, as an expression of his moral and political views. In other paintings, well-known political figures appear in the allegorical dramas that Georges creates.

In all these works, whether portraits of his family or allegories, Georges sets up challenging visual problems for himself. Having studied the techniques of the Old Masters, Georges strives for a perfect balance suitable to the subject and topic of the paintings. In *Back Yard*, he puts the plane of the table at eye level and almost centered. By placing the napkin on the front of the left corner of the table, he establishes the frontal picture plane and then draws our eye into the canvas through each of the other planes, eventually into the background of trees, landscape, and clouds. In addition, he sets up a symmetrical balance between elements on either side of the canvas: on the left, the overhanging leaves and cloud formation; and on the right, his family and the vertical element of the tree. Although the figures are posed, they are in relaxed attitudes and express a sense of intimacy with one another; this is especially evident in the relationship of the two girls to their mother.

Painting in traditional techniques entirely appropriate to a realist, Georges uses a limited palette and fluent, dramatic brushstrokes, building up his forms as he models them in light and shadow. He has advocated the primacy of figurative painting and has been an outspoken advocate of realism, both verbally and pictorially.[46] Though he has traditional values, he is contemporary in approach. Georges's brushstroke is direct and forthright with no hint of artificiality. His is the intimate world of the painter, reflecting personal values combined with a sharp intellect.

Provenance: from the artist, 1976.

46. Diane Cochrane, "Paul Georges: The Object is the Subject," *American Artist* 38/386 (September 1974): 62.

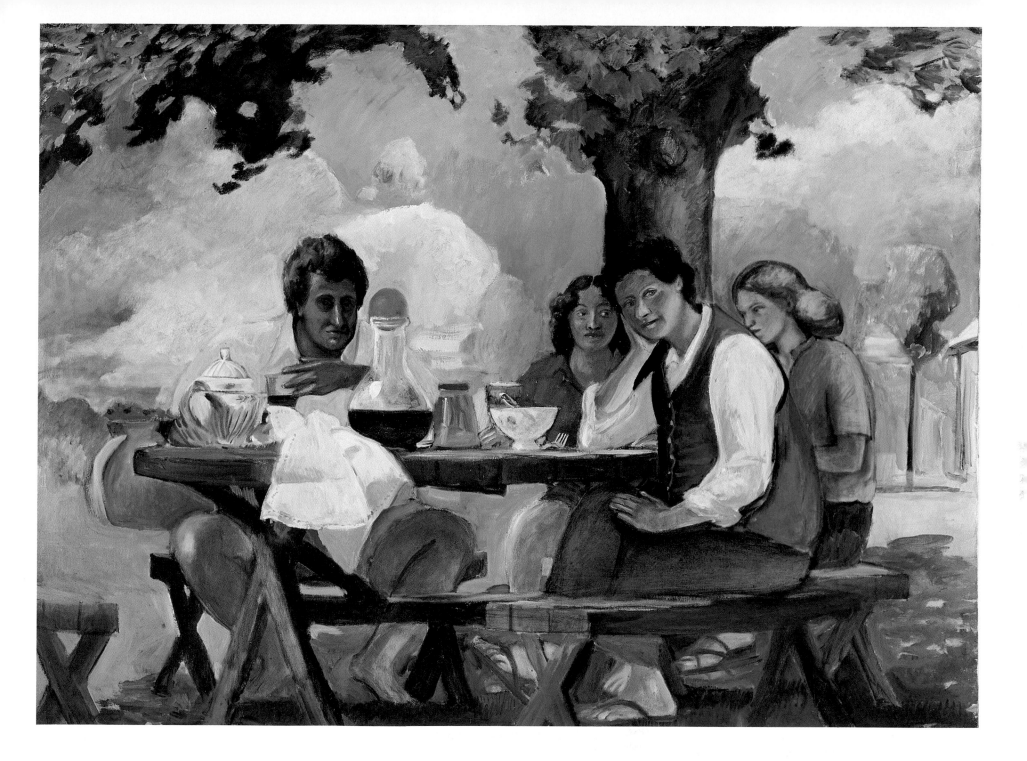

Gilbert and George
(Gilbert Proesch, English (born in Italy) 1943-;
George Passmore, English, 1942-)

34. *The Tree*, 1978
Sixteen gelatin-silver photographs, 60.3 × 50.2 (23¾ × 19¾)
 each, 242.0 × 201.6 (95¼ × 79⅜) overall
Signed on lower right: *The Tree/Gilbert and George/1978*
Virginia Museum of Fine Arts, Gift of
 The Sydney and Frances Lewis Foundation, 85.390.1/16

Gilbert Proesch and George Passmore met at St. Martin's School of Art in London in 1967. Their subsequent and ongoing collaboration is unparalleled in contemporary art. What sets Gilbert and George apart is their total involvement in art. In 1972 George explained, "We developed a new concept of art, 'art for all,' in which our bodies became the substance of our work."[47] From 1969 to 1970 they produced what they called "living sculptures." Painted on their faces and hands and dressed alike in conservative suits, white shirts, and identical ties, the two young men on a daily basis sang songs and went through various motions. Known as "Underneath the Arches," their act was performed over three years. Their only accessories were a cane and a glove. Hour after hour they were accompanied by a tape playing the song "Underneath the Arches" as they slowly and mechanically performed stilted movements while they were surrounded by oversized folded drawings on the gallery walls. In this manner they were not merely the artists, they became the art. Their work is similar to the "performance art" of the period.

In 1971 Gilbert and George exhibited their first multi-photo pieces, which gradually evolved into more organized, cohesive images such as *The Tree* in which individually framed photographs abut one another to form complex imagery, often including photo self-portraits. In *The Tree*, the self-portraits appear in the frieze at the bottom of the work and the sinister outline of the tree emerges from the black shadows and their faces.

Provenance: Sonnabend Gallery, New York, 1978.
Published: Brandt and Butler, *Late Twentieth Century Art*, p. 24, no. 20 (illus.); Brenda Richardson, *Gilbert & George* (Baltimore: Baltimore Museum of Art, 1984), p. 85 (illus.).
Exhibited: *Late Twentieth-Century Art From The Sydney and Frances Lewis Foundation Collection*: The Anderson Gallery, Virginia Commonwealth University, Richmond, December 5, 1978-January 8, 1979; Institute of Contemporary Art, University of Pennsylvania, Philadelphia, March 22-May 2, 1979; The Dayton Art Institute, Dayton, Ohio, September 13-November 4, 1979; Brooks Memorial Art Gallery, Memphis, December 2, 1979-January 27, 1980; Dupont Gallery, Washington and Lee University, Lexington, Virginia, February 18-March 21, 1980; The Toledo Museum of Art, Toledo, September 21-November 9, 1980; Madison Art Center, Madison, Wisconsin, November 23,1980-January 18, 1981; Ulrich Museum, Wichita State University, Wichita, April 1-May 31, 1981; Allen Priebe Art Gallery, University of Wisconsin-Oshkosh, Oshkosh, January 27-March 15, 1981; Gibbes Art Gallery, Charleston, South Carolina, October 15, 1981-January 10, 1982; Mississippi Museum of Art, Jackson, January 31-March 14, 1982; University of Tennessee, Knoxville, March 28-May 30, 1982; University Memorial Gallery, University of Rochester, Rochester, January 30-March 13, 1983; Everson Museum of Art, Syracuse, New York, March 25-May 29, 1983. *Gilbert and George*: The Baltimore Museum of Art, Baltimore, February 19-April 15, 1984; Contemporary Arts Museum, Houston, June 23-August 19, 1984; The Norton Gallery of Art, West Palm Beach, Florida, September 29-November 25, 1984.

47. Donald Zec, "The Odd Couple," *Daily Mirror* (London), 5 September, 1972.

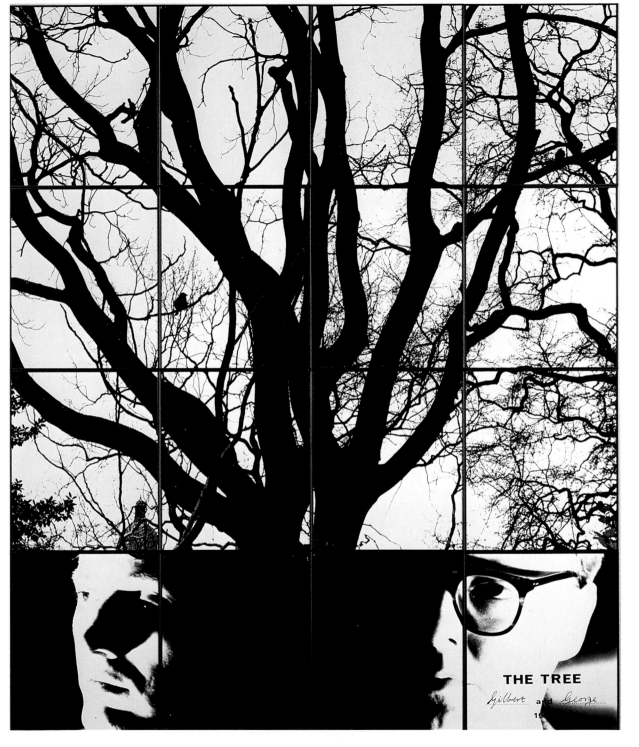

THE TREE

Gilbert and George

19

73

Gregory Gillespie
American, 1936-

35. *Self-Portrait (Torso)*, 1975
Oil and acrylic on canvas, 76.8 × 62.9 (30¼ × 24¾)
Unsigned
Virginia Museum of Fine Arts, Gift of
 Sydney and Frances Lewis, 85.391

Gregory Gillespie, like Paul Georges, is an atypical contemporary painter because his style is firmly grounded in the tradition of Old Master painters. Although he worked and studied in Italy, the tradition of the Flemish-Germanic artists is perhaps the strongest influence on his work. *Self-Portrait (Torso)* immediately recalls the self-portraits of painters such as Albrecht Dürer. The stark frontality, the precise photographic realism, and the supporting panel are all traditional techniques and methods of European masters.

Self-portraiture is only one of Gillespie's subjects, but it has recurred throughout his oeuvre. His earlier paintings, done while in Italy, were similar to small stage settings or shrines in which people were captured in a mixture of paint and photographic images. They often imply a surrealistic content and a high degree of eroticism. Upon his return to the United States, his paintings became larger and his subject matter changed to include pictures of family and friends, still lifes, and fantastic landscapes. The landscapes, which recall the works of Bosch, appear to be in a state of decay and are populated by odd creatures and strange gnarled trees and bushes.

Of Gillespie's many self-portraits, *Self-Portrait (Torso)* is one of the most analytical and disturbing. "When I painted that head-and-torso self-portrait, I was in a quiet trance. I remember I had my eyes closed, and when I opened them, there in front of me, was a mirror. I was looking at my reflection from a very quiet and deep space inside of myself . . . and it was like seeing someone else. I was really very close to the mirror, and things got very exciting when I started painting the flesh parts."[48]

To achieve the fine detail of his paintings, Gillespie uses a magnifying glass and a fine sable brush. He reworks the paintings to get the exact texture, color, and composition. His surroundings affect his paintings, whether Florence, Rome, or, most recently, North Andover, Massachusetts, but it is not the landscape around him that he paints. The actual landscape may influence his work, but it is changed through the artist's hand to become the landscapes of his own mind. It is difficult for us to enter these landscapes because they exist in a dreamscape. Whether he is painting self-portraits, still lifes, or landscapes, Gillespie strives for what he calls the "molecular feeling"[49] of things. While working on this painting, he almost sensed the blood pulsing through the "vessels" of the self-portrait. The viewer may sense that this is not a cold, impersonal image but a deeply human, almost animate picture.

Provenance: Forum Gallery, New York, 1976.
Published: Abram Lerner, *Gregory Gillespie* (Washington, D.C.: Smithsonian Institute Press, 1977), p. 97, no. 66 (illus.); John Gruen, "Gregory Gillespie's Dense Reality," *ARTnews* 76/3 (March 1977): 78-81 (illus.); John Canaday, "Gregory Gillespie, and Why the Whitney Should be Kicking Itself," *The New Republic* (February 4, 1978): 31 (illus.); *As We See Ourselves: Artists' Self-Portraits* (New York: Heckscher Museum, 1979), p. 36 (illus.); Thomas Styron, *American Figure Painting* (Norfolk: Chrysler Museum, 1980), p. 84 (illus.); Frank Goodyear, *Contemporary American Realism Since 1960* (Boston: New York Graphic Society, 1981), p. 55, no. 25 (illus.); *Real, Really Real, Super Real: Directions in Contemporary American Realism* (San Antonio: San Antonio Museum Association, 1981), pp. 76-77, pl. 8.
Exhibited: *Gregory Gillespie*: Forum Gallery, New York, November 1976. *Gregory Gillespie*: Hirshhorn Museum and Sculpture Garden, Washington, D.C., December 22, 1977-February 12, 1978. *As We See Ourselves: Artists' Self-Portraits*: Heckscher Museum, Huntington, New York, June 22-August 5, 1979. *Three Approaches to Realism: Beckman, Davenport, Gillespie*: Institute of Contemporary Art, Virginia Museum of Fine Arts, Richmond, March 8-April 24, 1983. *Artists Choice—Younger Artists*: Artists Choice Museum, New York, September 6-18, 1980. *American Figure Painting 1950-1980*: Chrysler Museum, Norfolk, October 17-November 30, 1980. *Real, Really Real, Super Real: Directions in Contemporary American Realism*: San Antonio Museum of Art, San Antonio, March 1-April 26, 1981; Indianapolis Museum of Art, Indianapolis, May 19-June 28, 1981; Tucson Museum of Art, Tucson, July 19-August 26, 1981; Museum of Art, Carnegie Institute, Pittsburgh, October 24-January 3, 1982. *Focus on the Figure: Twenty Years*: Whitney Museum of American Art, New York, April 14-June 13, 1982.

48. John Gruen, "Gregory Gillespie's Dense Reality," *ARTnews* 76/3 (March 1977): 81.
49. From an interview with Gregory Gillespie published by Abram Lerner in *Gregory Gillespie* (Washington, D.C.: Smithsonian Institution Press, 1977), p. 29.

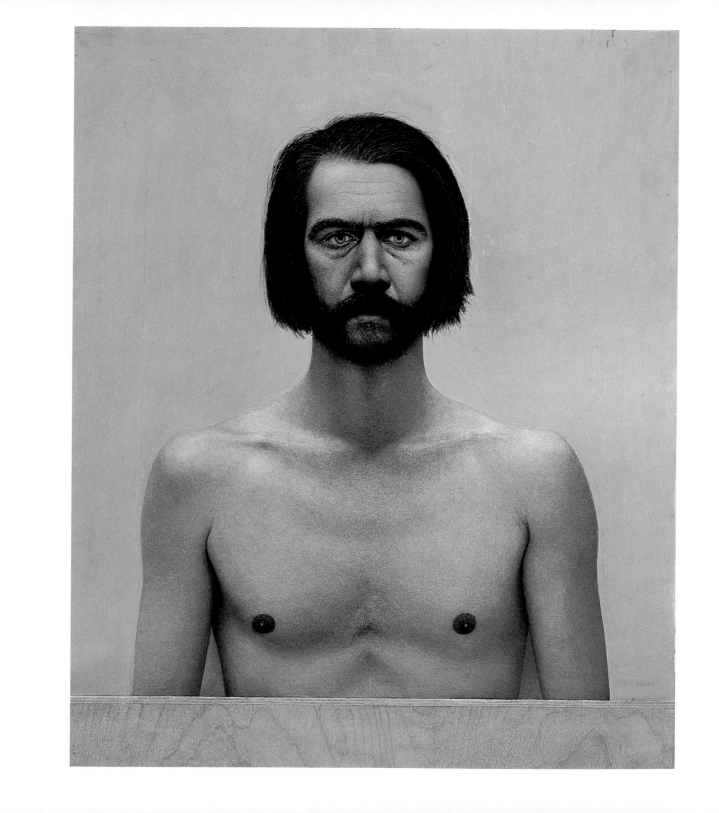

Sam Gilliam
American, 1933-

36. *Of Cities American*, 1979
Acrylic on canvas, 203.2 × 355.6 (80 × 140)
Signed on reverse, upper left: *Of Cities American/79 Sam Gilliam*
Virginia Museum of Fine Arts, Gift of
 The Sydney and Frances Lewis Foundation, 85.392

Because he has lived in Washington, D.C. since 1962, Sam Gilliam is often associated with the Washington Color School. His early work, which involved bright fields of color poured onto the canvas, validates the comparison. As his work developed, however, it had more similarity to Abstract Expressionism of the 1950s.

Never content to be a follower, Gilliam has been an innovator of new modes of expression. Although in the early 60s he had worked with stretched, framed canvases, he later achieved national and international recognition for his large canvases, which he left unstretched, tied in knots, draped from ceilings, thus freeing his paintings from the confines of a frame. His paintings became three-dimensional and he was able not only to interject color into the exhibition space but also to manipulate literally the space itself.

In the late 1970s Gilliam went back to stretching his works, although the paintings were not done in the traditional manner. Working with his canvas on the floor, Gilliam uses a rug rake to pull acrylic paint into the pattern he wishes. As he manipulates the paint, color and gestures become as important to Gilliam as to the Abstract Expressionists. He works on a number of paintings at the same time, then cuts out sections of various canvases which he collages to other areas.

Of Cities American has collaged rectangles on the left and the triangles on the right. It is part of a series dealing with American cities and may derive from maps or aerial views. The work has similarities to Cubism, as well as to Abstract Expressionism.

Concerning *Of Cities American*, Gilliam has said, "As an artist I never felt that I was lost in distinctive/extinctive style. *Of Cities American* is, of course, a painting, a proof. I introspectively tried to look at Cubism in terms of direction, cities/seeing, map plans. I looked, I sought an aspect of fusion. This painting became a 'hold' on what I thought. Sometimes an artist just goes through it, rather than explaining it. I felt that much of my painting has been fixed on this ability to make a different kind of field, acknowledging Johns, Hartley, and possibly, Pollock. *Of Cities American* is a found space, continent, enclosure. It was a point of growth for me and a very vital aspect of searching, and knowing and unknowing."[50]

Provenance: Hamilton Gallery, New York, 1979.
Published: Brandt and Butler, *Late Twentieth-Century Art*, p. 26, no. 22 (illus.).
Exhibited: *Late Twentieth-Century Art From The Sydney and Frances Lewis Foundation Collection*: The Dayton Art Institute, Dayton, Ohio, September 13-November 4, 1979; Brooks Memorial Art Gallery, Memphis, December 2, 1979-January 27, 1980; Dupont Gallery, Washington and Lee University, Lexington, Virginia, February 18-March 21, 1980; The Toledo Museum of Art, Toledo, September 21- November 9, 1980; Madison Art Center, Madison, Wisconsin, November 23, 1980-January 18, 1981; Ulrich Museum, Wichita State University, Wichita, April 1-May 31, 1981; Edna Carlsten Gallery, University of Wisconsin-Stephens Point, January 27-March 15, 1981; Morehead State University, Morehead, Kentucky, August 31-October 16, 1981; Columbia Museum of Art, Columbia, South Carolina, November 15, 1981-January 10, 1982; Mississippi Museum of Art, Jackson, January 31-March 14, 1982; University Memorial Gallery, University of Rochester, Rochester, January 30-March 13, 1983; Everson Museum of Art, Syracuse, New York, March 25-May 29, 1983; Huntington Galleries, Huntington, West Virginia, June 2-August 18, 1984.

50. Letter, dated October 13, 1984, from the artist to the author. The letter is part of the Lewis Foundation archives in the Department of 20th-Century Art, Virginia Museum of Fine Arts.

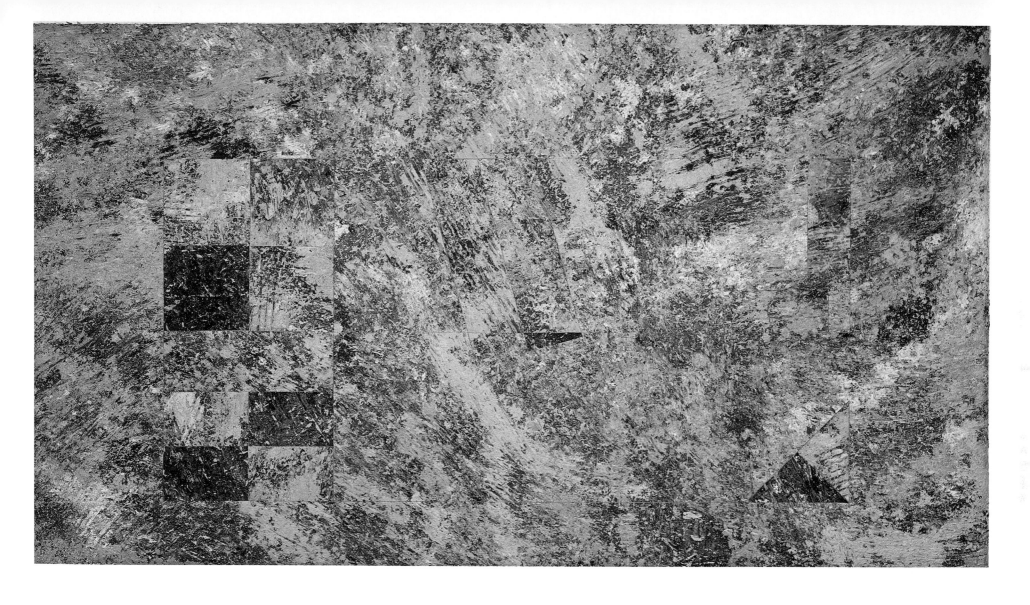

Ralph Goings
American, 1928-

37. *Burger Chef Interior*, 1972
Oil on canvas, 124.5 × 142.7 (49 × 56½)
Signed, lower right: *Goings 72*; reverse upper left:
 Ralph Goings 1972 "Burger Chef Interior"
Virginia Museum of Fine Arts, Gift of
 Sydney and Frances Lewis, 85.393

Middle America provides the subject matter for Ralph Goings's paintings. Goings is fascinated by the sites along the highways of his native California, and since 1969 he has been "rendering" images of the icons of middle America: trucks, fast-food drive-ins, luncheonettes, food stores, and, recently, the inhabitants of these ubiquitous entities.

Goings's earliest subjects were pickup trucks, then a status symbol in California. These paintings were based on his photographs. Eventually he included the drive-ins and stores where such vehicles are often found. Like a movie director zooming in on a scene, Goings moved into these buildings, documented their signs, plastic booths, jukeboxes, and all of the other accoutrements of the fast-food business. In more recent works, however, Goings has included figures. In addition, he has been fascinated by the accessories in these plastic and chrome environments: the ketchup bottles, mustard jars, salt and pepper shakers, napkin holders, and china and silver. Like a still-life painter, Goings has rendered these items in concise and careful detail, giving these common glass and plastic objects a dignity and monumentality that his predecessors found in fruit, silver, gold, and crystal. In scenes such as *Burger Chef Interior* the focus is well within the confines of the building looking out into the parking lot. With this unusual view, Goings directs the perspective from the inside looking out and not the more usual reverse. In none of Goings's earlier paintings, do figures occur. Their presence is implied, to be sure, but not delineated.

Using a 35mm camera as a sketchbook, Goings projects the chosen image onto the canvas and uses the slide as a guide in laying out the drawing and as a reference for the final painting, but the final work is not an exact, slavish copy of the photograph. Carefully edited and reworked, Goings's paintings are complex studies in the formal problems and inter-relationships of space, light, and color. He transmits his experience. His careful compositions and fastidious painting give a solidity to his paintings comparable to the subjects he depicts.

Provenance: O.K. Harris Works of Art, New York, 1972.
Published: Louis K. Meisel, *Photo-Realism* (New York: Harry N. Abrams, 1980), p. 286, no. 603 (illus.).
Exhibited: *Young American Artists in the Lewis Collection*: Roanoke Fine Arts Center, Roanoke, Virginia, January 7-February 3, 1973. *Divergent Representations: Five Contemporary Artists*: National Collection of Fine Arts, Washington, D.C., June 15-September 3, 1973. *Real Cool/Cool Real*: Duke University Museum of Art, Durham, North Carolina, September 28-October 21, 1973. *Our Land, Our Sky, Our Water*: Spokane, World Exposition, Spokane, May 1-November 1, 1974.

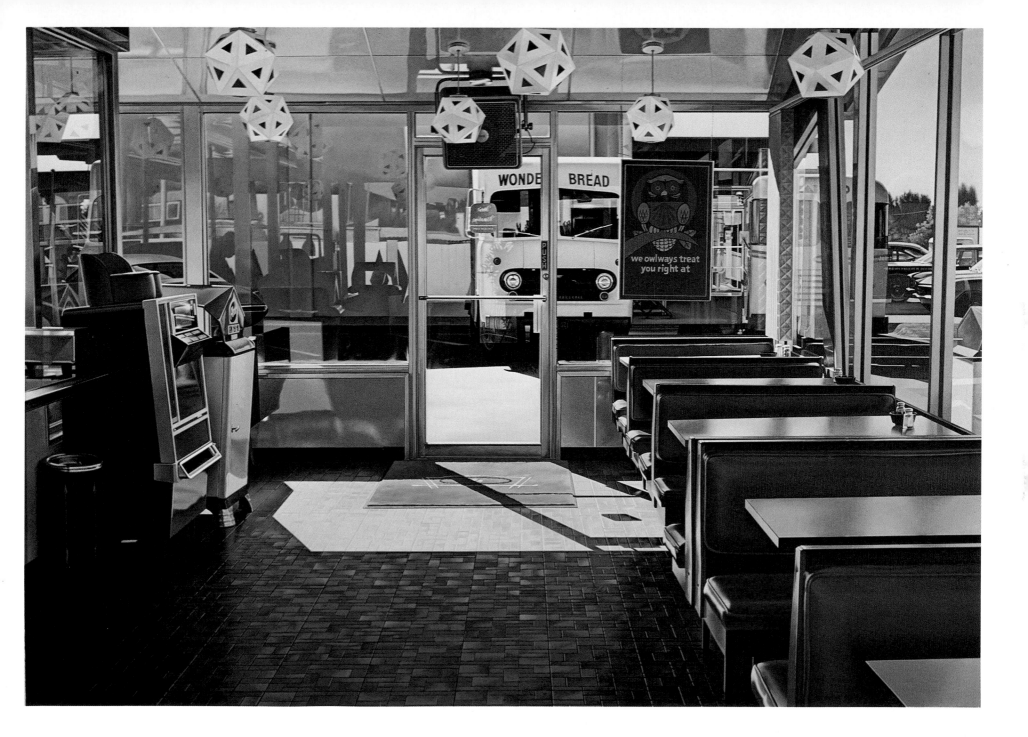

Sidney Goodman
American, 1936-

38. *Street Scene Autumn*, 1974-77
Oil on canvas, 200.0 × 298.4 (78¾ × 117½)
Signed lower right: *Goodman 74-77*
Virginia Museum of Fine Arts, Gift of
 Sydney and Frances Lewis, 85.394

Sidney Goodman works in the tradition of the great Philadelphia realists Thomas Eakins and Thomas Anshutz. Unlike his predecessors, however, Goodman leaves the meanings of his works unclear. This sense of mystery and ambiguity has been an important part of Goodman's paintings since 1961 when one of his works was included in the Museum of Modern Art's exhibition *Return to the Figure* and he emerged as a prominent young realist painter. The surreal quality of these early works is as omnipresent as themes of horror and terror. Since then, however, the focus of Goodman's works has changed from one of frightened mystery to one of examining the human condition in a mysterious manner.

Of his comparison to Edward Hopper, Goodman says, "We are both interested in light, but the major difference is that there's a little more paranoia, a little more anxiety, a darker, more ominous presence in the work. There is the light in it but the concern is a little more subjective. There are also more differences than there are similarities."[51]

Street Scene Autumn documents the fears and anxieties that are often apparent in Goodman's paintings. The central, dominant motif is the ominous red dumpster from which all action and motion seems to radiate. Except for the seated figure on the right, who appears to be either rising or in the state of sitting down, the figures, all of which are male, seem to be fleeing from this ominous presence. Originally Goodman had a recumbent figure in the immediate foreground, but he felt that the obvious morbid implications of the image were too apparent and took away some of the mystery.[52] He deleted it, leaving only mounds of debris and trash. The energy radiating from the center is echoed by the coloration of the trees and the city as if they were the source of light in the scene. This sense of light draws us into the drama, questioning what is causing the action and why there is a mood of threat and concern.

Provenance: Terry Dintenfass Gallery, New York, 1980.
Published: Richard Porter, ed., *Sidney Goodman: Paintings, Drawings and Graphics 1959-1979* (University Park, Pennsylvania: The Pennsylvania State University, 1980), p. 53, no. 66 (illus.); Janet Wilson, "Sidney Goodman: 'When the hand touches the canvas that's the real ball game,'" *ARTnews* 79/3 (March 1980): 77 (illus.); *Sidney Goodman: Recent Work* (Boston: Boston University Art Gallery, 1982), p. 4, no. 3 (illus.).
Exhibited: *Sidney Goodman: Paintings, Drawings, and Graphics, 1959-1979*: Museum of Art, The Pennsylvania State University, University Park, July 5-October 12, 1980; The Queens Museum, Flushing, New York, November 8-January 4, 1981; Columbus Museum of Art, Columbus, January 17-February 15, 1981; Delaware Art Museum, Wilmington, May 1-June 14, 1981. *Sidney Goodman*: Institute of Contemporary Art, Virginia Museum of Fine Arts, Richmond, December 15, 1981-January, 1982; Boston University Art Gallery, March 17-April 11, 1982.

51. Janet Wilson, "Sidney Goodman, 'When the hand touches the canvas that's the real ball game,' " *ARTnews* 79/3 (March 1980): 76.
52. Richard Porter, *Sidney Goodman: Paintings, Drawings, and Graphics, 1959-1979* (University Park, Pennsylvania: Pennsylvania State University, 1980), p. 9.

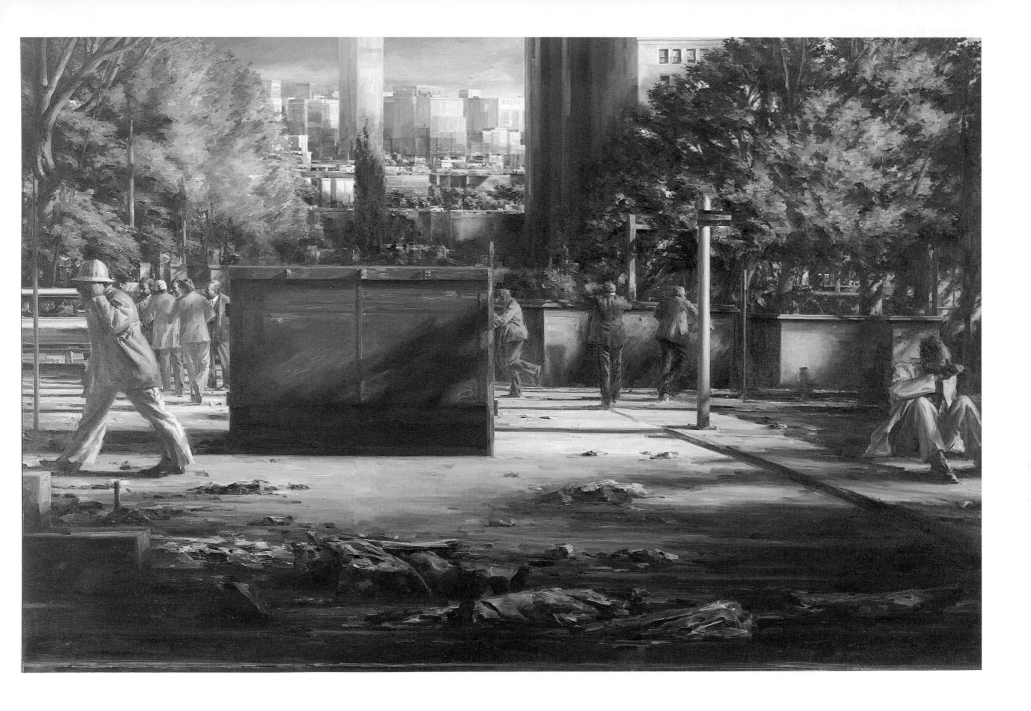

81

Robert Goodnough
American, 1917-

39. *Abduction*, 1963
Oil on canvas, 213.3 × 213.3 (84 × 84)
Signed, lower right: *Goodnough, 1963*
Virginia Museum of Fine Arts, Gift of
 Sydney and Frances Lewis, 85.395

Since 1946, when he first moved to New York, Robert Goodnough has attempted to resolve problems of shape, color, and form. During these years Goodnough's approach to painting has gone through a series of changes, through which he has developed a personal and unique vocabulary of images. These have served as his answer to the questions and problems inherent in all art.

Having studied at Syracuse University before World War II, Goodnough moved to New York to become an artist after he was discharged from the army. He studied at the Amedée Ozenfant School of Fine Arts in New York in 1946 and in the following year in Provincetown on Cape Cod with Hans Hofmann. Returning to New York, he enrolled at New York University where he later obtained his master's degree. In the late 40s he became acquainted with the first generation Abstract Expressionists, Pollock, Kline, de Kooning, and was strongly influenced by their work. He enjoyed the freedom and independence they advocated but he was more interested in interjecting ideas into his painting as opposed to their preference for the purely gestural and emotional.

In the 50s his work gradually evolved from analytical cubism to figurative imagery as seen in *Abduction*, part of a series begun in 1962 and loosely based on Rubens's *Rape of the Daugh-*

ters of Leucippus. Shortly thereafter he read Katherine Anne Porter's *Ship of Fools* and began a series of *Boat* paintings. *Abduction* is a transitional work that falls between the earlier works in the same set and the *Boat* series. Involving many comic shapes and images, it is a complex intertwining and intermingling of figures, some with abstract faces, others with lifelike limbs. They form a central pyramidal composition capped by the circular elements read as clouds and suns.

In his later work Goodnough made his images less complicated by reducing the number of elements. Simple shapes and their relationship to large overall painted backgrounds predominate. These later paintings especially show the consistent influence of collage on his work, a technique with which he has experimented for many years.

In addition to experimenting with color and shape, Goodnough often has included social commentary in his paintings. For example, the *Boat* series expresses his sentiments against the war in Vietnam. Although the comic aspects of his imagery relate to the works of Miró, whom he had met earlier in New York, the paintings were primarily vehicles for speaking out against the violence of war. Since then his paintings have become less political and purer in terms of paint, shape, and color. Goodnough

believes that the subconscious plays an essential role in art. Intuition as well as past experience are important to bring paintings to completion. He has expressed his subconscious, and his work appeals to the intellect, not to the emotions. For this reason much of work has been termed impersonal. "I like the idea of my work being impersonal. The paintings were not intended to be what I would call romantic, in the sense of portraying a strong mood. They were much more subtle, at least the paintings of that period (early 1970s). I still like a certain quality of impersonalness in art . . . and I believe that art has a certain higher quality, higher than just the emotional expression. In Abstract Expressionism you may get too much emotion. I guess one might say that emotion is personal. As you get away from expressing strong emotion, you become more impersonal, or it may seem that way, but at the same time I believe you are speaking to other people on a higher level."[53]

Provenance: from the artist, 1966.
Exhibited: *Selections from the Lewis Collection*: Richmond Artists' Association Carillon Show, Richmond, March 1969. *Selections from the Lewis Collection: Twentieth-Century Gallery Loan Exhibition*: Botetourt Gallery, Earl Gregg Swem Library, College of William and Mary, Williamsburg, April 1970.

53. Martin H. Bush, "An Interview with Robert Goodnough," *Arts Magazine* (February 1979): 137.

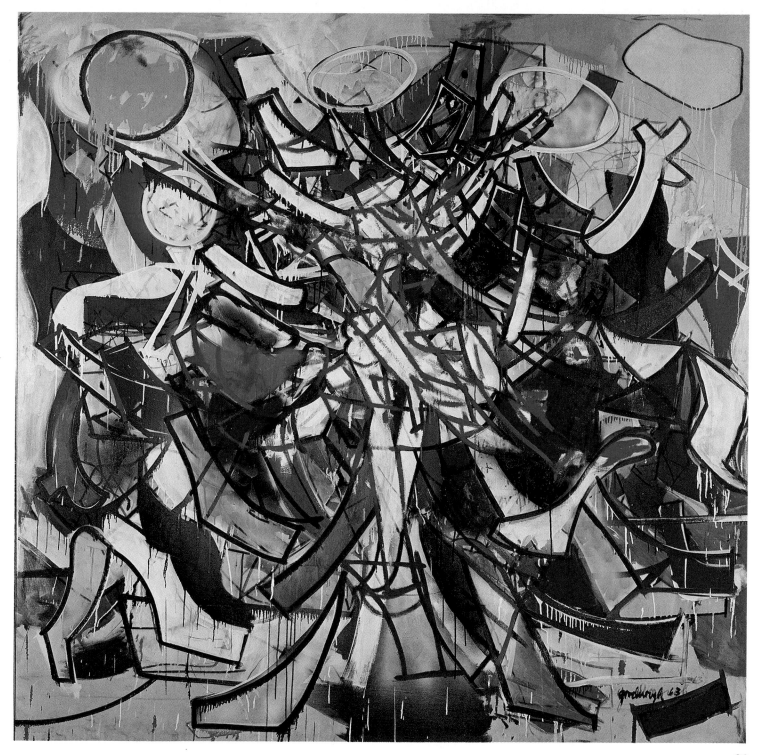

Adolph Gottlieb
American, 1904-1974

40. *Rolling*, 1961
Oil on canvas, 182.8 × 228.6 (72 × 90)
Signed on reverse: *Adolph Gottlieb/Rolling/1961/#6107*
Virginia Museum of Fine Arts, Gift of
 Sydney and Frances Lewis, 85.396

On June 13, 1943 Adolph Gottlieb, Mark Rothko, and Barnett Newman published a manifesto in the *New York Times* summarizing their attitudes toward art and their reasons for their abstract style. They stated: "To us art is an adventure into an unknown world, which can be explored only by those willing to take the risk. This world of the imagination is fancy-free and violently opposed to commonsense. It is our function as artists to make the spectator see our way, not his way. We favor the simple expression of the complex thought. We wish to reassert the picture plane.... The subject is crucial and only that subject-matter is valid which is tragic and timeless."[54]

To apply this controversial manifesto to Gottlieb's mature work, of which *Rolling* is an example, may seem a difficult endeavor. Although literal subject matter is not and has not been a subject of his paintings for many years, the emotion he elicits from his use of shape and color is timeless and thus reaffirms his earlier statement. His abstract, often rectangular images define the picture plane.

Part of Gottlieb's third series of mature works or "bursts," *Rolling* follows the "pictographs" of 1941 to 1951 and the "imaginary landscapes" of 1951-1957. For the pictographs, Gottlieb divided his canvas with a series of grids and placed seemingly familiar objects within each rectangle. Because of the isolation of the objects and the lack of reference to one another, they took on a totally different meaning suggesting symbols related to primitive and archaic art. These cryptic messages referred to the subconscious. Next Gottlieb began painting his imaginary landscapes, which were horizontally divided into earth and sky. Again, Gottlieb flattened the picture plane and created a special language of symbols and images, using the type of gestural brushstrokes associated with the New York School. Although he referred to this series as imaginary landscapes, Gottlieb denied that he was a landscape painter or that he was significantly influenced by the landscapes.

In 1957, the landscapes gradually led to the development of the "bursts," of which *Rolling* is an example. The disparate geometric forms that existed in the imaginary landscapes now appeared sensitively balanced and interrelated. In *Rolling*, the brilliantly colored discs hovering in the upper part of the painting look like objects in a sky above the tangled mass of black brushstrokes forming the lower register, which could represent the earth.

Light and color emanate from the floating and suspended discs. The mass of the blue and red discs is very carefully suspended and is delicately balanced against the mass of the black brushstrokes and the pink form to the left side. Although reduced in visual elements to the simplest forms and to a minimum of quantity, *Rolling* has a visual tension and formal shape. Free of traditional, representational subject matter, *Rolling* features Gottlieb's unique symbols and imagery, which make his subconscious visible through color and shape.

As Martin Friedman has written, "Gottlieb's art is one of revelation rather than exposition, and his painting gives form to the tenuous. He has consistently taken risks and abandoned successful ideas in order to break through to new and more vital ones. Through assertion of a few elemental forms throughout a long series of paintings, Gottlieb has achieved an expansive freedom. He has never permitted his painting to rest. It is imbued with the tension of discovery."[55]

Provenance: Mr. and Mrs. A.I. Sherr Collection, New York; Anita Friedman Fine Arts Ltd., New York, 1979.
Published: Ben Heller, "The Roots of Abstract Expressionism," *Art in America* 45/4 (1961): 46 (illus.); *Aujourd'hui* 6 (December 1961): 56; *Quadrum* 12 (1962): 138 (illus).
Exhibited: *Adolph Gottlieb*: Walker Art Center, Minneapolis, April 28-June 29, 1963; *VII Bienal de São Paulo*, Sao Paulo, September-December, 1963. *Adolph Gottlieb*: Whitney Museum of American Art, New York, February 14-March 31, 1968; The Corcoran Gallery of Art, Washington, D.C., April 26-June 2, 1968.

54. From the statement published by Robert Doty and Diane Waldman in *Adolph Gottlieb* (New York: Whitney Museum of American Art, 1968), p. 14.
55. Martin Friedman, *Adolph Gottlieb* (Minneapolis: Walker Art Center, 1963), unpaginated.

Robert Graham
American (born in Mexico), 1938-

41. *Heather*, 1979, second in an edition of nine
Cast bronze, paint, (172.7 × 30.5 66 × 12) diameter
Signed on rear of base plate: *R Graham cast 1979*
Virginia Museum of Fine Arts, Gift of
 Sydney and Frances Lewis, 85.397

Robert Graham is perhaps the leading Realist sculptor in America today. His work differs from much of the more experimental sculpture that has developed in recent decades and is rooted deeply in the history of figurative sculpture. Graham's beautifully proportioned, almost classical nudes transcend the boundaries of much traditional sculpture because an element of emotion is incorporated into them. They become distinctly personal, not idealized. Indeed, they are almost photo-realistic. When asked why he has always used the human figure in his work, he replied, "Everything's in it."[56]

By reducing the scale and giving his sculptures a patina more akin to metal than to flesh, Graham makes readily apparent the material of his work. Using only a few models, Graham photographs and videotapes his models repeatedly before sculpting their figures in clay and wax. A rubber mold is made over this sculpture, and molten wax is cast in the mold. Graham then reworks the cast and covers it with layers of soft clay to form a ceramic shell. In this "lost wax process," the wax-and-ceramic piece is heated, causing the wax to melt and flow, leaving the clay as a mold for the molten bronze. After casting, the ceramic shell is broken away and the rough bronze is refined. Sometimes, as here, Graham applies oil paint to sections of the patinated bronze.

Graham recently produced monumental sculptures for the entrance to the Los Angeles stadium in which the summer games of the twenty-fourth Olympiad were held. In addition, he is one of four sculptors working on the Franklin Delano Roosevelt memorial being erected in Washington, D.C. The colossal memorial is a challenge to Graham, who is used to working on a much smaller scale.

Provenance: Robert Miller Gallery, New York, 1979.
Published: Frank H. Goodyear, Jr., *Contemporary American Realism Since 1960* (Boston: New York Graphic Society, 1981), p. 191, no. 55 (illus.).
Exhibited: *Robert Graham*: Robert Miller Gallery, New York, November 6-December 2, 1979. *Contemporary American Realism Since 1960*: Pennsylvania Academy of Fine Arts, Philadelphia, September 18-December 13, 1981; Virginia Museum of Fine Arts, Richmond, February 8-April 4, 1982; Oakland Museum, Oakland, California, May 6-July 25, 1982.

56. Barbara Isenberg, "Robert Graham: Ignoring the Lessons of Modern Art," *ARTnews* 78/1 (January 1979): 68.

Red Grooms
American, 1937-

42. *Matisse in a Garden*, 1973
Paper, 108.0 × 92.1 × 122.2 (41½ × 36¼ × 48⅛)
Signed on base: *Red Grooms 1973*
Virginia Museum of Fine Arts, Gift of
 Sydney and Frances Lewis, 85.398

For Red Grooms nothing is too trivial to be a subject of his art. Works of the Old Masters, portraits of artists and other cultural figures, monumental panoramas of Chicago and Manhattan, sports figures, astronauts, and movie stars are all fair game as subjects in Grooms's zany world. He uses an unlimited imagination and a variety of media to interject fun, humor, satire into art, and to bring a myriad cast of characters before his audience.

Grooms studied at the School of the Art Institute of Chicago, the George Peabody College for Teachers in Nashville, the New School for Social Research in New York, and the Hans Hofmann School of Fine Arts in Provincetown on Cape Cod before settling in New York in 1957. Within two years Grooms was involved in the New York art world and was appearing in happenings, which appealed to his showman's proclivities. Since then his art has been a mixture of a show business and the fine arts, always mirroring his own life and own world, never being caustic, but always with a sly glance of skepticism and wit.

Between 1968 and 1975 Grooms produced three major panoramic environments entitled *City of Chicago*, *The Discount Store*, and *Ruckus Manhattan*, perhaps his most famous creation. Each of these enormous and extravagantly constructed pieces gave him an opportunity to involve the viewer in his work by providing distorted and frenzied pictorial environments, which literally surrounded his audience. The complex spatial arrangements of these miniaturized versions of our familiar world—subways, landmark buildings, statues, heroes and villains, rivers and bridges—all are combined in a state of controlled lunacy. In creating these panoramic conceptions, Grooms works with a large crew of artists and technicians. Although they each contribute their share to the final product, Grooms himself serves as the controller and director of the final production.

In 1973 Grooms produced a series of three-dimensional portraits that included Pablo Picasso, Gloria Swanson, and Henri Matisse. In each, he carefully endowed his subject with appropriate facial expressions, clothing, and accessories. Gloria Swanson appears to have stepped out of *Sunset Boulevard*, and Picasso sits smoking in a café. The Matisse portrait, however, is the *tour de force*. Made of 100% rag watercolor paper, the composition has the quintessence of the elderly Matisse contemplating his long artistic life while sitting among the flowers of his garden. A female nude, who could be a model for one of his famed odalisques or his muse, peers discreetly over his shoulder. There is no drawing, no paint, only three-dimensional form detailed through careful construction, cutting, and assembly.

As part of his continuing visual commentary on the American character or "caricature," Grooms later produced painted bronzes depicting the great American Southwest, New York, football games, and other images. All of the elements characteristic of American life are presented in Grooms's typically distorted Expressionist manner: cowboys and Indians, fans and cheerleaders, and fast-food franchises. His recent interest in Japan is reflected in works produced in 1983 and 1984, including a panoramic view of Tokyo and scenes from the Japanese past.

Grooms's work has wide appeal because he depicts people from all walks of life and puts them on equal footing, taking jabs at both the famous and the unknown. By the same token, he elevates the common person to the level of stardom, causing us to re-evaluate ourselves and our surroundings. In many ways he is the conscience of present-day art but never loses his sense of humor. As Grooms says, his art is "either completely burlesque or just very controlled."[57]

Provenance: John Bernard Myers Gallery, New York, 1974.
Published: John Bernard Meyers, *Tracking the Marvelous* (New York: Grey Art Gallery and Study Center, 1981), unpaginated (illus.); Carter Ratcliff, *Red Grooms* (New York: Abbeville Press, 1984), pp. 140-41 (illus.).
Exhibited: *Tracking the Marvelous*: Grey Art Gallery and Study Center, New York University, April 27-May 30, 1981.

57. Quoted by Judd Tully in "Red Grooms has artful fun with high culture—and low," *Smithsonian* 16/3 (June 1985): 106.

Red Grooms 1973

Nancy Grossman
American, 1940-

43. *House*, 1969-70
Wood, leather, lacquer, 41.3 × 17.1 × 20.3 (16¼ × 6¾ × 8)
Signed on bottom of head in nails: *Nancy Grossman*
Virginia Museum of Fine Arts, Gift of
 Sydney and Frances Lewis, 85.399 a/b

When Nancy Grossman exhibited a group of drawings and of leather-bound heads and figures in 1971, John Canaday, art critic for the *New York Times* called her "the most impressive young American artist I know of."[58] His comment is typical of the response that Grossman's work has elicited; it both shocks and arouses respect for her ability to capture pent-up emotions and reflections.

Grossman studied at Pratt Institute and came under the influence of the painter Richard Lindner and the sculptor David Smith. Her early work in collage painting and assemblages of found objects were primarily abstract, but their forms appealed to her innate sensibility to humanity and reflected her surroundings. Her leather-bound heads and torsos were first shown in 1968.

Grossman carefully sculpts the form in wood, then lacquers the exposed skin surface such as the nose to produce a slick, smooth finish. She then covers the head or body with complex sewn leather strips, straps, buckles, harnesses, zippers, rivets, and other pieces of hardware, all of which suggest restraint, violence, and menace. But do these figures evoke images to be pitied? Do they reflect the dark sides of our culture or the restraints imposed by a society whereby persons are no longer able to communicate or interact? "Look at the censored faces in the street. You can almost see people saying, 'I'm not going to be caught feeling.' My figures feel right because they're all tied down. They may look frightening at first—after I had done a few, I ran out of my studio. Then I began to see how defenseless they were."[59]

The heads may also be self-portraits and may also reflect Grossman's experience. "It all begins with the head, the head has a mouth and we kill with words and we are wounded by words. If I survive in my life, it's because I externalize whatever good parts of it there are in me."[60]

Whether Grossman has fulfilled Canaday's expectations, her work certainly stirs associations and feelings. Powerful yet sensitive, her sculpture captures the suffering in the world. Finished in 1970, this head is still as relevant today, if not more so, as when it was produced.

Provenance: from the artist, 1970.
Exhibited: *Contemporary American Sculpture*: F&M Center Gallery, Richmond, April 30-June 6, 1975; *The Figure in Sculpture*: Institute of Contemporary Art, Virginia Museum of Fine Arts of Fine Arts, Richmond, October 10-November 14, 1979.

58. John Canaday, "The Least Cruel Artist Alive," *The New York Times*, 28 November 1971.
59. As quoted in "Trends: Beyond Nightmare," *Time*, 13 June 1969, 74.
60. As quoted by Corinne Robins in "Man is Anonymous: The Art of Nancy Grossman," *Art Spectrum* (February 1975): 37.

Philip Guston
American (born in Canada), 1913-1980

44. *The Desert*, 1974
Oil on canvas, 184.2 × 292.1 (72½ × 115)
Signed on shoe, lower right: *P.G.*
Virginia Museum of Fine Arts, Gift of
 Sydney and Frances Lewis, 85.400

In 1946 the Virginia Museum of Fine Arts awarded Philip Guston the John Barton Payne Medal and Purchase Prize for his painting *The Sculptor* (1943), which features a young artist with chisel and mallet working on a female torso. It is painted in a fairly realistic mode, similar to contemporary painting of that period. It is not experimental, but instead is a sensitive portrayal of familiar elements from the artist's world. This composition was one of many easel paintings and Works Progress Administration murals in which Guston realistically depicted and reacted to his environment. In many of these works, he included satirical or political overtones and railed against matters such as racial inequality, urban blight, and war.

By 1950, however, Guston was fully immersed in gestural painting, which was one of the characteristics of Abstract Expressionism. From 1951 to 1968, he explored abstract painting through a remarkable coloristic series of tightly constructed but loose rhythmic brushstrokes. The built-up forms resulted in a distinct overall approach to the canvas. Painted rapidly with a light palette, these vibrant, abstract works seem to emanate from a central core of heavier, darker tones to the very edges of the canvas achieving a total, overall effect. Guston felt that this method was a true revolution and a manner through which he could seek his true freedom.

In 1968 Guston shocked many people when he returned to figurative subjects. The new paintings had a palette similar to the abstract works but featured recognizable imagery drawn in cartoonlike manner. The images included lightbulbs, shoes, repetitive faces (mouthless and noseless), Klan hoods, cigars, nail-studded two-by-fours, and other very personal symbols juxtaposed in bewildering varieties.

As early as 1958 Guston had lamented the loss of the image and symbol in contemporary American painting. Although he himself had abandoned figurative painting, believing that changes and style and trends were inherent in artistic development, he nonetheless commented, "It (the change from figurative painting) is a loss from which we suffer, in this pathos motivates modern painting and poetry at its heart."[61] He continually wrestled with the issues of figurative versus non-objective painting and continued to develop his personal imagery during the final years of his life.

As with his abstract works, Guston approached the new figurative paintings with the desire to concentrate on the entire surface at one time. He thought carefully about the content and painted at the moment of conception. Mentally retaining the original concept, he worked swiftly on each part of the painting without stepping back to look at it. The recognizable images he painted were not based on actual objects arranged in specific order but were recollections of what he knew these objects looked like, translated immediately from his mind to the canvas. The background of *The Desert* is painted in much the same manner as his earlier abstract paintings. Short rapid brushstrokes of fleshtones painted wet-in-wet, form not only a backdrop for the painted figures but also an intergral part thereof.

Throughout his fifty-year career, Guston was a dedicated artist who used painting as personal communication, developed a unique style drawn from his experiences, and paid no attention to current fashion. Summing up his approach to art, Guston said, "Everything means something. Anything in life or in art, any mark you make has meaning and the only question is, 'what kind of meaning?'"[62]

Provenance: David McKee Gallery, New York, 1980.
Published: *Philip Guston* (New York: David McKee Gallery, 1974), p. 3, no. 1. (illus.); Dore Ashton, "*Yes, But . . . A Critical Study of Philip Guston* (New York: Viking Press, 1976), p. 170 (illus.); *Alexander Brook, Philip Guston, Clifford Still Memorial Exhibition* (New York: American Academy of Arts & Letters, 1980), no. 26; Norbert Lynton, *Philip Guston: Paintings 1969-1980* (London: The Whitechapel Art Gallery, 1982), p. 21 (illus.); John Buckley, Edward F. Fry, and Joseph Ablow, ed. *Philip Guston: The Late Works* (Melbourne: Center for Contemporary Art, 1984), p. 32, no. 17 (illus.).
Exhibited: *Philip Guston*: David McKee Gallery, New York, November/December 1980. *Alexander Brook, Philip Guston, Clifford Still Memorial Exhibition*: American Academy of Arts and Letters, New York, November 17-December 21, 1980. *Painting: A New Spirit*: Royal Academy of Arts, London, January 1981. *Philip Guston: Paintings 1969-1980*: The Whitechapel Art Gallery, London, October 13-December 12, 1982; Stedelijk Museum, Amsterdam, January 13-February 27, 1983; Kunsthalle, Basel, May 8-June 19, 1983. *Philip Guston: The Late Works*: National Gallery of Victoria, Melbourne, August 17-September 16, 1984; The Art Gallery of Western Australia, Perth, September 26-October 28, 1984; Art Gallery of New South Wales, Sydney, November 7-December 30, 1984.

61. As quoted by John I. H. Baur in *Nature in Abstraction: The Relation of Abstract Painting and Sculpture to Nature in Twentieth-Century American Art* (New York: Whitney Museum of American Art, 1958), p. 10.
62. Norbert Lynton, "Philip Guston Talking," *Philip Guston: Paintings 1969-1980* (London: The Whitechapel Art Gallery, 1982), p. 9.

93

Duane Hanson
American, 1925-

45. *Hard Hat, Construction Worker*, 1970
Painted polyester resin, clothes, wood, metal, plastic,
 120.7 × 106.7 × 89.0 (47½ × 42 × 35)
Unsigned
Virginia Museum of Fine Arts, Gift of
 Sydney and Frances Lewis, 85.401

Duane Hanson deals with illusion and reality. Because of his precise, meticulous style, he is comparable to the Photo-Realists. In particular, he explores middle America. Although works of 1970 and 1971 such as *Bunny, Housewife, Supermarket Shopper, Tourists, Rock Singer*, and *Sun Bather* are highly satirical of middle class manners and mores, his later works reveal deep compassion for the anxieties, loneliness, and desperation of the middle class. This mature work is much more quiet and gentle than his violent works of 1967 such as *Accident, Gangland Victim, Riot*, and *War*, and *Football Players* of 1969.

Hanson usually works with friends, acquaintances, and relatives as models, although he has used strangers he has seen on the street. He carefully molds each part of his subject's body in plaster. The several molds are then used to make casts in liquid polyester resin reinforced with fiber glass. Each part is refined and corrected and then joined together to form the entire sculpture. Hanson then paints the work with acrylic and oil paint, inserts glass eyes and lifelike hair, and dresses the body with appropriate clothes. Careful arrangement of the clothes and accessories complete the figure.

Despite their dress, some of Hanson's figures have been likened to much earlier works. Thus, *Hard Hat*, considered one of Hanson's finest pieces, has been compared to Rodin's *Thinker*.[63]

Representing a construction worker who has paused for lunch and is using an overturned bucket and plank for his makeshift bench, this sculpture vividly conveys the weight of the man's work in his expression and body gesture. His ideals are revealed by the flag decal on his hard hat. There is neither satire nor sarcasm here, nor even political comment.[64] It is a straightforward portrait of a typical, hardworking man taking a break. We are given no hint as to his specific job, his background, or his living conditions.

Hanson puts us in the place of the subject to provide a better understanding of the personality and often very difficult, lonely life of his subjects. Most often, he depicts the elderly, the working class, and/or the downtrodden in realistic and pathetic situations. Rare is the person who has more successfully blurred the distinction between art and life.

Provenance: O.K. Harris Works of Art, New York, 1970.
Published: Joseph Masheck, "Verist Sculpture: Hanson and DeAndrea," *Art in America* 60/6 (November-December 1972): 91 (illus.); *Saturday Review* (April 22, 1972): 37; Udo Kultermann, *New Realism* (Greenwich, Connecticut: New York Graphic Society, 1972), p. 38 (illus.); Dennis Adrian, *John DeAndrea/Duane Hanson: The Real and Ideal in Figurative Sculpture* (Chicago: Museum of Contemporary Art, 1974), unpaginated (illus.); Kirk Varnedoe, "Duane Hanson: Retrospective and Recent Work," *Arts* 49/6 (January 1975): 66-70; Martin L. Bush, *Duane Hanson* (Wichita: Edwin A. Ulrich Museum of Art, Wichita State University, 1976), p. 22 (illus.); Ellen Edwards, "Duane Hanson's Blue Collar Society," *ARTnews* 77/4 (April 1978): 57 (illus.); Martin Bush, ed. *Duane Hanson* (n.p. (Japan): Asahi

Shimbun, 1984), pp. 21, no. 1 (illus.), 55, no. 13 (illus.); Henry Geldzahler, *Pop Art 1955-70* (n.p. (Australia): International Cultural Corporation of Australia, 1985), p. 166 (illus.); Kirk Varnedoe, *Duane Hanson* (New York: Harry N. Abrams, 1985), p. 46, no. 5 (illus.).

Exhibited: *Directions 3: Eight Artists*: Milwaukee Art Center, Milwaukee, June 19-August 8, 1971. *John DeAndrea/Duane Hanson: The Real and Ideal in Figurative Sculpture*: Museum of Contemporary Art, Chicago, June 29-August 25, 1974; AFL-CIO Labor Studies Center, Silver Springs, Maryland, May 1975. *Sculpture: American Directions, 1945-75*: Department of Twentieth-Century Painting and Sculpture, National Collection of Fine Arts, Smithsonian Institution, Washington, D.C., October 3-November 30, 1975. *Duane Hanson*: Edwin A. Ulrich Museum, Wichita State University, Wichita, October 6-31, 1976; University of Nebraska, Lincoln, November 15-December 15, 1976; Des Moines Art Center, Des Moines, January 16-March 13, 1977; University Art Museum, University of California, Berkeley, March 29-May 22, 1977; Portland Art Museum, Portland, June 6-July 3, 1977; William Rockhill Nelson Gallery, Kansas City, Missouri, July 20-August 14, 1977; Colorado Springs Fine Arts Center, Colorado Springs, September 2-29, 1977; Virginia Museum of Fine Arts, October 15-November 11, 1977; Performing Arts Center and Theater, Clearwater, Florida, January-February 1984. *Sculptures by Duane Hanson*: Edwin A. Ulrich Museum of Art, Wichita State University, Wichita, April 25-June 10, 1984; Isetan Museum of Art, Tokyo, Japan, July 12-August 14, 1984; Daimaru Museum of Art, Osaka, Japan, September 12-September 24, 1984; Nagoya City Museum, Nagoya, Japan, November 13-November 25, 1984. *Pop Art 1955-70*: Art Gallery of New South Wales, Sydney, February 27-April 14, 1985; Queensland Art Gallery, Brisbane, May 1-June 2, 1985; National Gallery of Victoria, Melbourne, June 26-August 11, 1985.

63. Martin L. Bush, *Duane Hanson* (Wichita: Edwin A. Ulrich Museum of Art, Wichita State University, 1976), p. 43.
64. cf. Bush's opinion, ibid.

Al Held
American, 1928-

46. *B-G-3*, 1978
Acrylic on canvas, 213.4 × 213.4 (84 × 84)
Signed on reverse, lower center: *Al Held/79 e*
Virginia Museum of Fine Arts, Gift of
　　Sydney and Frances Lewis, 85.402

Between 1967 and 1978 Al Held restricted his palette to black and white alone and his forms to three-dimensional geometric images arranged in a complex and complicated space. This space, which he created and continued to refine over an eleven year-period, continually dealt with shifting focus. The scale of these paintings forces concentration on a small section at a time, not the whole picture.

Held's geometric forms are arranged in a highly structured manner, creating a very complicated space more cerebral than realistic. Complex interrelationships exist between the forms. There are no simple planes of foreground, middle ground, and background. The result is a dynamic and complex illusion that totally affects interaction with the picture plane.

In 1978 Held returned to color. His tones are not naturalistic, but unique to his palette. Each of the colors defines certain geometric shapes as in *B-G-3*. Thus the cube shapes are defined by one color, the circular shapes by another, and the grid shapes by a third. These are juxtaposed against a solid color which can be read as a background or as infinite space. The scale of the painting focuses on a smaller section. At first glance, total geometric shapes are seen as floating in a deep space. Actually, they are smaller elements juxtaposed against much larger geometric shapes, which are seen in an abstract form. For example, there appears to be an open curved grid that could comprise a huge globelike shape. We are shown only a small section crossing in diagonal form from lower left to upper right, but mentally we complete this image by thrusting out into space the elements shown and creating a huge circular grid network that would encompass the entire viewing area. In the same manner, the diagonally placed grid leads us back into the picture and gives us a sense of infinite space not only in recession but also in projection, thus involving us in the space of the painting.

Held draws the images directly on the canvas and paints the geometric shapes, sanding two to three times between each coat and continually making changes until the painting is finished. The surface is extremely smooth and flat, contrasting with the complexities of the space that is visually introduced.

Held says that "if you introduce paradox, chance, time, and contradiction in co-equal terms with fact, logic, stability and truth you could have a real mish-mash. So you have to structure it."[65] He attempts to make order out of chaos. To him this is today's reality.

Provenance: André Emmerich Gallery, New York, 1977.
Published: Robert Berlind, "Al Held at André Emmerich," *Art in America* 67/3 (May-June 1979): 138 (illus.); Irving Sandler, *Al Held* (New York: Hudson Hills Press, 1984), p. 140 (illus.).
Exhibited: *Al Held*: André Emmerich Gallery, February 17-March 17, 1979.

65. As quoted by Brandt and Butler in *Late Twentieth Century Art*, p. 33.

Charles Hinman
American, 1932-

47. *Tall Red*, 1979
Acrylic on canvas, 177.8 × 129.5 × 15.2 (70 × 51 × 6)
Signed on reverse, lower right: *C Hinman 79*
Virginia Museum of Fine Arts, Gift of
 The Sydney and Frances Lewis Foundation, 85.403

Charles Hinman has created elaborately shaped paintings since 1963. Not content to shape the perimeter of his canvases, he modulates the entire work so that it projects from the wall in various angles and depth. He taught himself carpentry for building the complex stretchers required for his paintings.

Although Hinman's works appear to be very deep spatially, they are actually very shallow. *Tall Red* is only six inches deep. The choice of colors and the illusionistic forms give a greater sense of depth than actually exists.

Tall Red is part of an ongoing series of three-dimensional canvas constructions. As Hinman has claimed, "There is a visual play between the real space of the object, and the pictorial made by the use of colors, overlapping planes, and linear compositions.

"Another important aspect of this theme is to observe how the double curved or warped surface of the canvas qualifies how one perceives the geometric forms employed in the work."[66]

One of Hinman's concerns is space, not only the space occupied and created by the sculptural piece, but also the space in which the painting is hung. Hinman says, "The shaped canvas is an idiom that deals with the idea of environment. The shape takes into itself the space on the wall and the room. I have made painted constructions for the ground plan, as well as those that hang in space, but primarily my interests have been to make relief sculpture for the wall."[67]

Provenance: Donald Morris Gallery, Birmingham, Michigan, 1980.
Published: Brandt and Butler, *Late Twentieth Century Art*, p. 33, no. 29 (illus.).
Exhibited: *Late Twentieth-Century Art From The Sydney and Frances Lewis Foundation Collection*: The Toledo Museum of Art, Toledo, September 21-November 9, 1980; Madison Art Center, Madison, Wisconsin, November 23, 1980-January 18, 1981; Allen Priebe Art Gallery, University of Wisconsin-Oshkosh, Oshkosh, January 27-March 15, 1981; Ulrich Museum, Wichita State University, Wichita, April 1-May 31, 1981; Morehead State University, Morehead, Kentucky, August 31-October 16, 1981; Columbia Museum of Art, Columbia, South Carolina, November 15, 1981-January 10, 1982; Mississippi Museum of Art, Jackson, January 31- March 14, 1982; Worcester Art Museum, Worcester, Massachusetts, September 10-October 31, 1982; Allentown Art Museum, Allentown, Pennsylvania, November 14, 1982-January 16, 1983; University Memorial Gallery, University of Rochester, Rochester, January 30-March 13, 1983; Everson Museum of Art, Syracuse, New York, March 25-May 29, 1983; Randolph-Macon Woman's College, Lynchburg, Virginia, November 6-December 17, 1983; Muscarelle Museum, College of William and Mary, Williamsburg, February 4-April 14, 1984; Huntington Galleries, Huntington, West Virginia, June 2-August 18, 1984.

66. Letter, dated May 13, 1980, from the artist to Susan L. Butler, former vice-president of the Sydney and Frances Lewis Foundation. The letter is now part of the Lewis Foundation archives in the Department of 20th-Century Art, Virginia Museum of Fine Arts.
67. Ibid.

David Hockney

English, 1937-

48. *Blue Interior and Two Still Lifes*, 1965
Acrylic on canvas, 145.0 × 144.5 (57 × 56¾)
Unsigned
Virginia Museum of Fine Arts, Gift of
 Sydney and Frances Lewis, 85.404

David Hockney has been compared to the English Pop artists primarily because the subjects he chooses to paint are familiar and accessible. He studied at Bradford College of Art in West Yorkshire and later, from 1959 to 1962, at the Royal College of Art in London, which was influential in the rise of English Pop Art. Hockney and fellow students Allan Jones and Ron Kitaj were active painters when Pop Art emerged. Hockney's work is not the same as American Pop Art. He did not turn to the popular media or to popular imagery for his inspiration but to autobiographical subjects, his native England, his adopted California, and his family and friends.

Although his technique and subjects are unique and personal, Hockney refers often to other artists' work, both past and present. *Blue Interior and Two Still Lifes* has allusions to both Cézanne and the color-field painters of the 1960s. As Hockney has said, "The 'artistic devices' are images and elements of my own and other artist's work and ideas of the time. All these paintings (*Picture of a Still Life, Blue Interior and Two Still Lifes, Monochrome Landscape with Lettering*, and *Portrait Surrounded by Artistic Devices*) were, in a way influenced by American abstractionists, particularly Kenneth Noland, whom I got to know through Kasmin (Hockney's dealer) who was showing him. I was trying to take note of those paintings. The still lifes were started with the abstraction in mind, and they're all done the same way as Kenneth Noland's, stained acrylic paint on raw cotton duck, and things like that."[68]

Thus the technique of *Blue Interior and Two*

Still Lifes directly relates to Noland and to the color-field painters. The images, however, bear more of a reference to Cézanne, particularly in the use of the three cylinders in the center foreground of the painting. Hockney was experimenting with a series of still lifes. He took Cézanne's concept of nature as a set of geometric volumes and arranged them in his compositions. Slight modeling gives three-dimensionality. The shadow behind the three colored rectangles in the upper half of the painting imparts a sense of floating and a three-dimensional space, which is completed by the perspective of the carpet, chair, and sofa. The framing motif of the "artistic elements" is another compositional device that Hockney put in a number of paintings of this time.

Despite Hockney's characteristic simplification of forms to their basic elements, perhaps accounting for much of the accessibility of his art, a strong sense of elegance, sophistication of composition, humor, and intimacy has also pervaded his work. Although Hockney believes that subject matter is important, he also feels that style is a basic issue. His style is characterized by a vivid but somewhat limited palette and a keen sense of draftsmanship.

In 1981 Hockney designed both the sets and the costumes for the Metropolitan Opera's production of *Parade—A French Triple Bill*. Although this was Hockney's first American theatre design venture, he had received several other commissions for such work in England, beginning with the production of Alfred Jarry's *Ubu Roi* in 1966. In addition, he did Stravinsky's *Rake's Progress* and Mozart's *The Magic Flute*.

Theatre commissions are a natural extension of Hockney's art. In many ways his works are theatres in which he stages his own artistic productions. Thus making the transition to the real stage came easily for Hockney, as he enlarged his compositional devices in response to the audience, music, and actors and actresses.

Hockney also is an accomplished photographer. For years he has used photographs as reference material for his paintings. Studies of swimming pools, friends, parents, the play of light on landscapes and interiors have all been fascinating subjects that Hockney has captured on film. In recent years he has taken multiple photographs of friends and acquaintances and rearranged them to form quasi-cubist portraits.

Provenance: Barry Miller Gallery, London; Lapidus Collection, Geneva; Christie, Manson & Woods, London, 1979.
Published: E. Crispolti, *La Pop Art* (Milan, 1966), p. 108 (illus.); *David Hockney: Paintings, Prints, and Drawings 1960-1970* (London: The Whitechapel Art Gallery, 1970), p. 50, no. 65.5 (illus.); *David Hockney by David Hockney*, N. Stangos, ed. (London: Thames & Hudson, 1976), p. 120, no. 30 (illus.); *Contemporary Art* Sale catalogue, Christie, Manson & Woods, London, December 4, 1979, no. 18 (illus.).
Exhibited: *David Hockney: Pictures with Frames and Still Life Pictures*: Kasmin Gallery, London, December, 1965. *David Hockney*: Galleria dell' Arieta, Milan, March, 1966. *Young English Painters*: Palais des Beaux-Arts, Brussels, October 1967. *Junge Generation Grossbritannien*: Akademie der Künste, Berlin, April-June 1968, *David Hockney*: Whitworth Art Gallery, Manchester, February-March, 1969. *David Hockney—Paintings Prints and Drawings 1960-1970*: The Whitechapel Art Gallery, London, April-May 1970; Kestner-Gesellschaft, Hanover; Museum Boymans-van Beuningen, Rotterdam; Muzejsavremeneumetnosti, Belgrade.

68. *David Hockney by David Hockney* (London: Thames and Hudson, 1976), pp. 100-01.

Jean-Olivier Hucleux
French, 1923-

49. *Cemetery IV*, 1973
Oil on panel, 198.1 × 297.1 (78 × 117)
Unsigned.
Virginia Museum of Fine Arts, Gift of
 Sydney and Frances Lewis, 85.405

Jean-Olivier Hucleux completed his first paintings between 1940 and 1945. In 1945 he abandoned painting and did not resume it until 1968. He says that for these twenty-three years, despite his passion for painting, there was something better to do. He immersed himself in "intentional silence."[69]

The *Cemetery* series, derived from photographs of a cemetery near his home outside of Paris, lasted from 1971 to 1973. He projected an image onto a plywood ground, made a grid, and then painted with a very fine brush, using a magnifying glass. The final coating was a heavy varnish layer, known as *vernis glycérophtalique incolore*.[70]

The cemetery is a perfect subject matter for Hucleux. He describes his super-realist painting as a "mystique of silence."[71] He looks upon the cemetery as a synthesis of life, as a final stage that we approach. It is not an event or happening but, no matter how we think about it, we cannot escape, the ending is inevitable.

Whether he depicts cemeteries, twins, friends, acquaintances, or collectors, their dazzling reality imparts a surrealism not apparent in the work of his American counterparts. Hucleux is conscious of this quality. He refers to superrealism as seeing reality through exceptionally clear glasses that give a hallucinatory effect.

Painting does not come easily to Hucleux. He finds it physically and mentally challenging. "There is only one interesting thing in a painting; it is not to make an image, nor an aesthetic effect, but to seize life itself and when, by a miracle of fidelity, one is able to unite with it. . . .It is an immense aesthetic whole like life itself! A painting is not the end of the release mechanism like a photograph but at the end of a brush and it is a ruthless fight within oneself, it is a restitution!"[72]

Provenance: From the artist, May, 1973.
Published: *Copie Conforme?* (Paris: Musée National de l' Arte Moderne, Centre Georges Pompidou, 1979), p. 55 (illus.).
Exhibited: *Copie Conforme?*: Musée National de l' Arte Moderne, Centre Georges Pompidou, Paris, April 19-June 11, 1979.

69. Jean-Olivier Hucleux in a conversation with Jennifer Gough-Cooper and Jacques Caumont in "Je ne sais pas si je devrais dire tout ça, mais tant pis!...," *Copie Conforme?* (Paris: Centre Georges Pompidou, 1979), p. 68.
70. I am indebted to H. Stewart Treviranus for his comments on the medium used by the artist in creating *Cemetery IV*.
71. *Copie Conforme?*, p. 68.
72. Ibid.

103

Ralph Humphrey
American, 1932-

50. *Warner*, 1967
Acrylic and acrylic fluorescent on canvas, 152.4 × 152.4 (60 × 60)
Unsigned
Virginia Museum of Fine Arts, Gift of
 Sydney and Frances Lewis, 85.406

Ralph Humphrey studied at the Butler Art Gallery in Youngstown, Ohio, in 1948 and later attended Youngstown University. In 1956 he moved to New York, where he taught at the Art Students' League and Harley House. He later taught at Bennington College in Vermont and at Hunter College in New York.

Color, a sense of space, and light are important to him. Originally a representational painter, Humphrey subsequently gave greater prominence to the evocation of light and time than to the representation of figures and objects. Basically a minimalist, Humphrey departs from much of minimalist philosophy by creating a specific planar space in his figure-ground relationship. The horizontal stripes rendered in fluorescent color give an impression of space to the soft, ambiguously colored ground.

Although color is the key factor in Humphrey's paintings, his style and technique have changed radically in the last few years. In the late 1970s he created massive, heavily constructed paintings with rich, deep colors applied in impasto to surfaces built up of small wood strips. He also began a series of heavily pigmented works that projected from the wall. The subtle nuances and interrelationships of color interested Humphrey more than the shape of the works.

Both the early and later work elicit contemplation. Timelessness of space and light predominate. An undisguised sensuality not usually associated with minimalist painting exists in all these works. The artist presents a combination of technique and sensitive colors.

Of his paintings Humphrey says, "When you look at the work you should become aware of time. I hear remarks about my odd color. It's not at all. I am trying to get a sense of things as they are, a reality, at this time. . .the fluttering of light, the fluctuations life has. The forms, the light, give it a definite sense of a specific time. . .It should not suggest prairies or open windows. There might be vague references to that, but that's not the point. Space going back is going to relate to some illusionistic space, even a stage space, but if it starts coming forward and you can start to work with a certain kind of light in relation to the object, then you're going to get a different sense of time. It's not the illusion of memory."[73]

Provenance: Bykert Gallery, New York, 1968.
Published: Scott Burton, "A Different Stripe," *ARTnews* 66/10 (February 1968): 36-37, 53-56; Wyrick, *Contemporary American Paintings*, p. 45 (illus.).
Exhibited: *Richmond Artists Association Carillon Show*: March 1969. *Twentieth-Century Gallery Loan Exhibition*: Botetourt Gallery, Earl Gregg Swem Library, College of William and Mary, Williamsburg, April 1970. *Contemporary American Paintings from the Lewis Collection*: Delaware Art Museum, Wilmington, September 13-October 27, 1974.

73. Ralph Humphrey and Priscilla Colt, "Ralph Humphrey: Statement and Critique," *Arts Magazine* 49/1 (February 1975): 56.

Bryan Hunt
American, 1947-

51. *Conductor*, 1982, first in an edition of three
Cast bronze, 370.8 × 137.1 × 78.7 (146 × 54 × 31)
Signed on vertical member: *Bryan Hunt 83 1/3*
Virginia Museum of Fine Arts, Gift of
The Sydney and Frances Lewis Foundation, 85.407

Bryan Hunt is an extremely gifted draftsman in bronze. His figures, landscapes, and waterfalls involve the relationship of lines, shapes, and planes. Bronze sculptures are often massive, positive images, very static in appearance. Unlike any predecessor, Hunt presents both the positive image in bronze and the negative spaces defined by the elegant, thin sculptural lines of his castings, resulting in the capturing of movement.

Hunt studied at the University of South Florida in Tampa and later received his B.F.A. from Otis Art Institute in Los Angeles. In 1972 he participated in the independent study program at the Whitney Museum of American Art in New York. Today he lives and works in New York.

Hunt's early sculptures involved airship shapes that seemed to float effortlessly. Made of balsa, silk, and paper, they negated their bulk and size in the same manner that his more recent works seem to defy the weight of bronze materials.

Much of Hunt's inspiration comes from Europe and from landscapes. He continually makes sketches for his sculptures, and once his ideas are firm, he creates a plaster model and makes a bronze cast.

The long, sinuous linear elements of his sculpture are directly related to the lines in his preparatory drawings. The more massively sculpted elements relate to nature and particularly to flowing water. Even in *Conductor*, the line swirling from the apex down the vertical element and forming a miniature waterfall at the foot conveys movement and flow. As important as that element is, however, the thinner, vertical elements are of equal importance, as are the negative spaces between them. From each angle the image becomes totally different as the negative spaces take dominance at times over the sculptural elements to define and give form and mass to the total piece.

Conductor guides the various compositional elements through abstraction and refers to "movement, as the figure moves through the landscape—as turning a corner and finding something."[74] The multiplicity of aspects in his sculpture creates excitement. The carefully sculptured elements show us the hand of the sculptor in their irregular texture and relate to the tradition of Rodin and Degas, but the total concept is that of a contemporary artist.

Provenance: Blum Helman Gallery, New York, 1983.
Published: *Bryan Hunt* (New York: Blum Helman Gallery, 1983), unpaginated (illus.).
Exhibited: *Bryan Hunt*: Blum Helman Gallery, New York, March 30-May 14, 1983. *Bryan Hunt: Recent Sculpture*: Margo Leavin Gallery, Los Angeles, April 23-May 28, 1983. *Gallery Six: Bryan Hunt, Recent Sculpture*: Los Angeles County Museum of Art, Los Angeles, April 21-June 19, 1983.

74. Letter, dated Ocotber 8, 1984, from the artist to the author. The letter is part of the Lewis Foundation archives in the Department of 20th-Century Art, Virginia Museum of Fine Arts.

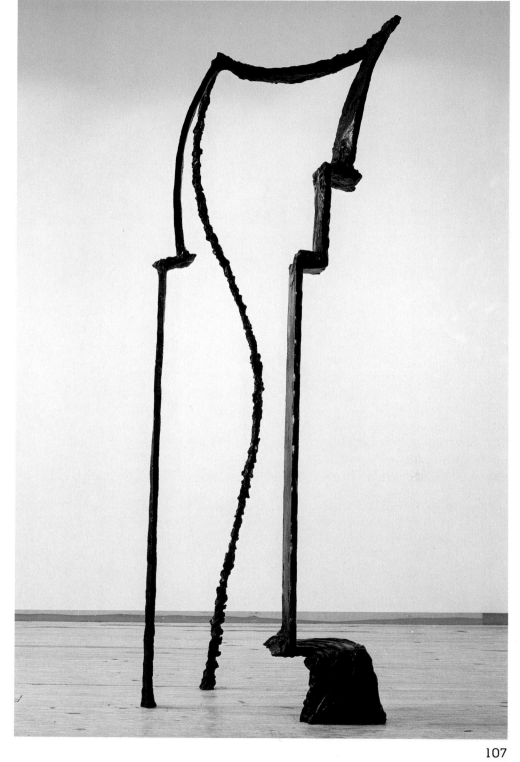

Jorg Immendorff
German, 1945-

52. Untitled (from the series *Café Deutschland*), 1982
Oil on canvas, 250.0 × 310.0 (98½ × 122)
Signed on reverse, lower right: monogram, *82*
Virginia Museum of Fine Arts, Gift of
 Sydney and Frances Lewis, 85.408

The series of paintings entitled *Café Deutschland* by Jorg Immendorff is a synopsis of the history of the artist's native Germany and the myriad personalities, forces, and events, that have shaped it. The paintings obviously reflect both the Teutonic heritage of order and the chaos and instability of the present East-West political situation.

The first of the *Café Deutschland* paintings, produced in 1977 as a response to *Caffè Greco* by the Italian artist Renato Guttuso, was, according to the writer Toni Stooss, "a diametrically opposed counterpart."[75] For the next several years Immendorff continued his theme "to provide a backdrop to events directly concerning the two Germanys as a zone for mental action, a 'Theatrum Mundi' along the 'seam' of Germany, as a theatre of war located between the symbols of East and West, and—no less importantly—as a conceptual meeting place for the two friends and fellow painters, Immendorff and Penck (A.R. Penck, a close friend who worked in Dresden)."[76]

The series represents the artist's private world inhabited by public figures, images, and symbols. Ideological conflicts are made real by persons and objects. Immendorff does not allow his paintings to become mere political posters. Throughout the series he maintains broad brushstrokes, employing the conventional methods of scale, color, and perspective, thereby creating an involved depth in a stage on which his international cast performs.

The café abounds with familiar personages appearing in unlikely juxtapositions. In the left foreground is an image bearing a close resemblance to Hitler, while on the right edge Chairman Mao carries a flashlight, as if serving as an usher. An icy blue swastika clings to the suspended ceiling. Several of the inhabitants of the café carry oddly shaped pieces of ice. The artist himself appears in the immediate foreground drawing designs in a blanket of ice, which flows over a tabletop. Stooss says that the ice appeared in 1977-78 "apparently to symbolize 'Germany as a winter's tale' on both sides of the

border."[77] The dead horses could possibly symbolize the remains of the quadriga from the Brandenburg Gate, originally a gateway of peace.

In these complex paintings Immendorff does not make personal political statements as much as he illustrates the political forces at work in Germany. Through his dramatic training, Immendorff produces visual plays, a complex cast of characters drawn from historical and modern sources. In his works Immendorff communicates his anguish with the complex problems that his divided country must face.

Provenance: Sonnabend Gallery, New York, 1982.
Exhibited: *Immendorff*: Sonnabend Gallery, New York, October 1982. *Image Innovations: The Europeans*: Institute of Contemporary Art, Virginia Museum of Fine Arts, Richmond, May 10-June 12, 1983.

75. For a more detailed analysis of Immendorff's café series see Toni Stooss, "The 'Cafe' for the 'Theme': a Collage," in *Jorge Immendorff* (New York: Mary Boone Gallery, 1984), unpaginated.
76. Ibid.
77. Ibid.

Neil Jenney
American, 1945-

53. *Swimmer and Reflection*, 1970
Acrylic on canvas, 186.7 × 133.4 (73½ × 52½)
Signed on reverse, upper right: *Neil Jenney 1970/New York City*
Virginia Museum of Fine Arts, Gift of
 Sydney and Frances Lewis, 85.409

Unlike his recent works, Neil Jenney's early paintings, of which *Swimmer and Reflection* is an example, are not precisely detailed but are joyfully and exuberantly wrought in a style similar to Abstract Expressionism. In *Swimmer and Reflection*, bold brushstrokes immediately convey to us a sense of water surrounding the swimmer, whose outlines and detail are also sketchy. Nonetheless, this painting and other early works are representational, despite the gestural style.

Because of the sameness in the brushstroke, there is little sense of foreground or background. Figure and ground become one as each brushstroke tends to flow into the next with drippings from one flowing down into the other. In his use of everyday objects and images, Jenney owes a debt to Pop Art, but he is no more a Pop artist than an Abstract Expressionist. At a

time when most artists avoided both narrative content and frames, Jenney not only told stories in his works but also emphasized the frame and painted the title to de-emphasize the illusion of the imagery.

Jenney has turned to precise paintings frequently dominated by large-scale frames. His works show a concern for the environment and the quality of life, but his images are often fearful. Although we see details of nature such as closeups of trees in the immediate foreground, scenes in the distance cause fear for the future. In particular the painting titled *Meltdown Morning* depicts a small nuclear cloud on the horizon. The familiar black frame not only gives a sense of foreboding to this and other scenes but also constricts the tableau of the action.

In all his work Jenney is deeply concerned

with realism and its communicative power and with the artist's power to change our environment and our culture. "All realism must resolve abstract complications because you are involved with space and balance and harmony. Realism is a higher art form because it is more precise—it not only solves all abstract concerns, but it involves precise philosophical interpretation. I am not trying to duplicate something that I see in nature because you must always compromise—it is always going to be paint, you cannot outpaint the paint."[78]

Provenance: Vivian Horan, New York, 1981.
Exhibited: *Exchanges III*, Henry St. Settlement, New York, June-July, 1981.

78. As quoted by Mark Rosenthal in *Neil Jenney* (Berkeley, California: The University Art Museum, University of California at Berkeley, 1980), p. 49.

Alfred Jensen
American (born in Guatemala), 1903-1981

54. *Plus; Per I-Minus; Per II*, 1962
Oil on canvas, 2 panels, each 162.5 × 137.2 (64 × 54)
Signed on reverse of each panel, upper left: *Plus; Per I-Minus;*
 Per II 64 × 54 Painted by Alfred Jensen
Virginia Museum of Fine Arts, Gift of
 Sydney and Frances Lewis, 85.410.1/2

For over fifty years until his death in 1981, Alfred Jensen created a body of work that is both visually accessible through its prismatic colors applied in heavy impasto and obscure in its numerical and geometric symbology derived from such diverse sources as Goethe, the *I Ching*, the Delphic Oracle, and J. E. S. Thompson's *Maya Hieroglyphic Writing*. Drawing freely from these complex writings, Jensen sought to endow his brilliant colors with what he referred to as the "magic inherent in numbers."[79]

Jensen attended the San Diego Fine Arts School in 1925 and in the following year went to Munich to study with Hans Hofmann. In 1928, however, he broke with Hofmann and traveled to France. He enrolled at the Académie Scandinave in 1929 and studied with the sculptor Charles Despiau and the painters Othon Friesz and Charles Dufresne. With the fellow painter and wealthy collector Saidie Adler May, Jensen traveled throughout Europe, meeting many important artists. At this time he became familiar with Goethe's color theory. During the war he and May settled in the United States, where

Jensen continued reading Goethe's and other color theories and also painted representational works related to in those of the Abstract Expressionists.

From the early 1950s, when he had his first solo show, until his death in 1981, Jensen worked in a unique style using prismatic colors arranged in grids, circles, and other geometric shapes. Of his arcane theories and symbols, Jensen once said:

I use the concept based on the ancient Chinese use of 'The Great Plan of the Nine Classifications. The first, the Five Factors; the second, the Five Faculties; the third, an economical use of the Eight Regulators; the fourth, a harmonious use of the Five Deposers; the fifth, an established use of the Perfection . . .' and so on. 9 or $3 \times 3 = 9 = $ a square of nines. I also use or adhere to a circle shape. I am using the same concept, a mixture of Faraday's concept, harmonized with the ancient Chinese method. . . .

Since I try to convey the electromagnetic play and function of color, I make the im-

posing actors in their color hues play act their energies' presence or act out their roles.

Whether my emblematic structures are odd or even numbers or cool and warm color hues, or square shapes versus circular shapes, all combine to create a depth of vision to support and help me to express a modern world's happenings coupled and based with the ancient cultural expression of ancient civilization's art.[80]

Jensen's works can be appreciated without an understanding of their obscure influences. The juxtaposition of sumptuous color, rich impasto, and familiar shapes and numbers present a stimulus to the mind and a delight to the eye.

Provenance: Pace Gallery, New York, 1977.

79. Letter, dated August 12, 1978, from the artist to Susan L. Butler, former vice-president of the Sydney and Frances Lewis Foundation. The letter is part of the Lewis Foundation archives in the Department of 20th-Century Art, Virginia Museum of Fine Arts.
80. Ibid.

Jasper Johns
American, 1930-

55. *Between the Clock and the Bed*, 1983
Encaustic on canvas, 182.8 × 320.7 (72 × 126¼)
Signed on reverse, upper and lower right: *J. Johns 82-83*
Virginia Museum of Fine Arts, Gift of
 Sydney and Frances Lewis and
 The Sydney and Frances Lewis Foundation, 85.411

Since his first one-man exhibition at the Leo Castelli Gallery in New York in 1958, Jasper Johns has produced a prodigious body of work involving personal symbolism, impeccable technique. In 1963 *Newsweek* described him as "probably the most influential younger painter in the world."[81] Prominent in New York when Abstract Expressionism was dominant, Johns and Robert Rauschenberg bridged the gap between the gestural New York School (Abstract Expressionism) and the Pop Art movement. Johns took common objects such as the target, the face, the flag, and the coffee can and presented them in a new perspective. The Pop artists deleted Johns's painterly technique and presented the same objects in a direct manner.

Through two decades of prolific painting, printmaking, and sculpture, Johns has remained independent of stylistic movements. He has reworked several themes without ever losing interest in them. Many of his symbols and images are autobiographical or nationalistic. In other works, such as *Between the Clock and the Bed*, Johns presents challenges to interpretation. Composition, color, design, and technique, however, remain within comprehension.

Between the Clock and the Bed has the same title as Edvard Munch's self-portrait of 1942. Munch depicts himself full-length, standing in his bedroom and flanked on his right by a grandfather clock and on his left by a bed. The cross-hatching in both pictures is similar, though Johns conceived of it independently. As early as 1972 Johns had painted one-fourth of an untitled four-panel painting in the cross-hatched style. Concerning the initial use of this motif, Johns says "I was riding in a car, going out to the Hamptons for the weekend, when a car came in the opposite direction. It was covered with these marks, but I only saw it for a moment—then it was gone—just a brief glimpse. But I immediately thought that I would use it for my next painting."[82] Thus, even though it is an abstract pattern, it does relate to a biographical incident in the artist's life.

Like his other symbols, it is found elsewhere in Johns's work, including his very successful series *Corpse and Mirror, Scent, End Paper*, and *The Dutch Wives*, and in several lithographs and silkscreens.

Between the Clock and the Bed is an expansive painting that is bounded only by the frame.

To expand further the visual content, Johns has divided it visually into three sections separated by almost invisibly painted seams. The left and right sections mirror each other. We connect the two images together in a 360-degree panorama. Although the cross-hatching is a flat abstract element, a sense of space is created in the pictorial plane by the smaller cross-hatching in the lower right and left sections, by the highlights of color, which appear to give depth and layers to the lines, and by the illusion that some of the cross-hatching extends over or under other parts.

Provenance: Leo Castelli Gallery, New York, 1983.
Exhibited: *Jasper Johns*: Leo Castelli Gallery, New York, January 28-February 25, 1984.

81. See Michael Crichton, *Jasper Johns* (New York: Harry N. Abrams, 1977), pp. 23-70 for a good summary of critical reaction to Johns's work. The quotation here is given on p. 54.
82. Ibid., p. 59.

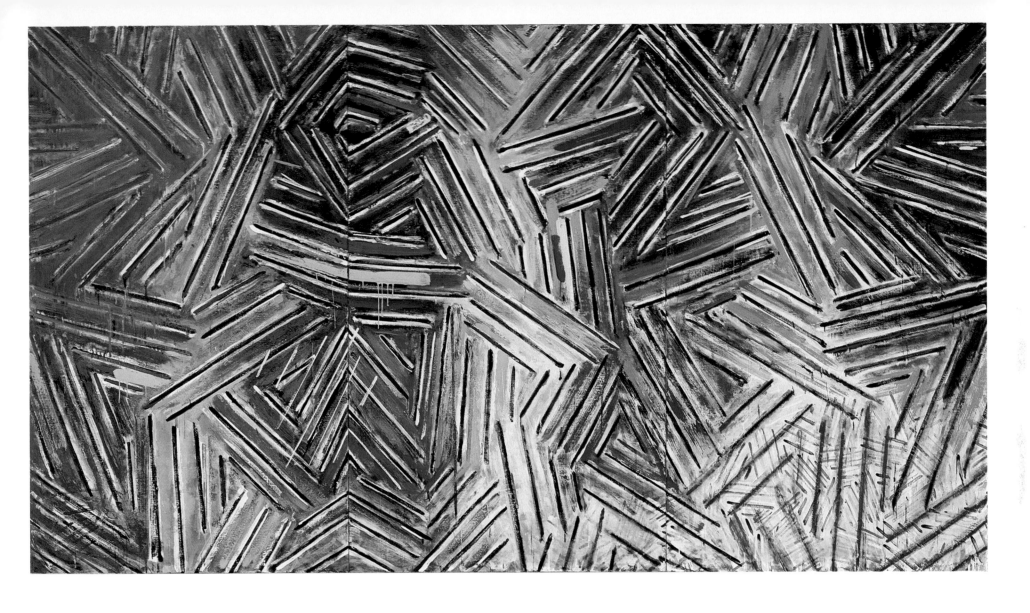

Alex Katz
American, 1927-

56. *Self-Portrait with Sunglasses*, 1969
Oil on canvas, 243.8 × 172.7 (96 × 68)
Unsigned
Virginia Museum of Fine Arts, Gift of
 Sydney and Frances Lewis, 85.412

For his entire career, Alex Katz has depicted himself, his friends, relatives, and colleagues, as well as flowers and landscapes. He has created a facile, cool, clean, dispassionate record of a group of specific persons as they have developed over three decades.

Having originally intended to be a commercial artist, Katz studied at Cooper Union in New York, but later studied at the Skowhegan School of Painting and Sculpture in Maine with Henry Varnum Poor, and in 1954 he had his first one-man show at the Roko Gallery in New York. During this time he participated in the activities of the avant-garde artists who congregated around East 10th Street in New York.

In the late 50s he began concentrating on portraiture. These early paintings have a frontal view and the subjects are usually shown as full-length figures existing in featureless landscapes; the style is rough, almost naive. In 1962 and 1963, he refined this style by bringing the figures into the immediate foreground, drastically cropping them to give an immediate presence, and expanding the overall scale and concept of the work. Around the same time he increased the size of the canvas and refined the style with both a minimum of illusion and a simplified but intensified sense of color. Many of his paintings are characterized by sharp juxtapositions of scale.

Katz captures his models at a brief moment without dwelling on their psychological inner life or emotive personalities. He depicts the good life. In his group portraits, the people gather in convivial surroundings, such as a pleasant New York loft or a summery outdoor lawn party in Maine.

Katz makes many life studies. He then does small sketches to resolve questions of composition and color. He often creates cutouts or small maquettes, which he can move around to reach a final, satisfactory composition. About his self-portraits, Katz has written, "I feel my self-portraits are a comment on the whole genre of artists' self-portraits. There is always something funny about them. They have a kind of beauty that has never been seen on the face of the earth! It just never existed!"[83] In each one, he depicts himself as a totally different personality, who is very much influenced by contemporary life styles. In one self-portrait of 1960, he appears half-length, wearing a white shirt and tie. It is his "Arrow shirt" portrait. In a 1962 work, he is depicted in a cropped closeup; his expression is stern, and he wears a black hat and black suit. In a 1977 self-portrait in the Lewis Foundation Collection, he is shown in what he calls his "movie star pose,"[84] the open collar and casual elegance obviously a product of the seventies.

The mode of dress and the hairstyle of *Self-Portrait with Sunglasses* (1969) give a clue about the date. "I have occasionally done self-portraits placing myself in a different social context. There are about six of these paintings.

The costume enables me to escape from the heavy, self-involved traditional self-portrait. The eyeglasses were an image of the time. I was happy to find a lively image rather than a familiar old story."[85] The spectacles block any expression of emotion in Katz's eyes and allow him to maintain a cool but elegant gaze.

Provenance: Marlborough Gallery; Mr. and Mrs. Robert Mayer Collection, Chicago; Pace/Hoffeld Gallery, New York, 1981.
Published: *Alex Katz in the Seventies* (Waltham, Massachusetts: Rose Art Museum, 1978), p. 22, no. 1 (illus.); Irving Sandler, *Alex Katz* (New York: Harry N. Abrams, 1979), p. 44, pl. 3; Frank Goodyear, *Contemporary American Realism Since 1960* (Boston: New York Graphic Society, 1981), p. 63, no. 30 (illus.); Gail Levin and Dewey F. Mosby, *Alex Katz: Process and Development: Small Paintings from the Collection of Paul J. Schupf '58* (Hamilton, New York: The Picker Art Gallery, Colgate University, 1984), p. 4, fig. 1 (illus.).
Exhibited: *Alex Katz*: Utah Museum of Fine Arts, University of Utah, Salt Lake City; University of California at San Diego; Minnesota Museum of Art, St. Paul; Wadsworth Atheneum, Hartford, Connecticut, 1971. *Alex Katz in the Seventies*: Rose Art Museum, Brandeis University, Waltham, Massachusetts, May 27-July 9, 1978. *Alex Katz: Process and Development: Small Paintings from the Collection of Paul J. Schupf '58*: Picker Art Gallery, Colgate University, Hamilton, New York, September 10-November 4, 1984.

83. Letter (1978) from the artist to Susan L. Butler, former vice-president of the Sydney and Frances Lewis Foundation. The letter is part of the Lewis Collection archives in the Department of 20th-Century Art, Virginia Museum of Fine Arts.
84. See Brandt and Butler, *Late Twentieth Century Art*, p. 39.
85. Letter, dated October 1984, from the artist to the author. The letter is part of the Lewis Collection archives in the Department of 20th-Century Art, Virginia Museum of Fine Arts.

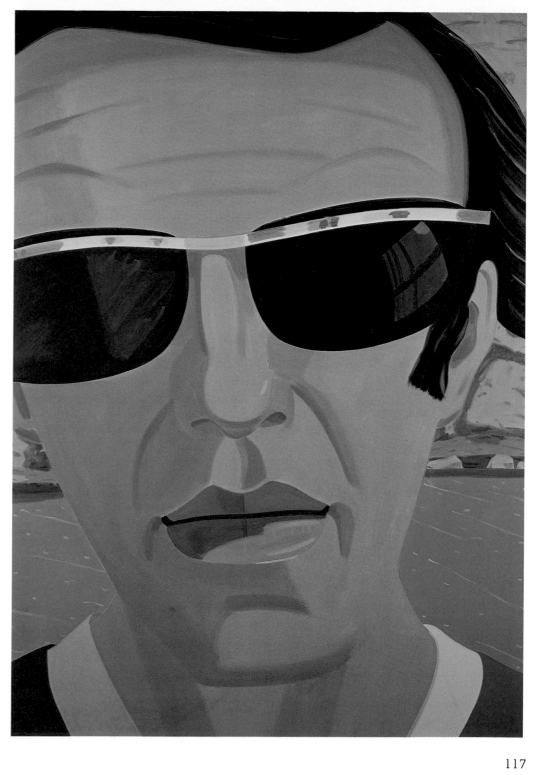

117

Ellsworth Kelly
American, 1923-

57. *Four Panels: Green Black Red Blue*, 1966
 Acrylic on canvas, 134.6 × 264.1 (53 × 104)
Signed: each panel signed on stretcher: *Kelly 362D 4"-10"*
 interval; green panel signed on canvas: *1966 EK*
Virginia Museum of Fine Arts, Gift of
 Sydney and Frances Lewis, 85.413.1/4

Ellsworth Kelly's paintings and sculptures are difficult in their simplicity. When first viewed, they seem to be made up merely of solid planes of unmodulated color either as separate panels or as part of compositions, but despite their abstract quality, they refer to nature and to the world around the artist.

While in the army during World War II, Kelly was assigned to the 603rd Engineers Camouflage Battalion. His work with colors, shapes, and particularly shadows may have exerted considerable influence on his art.[86] After the war, Kelly studied under Carl Zerbe at the School of the Museum of Fine Arts in Boston. In 1948 he went to Paris where he remained until 1954, when he returned to the United States. While in Paris, he developed a minimalist approach to art and began making multiple panel paintings. The minimalist, abstract elements that he incorporated into these paintings came from his observation of minute details of nature. Typical elements derive from a series of windows on a building, the negative space between the elements of a balustrade, the pattern of leaves or branches against the sky, shadows on a staircase, or the pattern of a brick walkway. During his residence in Europe he developed an intense interest in Romanesque architecture, and he also met several important artists, particularly Brancusi and Arp and the De Stijl painter Georges Vantongerloo. When he returned to New York, the influence of the New York School was prominent. Although he took exception to the gestural stroke of the Abstract Expressionists painters, his work was recognized as a significant contribution to abstract painting.

Four Panels: Green Black Red Blue continues a series that Kelly has explored for over thirty years. The relationship of the size of each painting, the space between each panel, and their respective colors are all important to Kelly in creating both tension and harmony.

An early prototype of this series of panel paintings is *Awnings, Avenue Matignon* (1950), a small pencil and gouache work done in Paris. It is a simple depiction of seven windows each covered partially by an awning in a different position. The result is a lively rhythm between the awnings and the open windows and the spaces between them. Kelly has continued to explore similar relationships in his panel paintings. He has also achieved considerable recognition for his sculpture which was the subject of a major retrospective at the Whitney Museum of American Art held in 1982.[87]

Provenance: Carter Burden Collection; Sydney Janis Gallery, New York; Anita Friedman Fine Arts Ltd., New York, New York, 1981.
Published: John Coplans, *Ellsworth Kelly* (New York: Harry N. Abrams, 1973), pl. 179.

86. See E.C. Goossen, *Ellsworth Kelly* (New York: The Museum of Modern Art, 1973), pp. 11-13.
87. For the catalogue of the exhibition, see Patterson Sims and Emily Rauh Pulitzer, *Ellsworth Kelly: Sculpture* (New York: Whitney Museum of American Art, 1982).

119

Anselm Kiefer
German, 1945-

58. *Landschaft mit Flügel* (*Landscape with Wing*), 1981
Oil, straw, lead on canvas, 330.2 × 553.7 (130 × 218)
Unsigned
Virginia Museum of Fine Arts, Gift of
 The Sydney and Frances Lewis Foundation, 85.414

Figuratively speaking, Anselm Kiefer is a painter of landscapes—the terrain of German history and German mythology. Kiefer's landscapes do not possess the tranquil beauty or the realism of the French Impressionists' work. Instead, he creates strong, vibrant, desolate, burnt-out landscapes that relate to recent German history. Kiefer grew up in a country brought to ruin by war and combines elements from personal experience with those from a romantic but melancholic Teutonic heritage.

Kiefer received most of his training privately with Peter Dreher in Karlsruhe and later with Josef Beuys in Dusseldorf. His major paintings of the early 70s have personal and religious themes. Depictions of beamed interiors, derived from the design of Kiefer's attic, appear in his large paintings. A personal symbol is the Trinity seen through flames appearing on chairs and floors. In some instances Satan appears, represented by a serpent. In 1974, although he continued to use Christian elements, he explored desolate and barren German landscapes.

At times he depicts the earth newly turned and set afire. The artist's palette often appears mystically suspended in space. In all of these vast landscapes the land is desolate. The season is usually winter; the farmer has abandoned the land. Kiefer does not deny the recent history of his country. Like his predecessors George Grosz, Max Beckmann, and Käthe Köllwitz, he shows the horror of war visited upon his country. Unlike these German Expressionists, Kiefer takes a neutral stance, making no value judgments.

Some of his paintings allude directly to warfare, as seen in miniature ships in zinc bathtubs embedded in the landscapes. Other images derive from Wagnerian tales and medieval German history. In *Landschaft Mit Flügel* (1981), as in the subsequent *Wölundlied mit Flügel* (*Wayland's Song with Wing*, 1982, private collection, London), Kiefer again offers a vast burnt-out landscape done in paint and straw. By using real straw, he forces the reality of the painting upon us. He combines this realism with German mythology, including the lead wing. In the second half of the *Poetic Edda* (*the Elder Edda*), an Icelandic saga containing myths about northern gods and heroes, the principal character, Wayland, escapes from the kingdom on homemade wings.[88] As Jürgen Harten has written, "Kiefer is interested in the mythological figure of the blacksmith, the dreaded sorcerer who brings up his ores from the chthonian deep, growths of the earth induced to melt by means of fire. Kiefer's Wayland-wing is made of lead, the saturnine element, one of the raw materials in the alchemist's pursuit of transmuting base metals into gold."[89]

In a series of large paintings produced in 1983, Kiefer depicted the exteriors and interiors of abandoned buildings, which were based on Albert Speer's architecture. We see the megalomaniac architecture of the Third Reich not glorified but abandoned, partially destroyed and burned out. In depicting the trauma of post-war Germany, Kiefer is a successor to the romantic painters and musicians of Germany.

Provenance: Mary Boone Gallery, New York, 1982.
Published: Robert Hughes, "German Expressionism Lives," *Time*, August 8, 1983: 66 (illus.); Benjamin Forgey, "Germany's Fractured Art," *The Washington Post*, July 2, 1984.
Exhibited: *Expressions: New Art from Germany*: St. Louis Art Museum, St. Louis, June-August 1983; Corcoran Gallery of Art, Washington, D.C., July-September 1984.

88. Jürgen Harten, *Anselm Kiefer* (Dusseldorf Städtische Kunsthalle, 1984), p. 102.
89. Ibid.

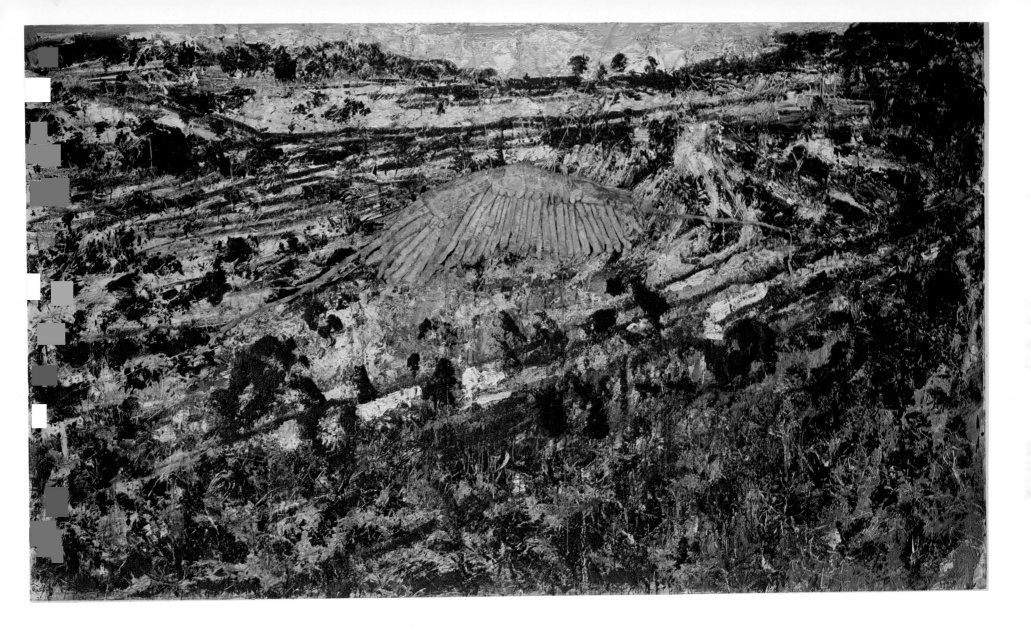

121

Franz Kline
American, 1910-1962

59. Untitled, 1955
Oil on canvas, 171.5 × 210.8 (67½ × 83)
Signed and dated on reverse: *Franz Kline 1955*
Virginia Museum of Fine Arts, Gift of
 Sydney and Frances Lewis, 85.415

Franz Kline's work epitomizes the grand, expansive, gestural sweep of Abstract Expressionism (the "New York School") of the 1950s. During twelve short years, Kline established a unique style, compatible with but different from that of his colleagues in the New York School.

Kline studied at Boston University, the Boston Arts Students League, and Heatherly's Art School in London. In 1938 he settled in New York where he lived and worked for the remainder of his life. At first he produced figurative images derived from the New York scene, realizing modest sales. Commissions such as his tavern murals characterize Kline's life during this period. He made many drawings in black and white, executing them in a brisk, rapid linear style with broad sweeps of ink, watercolor, and charcoal. Although they showed recognizable images, these early calligraphic studies perhaps developed into his later paintings. Even in these early drawings, we find both his love of quick gesture and his ability to capture recognizable form without relying on precise detail.

The transition from representational works to Kline's expressive style occurred in 1949. When he placed some of his small brush drawings under a Bell-opticon projector and cast the enlarged images on the wall, Kline saw that his small intimate brushstrokes no longer delineated the object. He therefore began to create gigantic, tense compositions in which the act of painting was the subject. For the rest of his life, Kline concentrated on the development of a prodigious series of black-and-white paintings. Although these works appear spontaneous, many of them were worked out in smaller preliminary sketches. Nonetheless, he conveyed an extemporaneity typical of the brilliant technique of Abstract Expressionist painting.

Not until the end of his life did Kline use color successfully. Although he experimented with color, he was not confident of duplicating the raw energy and emotion of black and white paintings.

This work, completed at the mid-point of the black-and-white series, is a tense composition dominated by bold intersecting verticals and horizontals, which create rhythm and tension. Through the use of broad house-painter's brushes and the ability to feign spontaneity, Kline creates an excitement and emotive power that epitomizes the slashing dynamism of Abstract Expressionism.

Provenance: Walter Gutman Collection, New York; Sarah Lawrence College, Bronxville, New York; H. Peter Findlay Inc., New York; Tarika Collection, Paris; Allan Stone Gallery, New York, New York; Peaches Gamble Collection, San Francisco, California; Allan Stone Gallery, New York.

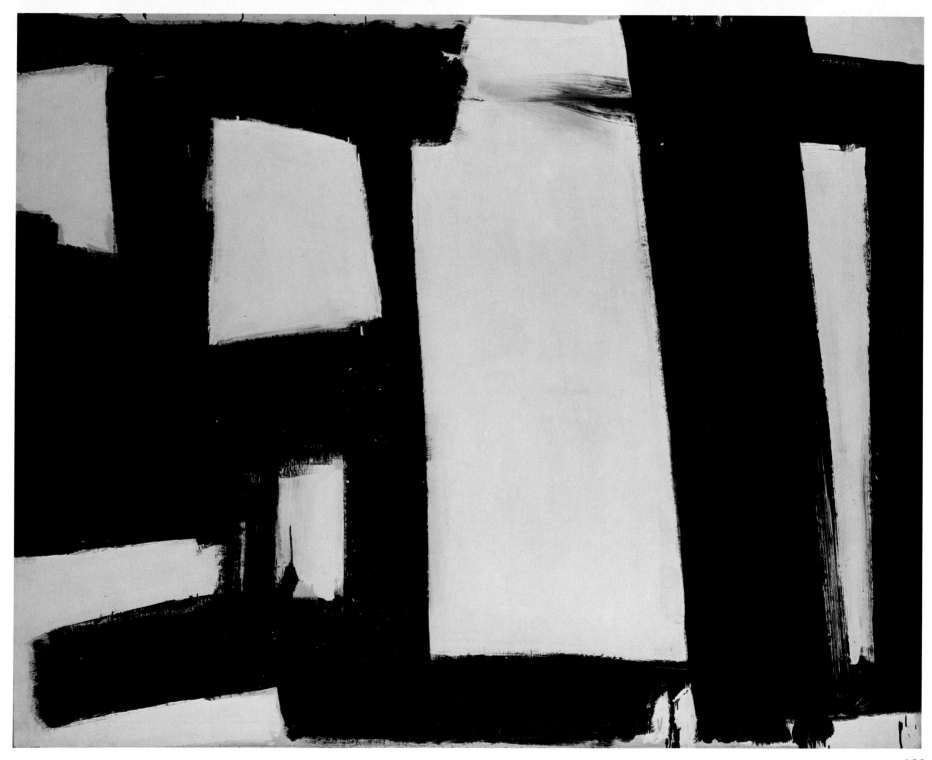

123

Nicholas Krushenick
American, 1929-

60. *Jungle Jim Lieberman*, 1969
Acrylic on canvas, 208.3 × 182.8 (82 × 72)
Signed on reverse upper right: *Nicholas Krushenick/Nov. 1969*
Virginia Museum of Fine Arts, Gift of
 Sydney and Frances Lewis, 85.416

Although Nicholas Krushenick has been grouped together with Pop artists, he denies any connection with them,[90] and rightly so. Whereas Pop artists use familiar, severely outlined images, Krushenick selects images that are totally non-representational and that have no basis in reality. His sharp images derive from his highly fertile imagination; despite efforts to decode their strange shapes, they simply exist as abstract expressions.

Krushenick studied at the Arts Students League in New York and spent his early career experimenting with a style similar to Abstract Expressionism. In 1959, however, he began creating hard-edge paintings after the invention of a rapid-drying and vibrantly colored acrylic paint. Since then, he has explored images that expand beyond the confines of the canvases. Many are defined by bold black outlines and brilliant planes of unmodulated color.

Jungle Jim Lieberman was named for a famous stock-car racer of the 60s. Kruschenick has said, "At the time I was working on this painting, I was looking for a new visual element. It turned out to be the use of black, horizontal, parallel lines. These lines were used later in a diagonal, pre-dating Lichtenstein's use of the same element. They appeared in a series of paintings I was working on."[91] There are three basic planes of color: red, yellow, white. The jagged edges and the horizontal parallel lines convey a sense of depth. The non-alignment of the horizontal lines in the yellow and white implies an overlapping of the two fields, both of which are behind the red. Krushenick thus creates perspective in a totally non-traditional manner.

By allowing the horizontal lines to run off the canvas, he imparts an expansiveness. The black outlines and the vibrant jagged shapes recall the characteristics of Pop Art. The pulsating motion of paintings such as *Jungle Jim Lieberman* removes his work from the cool approach characteristic of Minimalist painting. Kruschenick's is a painting of content made even more powerful by his intuitive sense of shape, form, and color. He works out many of his compositions through collage and relies upon the heavy black line to divide and keep pure the planes of color. "The moment you divide two colors with a black line, the colors become more vibrant to each other—the 'mixing' quality that usually occurs is made to disappear—they stay *pure* red and *pure* yellow—the colors seem to become more brilliant on their own—as independent vehicles."[92]

Provenance: Joffe-Friede Gallery, Hopkins Center, Dartmouth College, Hanover, New Hampshire, 1969.
Published: Wyrick, *Contemporary American Paintings*, p. 38 (illus.).
Exhibited: *Selections from the Lewis Collection: Twentieth-Century Gallery Loan Exhibition*: Botetourt Gallery, Earl Gregg Swem Library, College of William and Mary, Williamsburg, April 1970. *Contemporary American Painting from the Lewis Collection*: Delaware Art Museum, Wilmington, September 13-October 27, 1974. *A Bicentennial Exhibition: American Art Today*: University of Virginia Arts Museum, Charlottesville, March 9-April 30, 1976; Richmond Public Library, Richmond, May 1976; Washington and Lee University, Leesburg, May-June 1977.

90. Dean Swanson, *Nicholas Kruschenick* (Minneapolis: Walker Art Center, 1968) unpaginated.
91. Letter, dated October 28, 1984, from the artist to the author. The letter is part of the Lewis Collection archives in the Department of 20th-Century Art, Virginia Museum of Fine Arts.
92. Swanson, *Nicholas Kruschenick*, unpaginated.

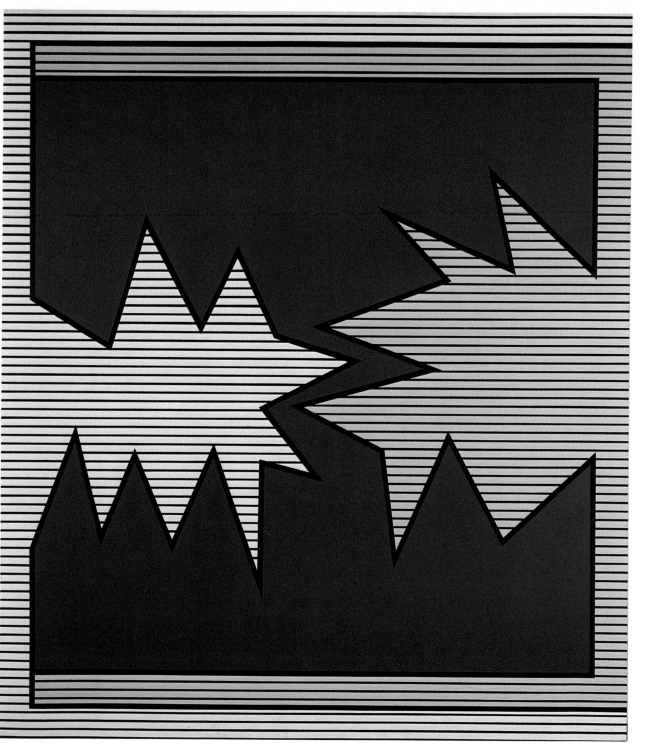

Alfred Leslie
American, 1927-

61. *Act and Portrait*, 1968-70
Oil on linen, oil on masonite (3 panels),
 152.4 × 122 (60 × 48), 274.3 × 182.8 (108 × 72),
 152.4 × 122 (60 × 48)
Your Kindness signed on board on
 reverse at top center: *Act and*
 Portrait/(I. Your Kindness)/Oil on
 masonite/Alfred Leslie/1969-
 1971/60″ × 48″; other two panels
 unsigned
Virginia Museum of Fine Arts, Gift of
 Sydney and Frances Lewis, 85.417.1/3

Alfred Leslie owes much to Caravaggio, David, and Georges de la Tour. As he wrote in 1975, "I wanted to put back into art all the painting that the Modernists took out by restoring the practice of pre-twentieth-century painting....I wanted an art like the art of David, Caravaggio, and Rubens, meant to influence the conduct of people. In order to achieve this, besides looking at these artists, I eliminated color, line, space, perspective, light, drawing and composition as nearly as I could. In order to further emphasize the individuality and the unique qualities of each person, I tried to record everything I could see. I also increased the size of the paintings so that there could be no question but that they were meant for public viewing and an institutional life and service."[93]

Since 1962 Leslie has produced large-scale portraits of persons who have influenced his life. Characteristics of these portraits are a frequent absence of background, a skillful use of chiaroscuro, and dull, vacant stares of his subjects. All three features appear in *Act and Portrait*, a triptych commemorating the birth of one of his children. The model is his wife, Constance, and the narrative images are mysterious. The paintings obviously refer to the cycle of life and death, but their exact meaning is obscure. The first painting, *Your Kindness*, is a portrait of his wife posed as Charlotte Corday, the woman who assassinated Jean-Paul Marat, the French revolutionary. The subject refers to David's *Death of Marat* of 1793 but places the center of attention not on the dying man but on the woman. She holds in her hand the letter that admitted her to Marat's private quarters and gazes with little or no expression. No specific hint of violence exists other than the connotations of historical facts.

The central image, *Common Sense*, the largest of the three, again portrays Constance, this time in jeans and a blouse. She is shown frontally with eyes downcast or closed. Only one chair leg seems to support her figure, giving a tremendous sense of imbalance. She holds a shotgun on her lap. A sense of violence and death by association, rather than by specific act, is evident.

The third painting, *Coming to Term*, the same size as the first, has his wife facing toward the central image. This time she is naked to the waist and very pregnant. Both the position of her hands and the strong light source coming from below and in front of her resemble the illumination in Georges de la Tour's paintings. The light, hands, and repose parallel depictions of the Virgin Mary.

Leslie's other famous series of paintings is the *Killing of Frank O'Hara*. Taking as his subject the 1966 automobile-pedestrian accident in which the famous poet was killed, Leslie shows in seven paintings the entire narrative from the beaches of Fire Island to the fatal mishap to the burial. Here again the barren backgrounds, interplay of light and dark, and blank stares appear, and so too Christian elements.[94]

Leslie's art is a confrontational narrative. The finely detailed paintings display the artist's command of his medium, and the larger-than-lifesize figures impart a monumentality to his work unequalled in the twentieth century. Leslie's is direct, no-nonsense painting recalling the works of the Old Masters.

Provenance: Noah Goldowsky Gallery, New York, 1972.
Published: *Alfred Leslie* (New York: Alan Frumkin Gallery, n.d.), no. 4 (illus.); Robert Hughes, "The Realist as Corn God," *Time*, January 31, 1972: 50-55 (illus.); Wyrick, *Contemporary American Paintings*, p. 10 (illus.); Linda Nochlin, "Leslie, Torres: New Uses of History," *Art in America* 64/2 (March-April 1976): 76 (illus.); John Arthur and Robert Rosenblum, *Alfred Leslie* (Boston: Museum of Fine Arts, 1976), no. 4 (illus.); Frank Goodyear, *Contemporary American Realism Since 1960* (Boston: New York Graphic Society, 1981), pp. 114-115, no. 58 (illus.).
Exhibited: *Contemporary American Paintings from the Lewis Collection*: Delaware Art Museum, Wilmington, September 13-October 27, 1974. *Alfred Leslie*: Allan Frumkin Gallery, New York, November 1975; *Alfred Leslie*: Museum of Fine Arts, Boston, May 4-June 27, 1976; Hirshhorn Museum and Sculpture Garden, Washington, D.C., November 11, 1976-January 9, 1977.

93. Alfred Leslie, *Alfred Leslie* (New York: Allan Frumkin Gallery, 1975), unpaginated. Reprinted by John Arthur in *Alfred Leslie* (Boston: Museum of Fine Arts, 1976), unpaginated.
94. Arthur, *Alfred Leslie*, unpaginated.

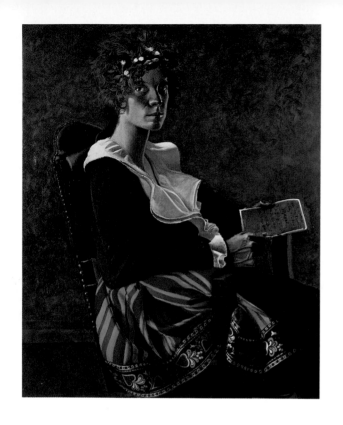
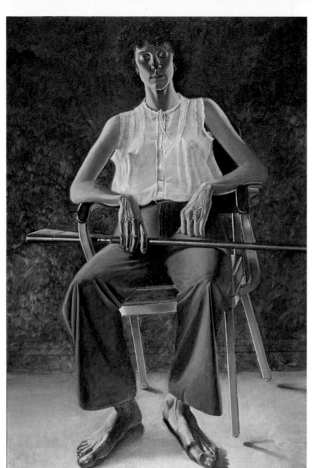
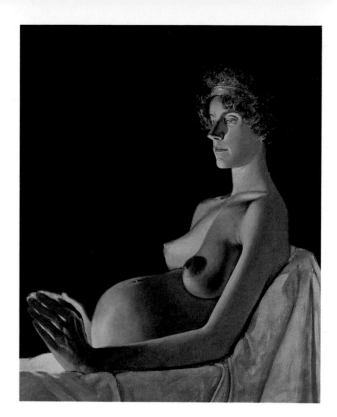

Roy Lichtenstein
American, 1923-

62. *Gullscape*, 1964
Oil and acrylic on canvas, 172.7 × 203.2 (68 × 80)
Signed on reverse: *Roy Lichtenstein '64*
Virginia Museum of Fine Arts, Gift of
 Sydney and Frances Lewis, 85.418

In the hands of a less competent or less imaginative artist, a mundane, almost banal seascape such as *Gullscape* would become a trite, uninspired rendition of a too often repeated theme. In Lichtenstein's capable hands, however, it becomes an expansive artistic statement that presents a complex arrangement of form and content.

Although he sets up various planes apparently related to atmospheric perspective, Lichtenstein denies the spatial relationship of these devices and instead champions the flat, two-dimensionality of the picture plane. The strong, horizontal bands comprising the lower third of the painting seem to reach to the horizon. However, by using the same tonality and scale for his distinctive stylistic dots in both the sky and the ocean, he reduces the composition to a single plane devoid of pictorial depth. Only the white clouds with their yellow highlights stretch back into the sky, but such ostensible depth is abruptly precluded by the relationship of the overlapping dots in the adjacent sky area to those in the foreground and upper left corner.

Lichtenstein's distinctive style emerged in his 1961 New York one-man show in New York.

Since then, he has built a vast repertoire of images deriving from seemingly mundane commercial images. He is a first generation Pop artist. His dot technique, derived from the Ben Day dot-printing method, connects him with commercial processes. Using this technique in combination with primary colors and a distinctive black outline, Lichtenstein monumentalizes the everyday imagery of advertising, comic strips, tourist images of classical ruins, seascapes and moonscapes, and works by other artists, including sardonic replications of Abstract Expressionist brushstrokes, still lifes, the art of the 1930s, Cubism, Futurism, and last, but not least, German Expressionism.

Gullscape departs somewhat from his use of primary colors in its overlaying of red and blue dots to form violet. Surprisingly, the most dense masses of the painting appear in the white clouds, which are really the negative spaces where the Ben Day dots have been deleted. The density is reinforced by the yellow edging, which reaffirms the weight and mass of the clouds. The result of all these techniques is not to present an illusionistic seascape but to show that the image is several times removed from reality,

having passed through some type of commercial process and then having been retranslated through the artist's brush. In *Gullscape*, as in all of Lichtenstein's Pop Art paintings, the familiar imagery is secondary to intent. Using formal devices, Lichtenstein pares down these images to their essentials in order to make a direct statement about the world in which we live.

Provenance: Leo Castelli Gallery, New York; Dr. and Mrs. Eugene A. Eisner Collection, Scarsdale, New York; Sotheby Parke-Bernet, New York, 1980.
Published: David Whitney, *Leo Castelli Ten Years* (New York: Leo Castelli Gallery, 1967), unpaginated (illus.); *Roy Lichtenstein* (Pasadena: Pasadena Art Museum, 1967), p. 47, no. 25 (illus.); Diane Waldman, *Roy Lichtenstein* (New York: Harry N. Abrams, 1971), pl. 90; John Coplans, *Roy Lichtenstein* (New York: Praeger Publishers, 1972), pl. 44; *Contemporary Paintings, Drawings and Sculpture.* Sale catalogue, Sotheby Parke-Bernet, New York, May 15-16, 1980, no. 554 (illus.).
Exhibited: *Roy Lichtenstein Landscapes*: Leo Castelli Gallery, New York, October 24-November 19, 1964. *Roy Lichtenstein*: Pasadena Art Museum, Pasadena, April 18-May 28, 1967; Walker Art Center, Minneapolis, June 23-July 30, 1967; The Solomon R. Guggenheim Museum, New York, September 18-November 9, 1969; William Rockhill Nelson Gallery of Art and Atkins Museum of Fine Arts, Kansas City, Missouri, December 18, 1965-January 18, 1970; Museum of Contemporary Art, Chicago, February 7-March 22, 1970; Columbus Gallery of Fine Arts, Columbus, July 9-August 30, 1970.

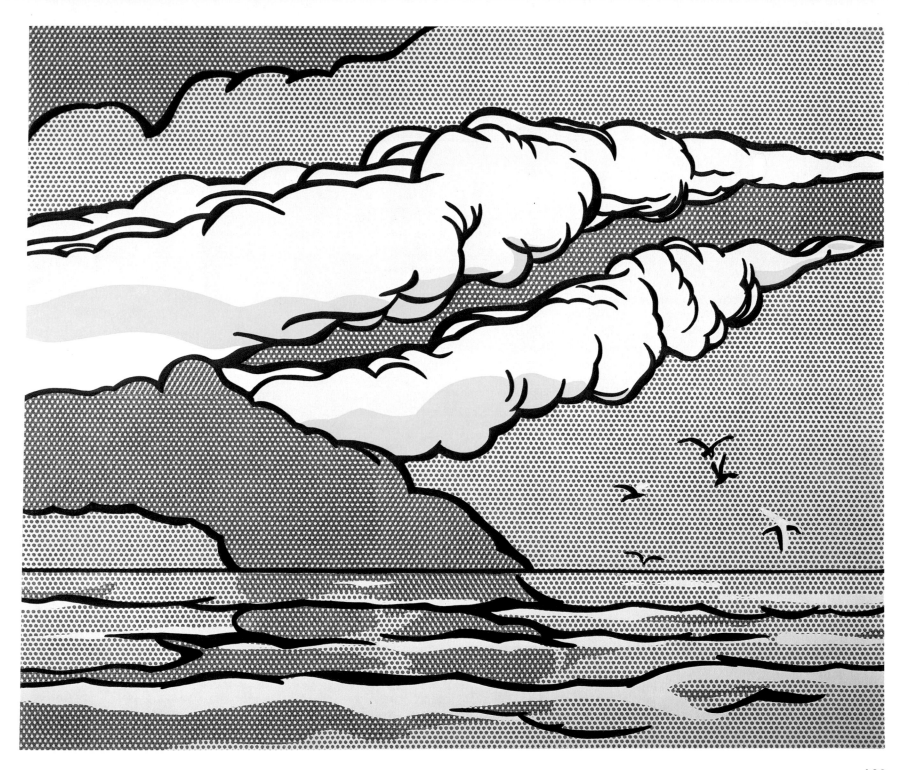

Richard Lindner
American (born in Germany), 1901-1978

63. *Couple*, 1977
Oil on canvas, 203.2 × 177.8 (80 × 70)
Signed lower right: *R. Lindner/1977*
Virginia Museum of Fine Arts, Gift of
The Sydney and Frances Lewis Foundation, 85.419

Richard Lindner's figures evoke memories of several historical eras. Often sporting contemporary fashions, his people frequently derive from the romantic Bavaria of the nineteenth century or from the corrupt and decadent Germany between the two world wars. Concurrent with these characters and sometimes in the same works are other, American figures patterned after the pimps, prostitutes, johns, thugs, and hustlers of Times Square. Prominent in Lindner's oeuvre is the theme of sexual manipulation. Men and women are both seducers and the seduced. Neither sex is entirely innocent or guilty.

Trained at the Academy of Fine Arts in Munich, Lindner fled Germany for France in 1933 when Hitler came to power. After many harrowing experiences in Europe, he came to New York in 1941 and did illustrations for such magazines as *Vogue, Harper's Bazaar,* and *Fortune.* In 1952 he began an academic career, teaching painting and drawing at the Pratt Institute in Brooklyn. Following his first solo exhibition at the Betty Parsons Gallery in 1954, he became increasingly interested in American themes. *Coney Island* (1961) is his first major American work, although German images still persist. Thus, the evil-looking carnival barker in *Coney Island* is both New York mafioso and German circus *Meister.*

Lindner's imagery derives not only from specific periods of German and American history but also from his imagination. Fascinated by both the theater and the history of the Nuremberg of his childhood, Lindner uses such symbols as the circus or cabaret leader, mad King Ludwig II of Bavaria, the Iron Maiden (an instrument of torture and a popular tourist attraction in Nuremberg), and dolls and toys (Nuremberg was once an important toy-manufacturing center). He combines these German images with the colorful and tawdry New York character-types mentioned above. Especially popular are figures of grossly plump children and abstract, often rectilinear designs, which were influenced by Ferdinand Léger and Piet Mondrian. The works of the German Expressionists Otto Dix and Max Beckmann are important sources as well.

The ambivalent nature of male-female relations is a recurrent theme, perhaps Lindner's most important. His men and women are timeless and universal. In *Couple,* the female figure, a streetwalker-goddess, is dominant and confronts us with her garish clothes, her outlandish, winged red hat, and her slit skirt, which reveals her fleshy thigh. She ignores the male figure, who stands behind and fondles her breast. Although the action is aggressive, there is little or no interaction nor eroticism. The woman's clothes, which might otherwise advertise her services, here become armor protecting her from the man. Nor is moral judgment passed on either of the two figures. If the woman is guilty for seducing the man, he is culpable for accepting her offer.

The woman in *Couple* is found many times in Lindner's other works. Often gaudily dressed or corsetted, she recalls the "Lulu" figure of German theater and cinema between the wars, such as in Franz Wedekind's plays *Erdgeist* (*Earth Spirit*) and *Pandora's Box* and in Lindner's *Woman in Corset* (1951) and *Man and Woman* (1953). Lulu, as the similar female figure in many of Lindner's works, is voluptuous and impersonal. Unaware or uncaring about her effect on men, she neatly epitomizes the ambivalence of sexual games.[95]

Provenance: Sidney Janis Gallery, New York; Galeries Maeght, Paris; Christie, Manson & Woods, New York, 1984.

Published: *Derrière Le Miroir* (Paris: Galeries Maeght, 1977), p. 19, no. 8 (illus.); *Richard Lindner* (New York: Sidney Janis Gallery, 1978), no. 8 (illus.); A. Jouffroy, "Les femmes de Richard Lindner," *XXe Siècle* 50 (June 1978): 24-28; "Exhibition Tehran 78," *Art in America* 66 (July-August, 1978): 15; *Richard Lindner* (St. Paul, France: Foundation Maeght, 1979), cover and p. 111, no. 39 (illus.); *Contemporary Art.* Sale catalogue, Christie, Manson & Woods, New York, May 8, 1984, no. 28 (illus.).

Exhibited: *Derrière le Miroir:* Galeries Maeght, Paris, 1977. *Exhibition Tehran 78:* Contemporary Arts Museum, Teheran, Iran, November 23-December 8, 1978. *Richard Lindner:* Foundation Maeght, St. Paul, France, May 12-June 30, 1979.

95. See Dore Ashton's *Richard Lindner* (New York: Harry N. Abrams, 1969), pp. 9-63 and Hilton Kramer's *Richard Lindner* (Boston: New York Graphic Society, 1975), pp. 11-37 for excellent accounts of Lindner's life and work.

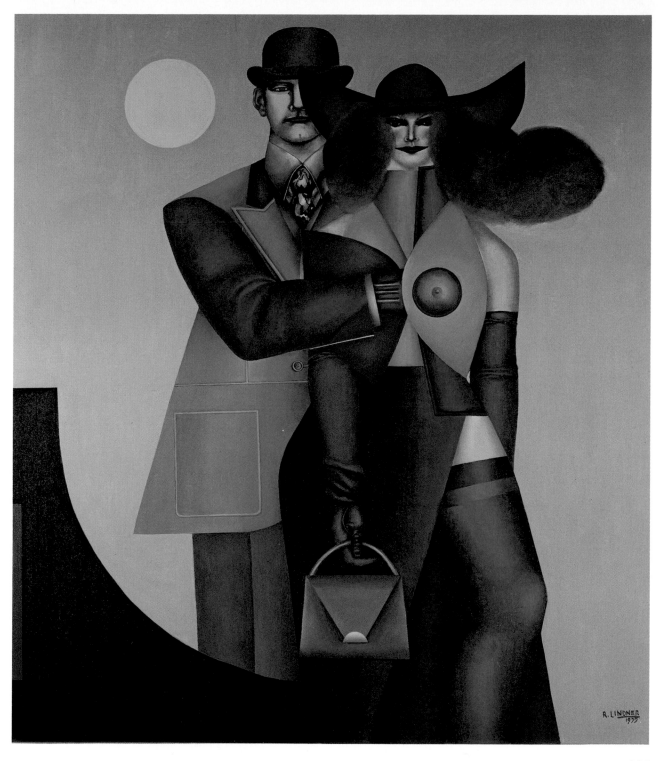

131

Robert Longo
American, 1953-

64. *Kill Your Darlings*, 1983-4
Glass, metal, acrylic, silkscreen on paper,
 198.1 × 255.7 × 76.2 (78 × 118 × 30)
Unsigned
Virginia Museum of Fine Arts, Gift of
 The Sydney and Frances Lewis Foundation, 85.420.1/4

In Robert Longo's work we find concern for the danger in our society today from injustice, bureaucracy, and in general, the pervasive envelope of death and violence eroding our lives. Longo believes that the artist's duty should be to serve as a watchdog and to forewarn society of these dangers. "A great deal of my art, particularly the relief, *The Sleep*, is about blowing the whistle on society. I had made the piece right after Jonestown and right before the Phalangist murders (the image is actually taken from a family leisure-wear ad). Here they are celebrating the image of genocide in family sportswear. *The Sleep* is a perfect example of the artist serving as a guardian of culture."[96]

Since graduation from State University College in Buffalo in 1975, Longo has worked in New York and produced a series of disquieting and confrontational images in various media. The images may appear somewhat innocent, but they evoke a sense of quiet desperation, violence, fear, and grief. The interrelationships of images are often obscure, allowing many interpretations.

His early series of drawings of men and women in a dance of death, twisting and turning with heads thrown back and eyes closed, convey the presence of an external force manipulating the figures. Many of these images were taken di-rectly from films and others derive from Longo's own photographs; he had his models pulled about by ropes while they tried to catch balls thrown at them. Longo's recent works, in which he decries the world's injustice, combines seemingly elusive images that are sometimes clarified but often mystified by their titles. It is unsettling in both its obscure and accusatory nature. Having been much involved in performance pieces, he looks at both these images and the gallery walls as part of a theater for his dramas.

Kill Your Darlings is a four-panel work in various media. Longo describes it as:

constructed in reference to the demise of Europe; the self-wrought abdication of Europe, as the historical, cultural, and economic center of the world. It speaks of America's relationship to Europe; of how we as Americans identify ethnologically with Europe even though our genealogy stems from a much broader base: 'Europe is the white man's burden.' The image is symbolically a dead bird. The eagle is the head of the bird and is rendered as if it isn't there. It invites its own destruction due to the temporary nature of the glass, it can be shattered. The metal archway forms the wings of the bird and is derived from a gate in Munich, a city whose architecture perverts Italian renaissance building for a romantic ideal. A city that also began the careers of two madmen, Ludwig the lunatic and Adolf Hitler, whose obsessions expedited the demise of Europe. A woman crying is the breast of the bird and represents a mother grieving for her son lost in war; the anguish of all mothers who have lost sons in the many wars fought in Europe. Finally there is the field of flowers, taken from a postcard, which is the tail of the bird. It portrays European manipulation of nature, of how Europe for centuries has redone nature and as such is able to create its own nature. (Observe the obsessive repetition of red and yellow flowers.) As the eagle has traditionally been the symbol of European power it is also a symbol of America. Therefore, the piece speaks not only of the eclipse of European power, it acts also as a warning, what has happened in Europe could happen to America.[97]

Provenance: Metro Pictures, New York, 1984.
Exhibited: *Robert Longo*: Metro Pictures, New York, 1984.

96. Maurice Berger, "The Dynamics of Power: An Interview with Robert Longo," *Arts Magazine* 59/5 (January 1985): 88.
97. Quotation by the artist, in collaboration with Brian Shaffer, in a letter to the author dated March 14, 1985. This letter is part of the Lewis Collection archives in the Department of 20th-Century Art, Virginia Museum of Fine Arts.

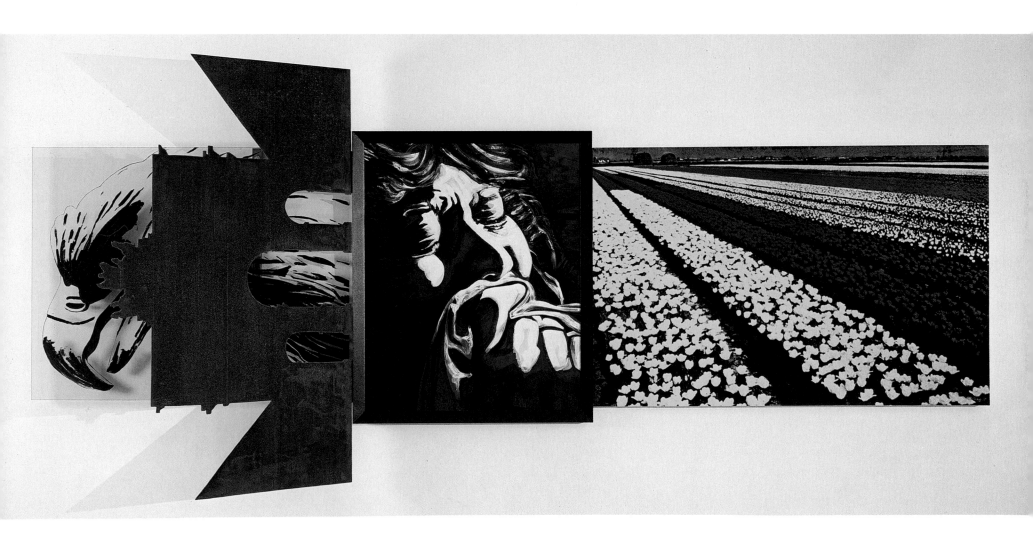

Morris Louis
American, 1912-1962

65. *Claustral*, 1961
Oil on canvas, 216.0 × 162.5 (85 × 64½)
Signed on reverse, upper left: *Claustral M Louis 61*
Virginia Museum of Fine Arts, Gift of
 Sydney and Frances Lewis, 85.421

The subject of Morris Louis's mature work is color. He strove to achieve the optimum effect of colors, whether transparent or opaque, and their interrelationships. His work is romantic and is related to Abstract Expressionism both in time and concept. Louis, however, was not interested in revealing his technique, thus differing from the gestural tendencies of the Abstract Expressionists. The optical, not the textual effect, is of prime importance. Color, and not gesture or symbolism, as a means of expression is the only subject.

Louis was part of a group known as the Washington Color School, which included Kenneth Noland, Thomas Downing, Paul Reed, Gene Davis, and Howard Mehring. All of these painters worked in an abstract mode and were interested primarily in color as content, generally working with unprimed canvases and water-soluble paints that were absorbed into the texture of the canvas and produced "stained" works. Major influences on both Louis and Noland were Jackson Pollock's work and particularly Helen Frankenthaler's stained painting *Mountains and Sea.* Trips to New York taught Louis some of the lessons his colleagues had already learned, but his isolation in Washington, D.C. permitted him to grow independent of the New York School.

From 1954 until his death in 1962, Louis created a series of paintings with distinct traits. His first major group was titled *Veils.* Great areas of thin paint were allowed to flow across the canvases to build up a translucency of color on a very large scale. The *Veils* series was followed in 1959 by *Florals* in which the overlapping stains originate from the center of the canvas and branch out towards the edges. Unlike the *Veils,* more distinction of individual colors occurs, rather than a total blending and overlaying of translucent colors. In 1962 Louis started the series *Unfurled* in which individual bands of color radiate side by side in a diagonal pattern leaving great expanses of bare white canvas between them. Unlike his earlier paintings, the major pictorial elements, that is, the distinctive passages of color, occur on the perimeters, and the center is unpainted.

Louis's final group, of which *Claustral* is an important part, is the *Stripes* series. Begun in 1961, the *Stripes* paintings were usually vertical, with a series of abutting and sometimes overlapping vertical bands of bright, opaque paints. Louis's exact technique is unclear. To judge from the appearance of his work, he may have stapled large canvases to a framework set upright and then poured the paint carefully in separate bands from the top, letting gravity compose the straight lines. The small peaks in canvases such as *Claustral* resulted from the running of the paint over the turned canvas and slightly down the backside. The part hanging over the top of the stretcher was incorporated into the composition, the stripes ending up with a "picket" effect. Careful cropping probably dictated the balance of the stripes in relationship to their position on the large field of unprimed canvas. In *Claustral* the artist achieved a slight imbalance by not centering the stripes but by positioning them on the right side of the canvas. The heavier colors appear on the right side giving this area much greater weight. Shortly before his death, Louis experimented with both horizontal and diagonal stripes created in much the same manner.

A prolific painter, Louis created works that resonate with color. His oeuvre comes close to the ultimate use of pure color as communication. No hint of subject exists, nor does texture interfere with the color. Louis's paintings have a majesty and drama, and they are appealing in their optical expression. Through his sensitive appreciation of color and his innovative techniques, Louis established himself as a major twentieth-century artist who served to join the art of the 40s and 50s with color paintings of the 60s.

Provenance: Carter Burden, New York; Anita Friedman Fine Arts, New York, 1982.

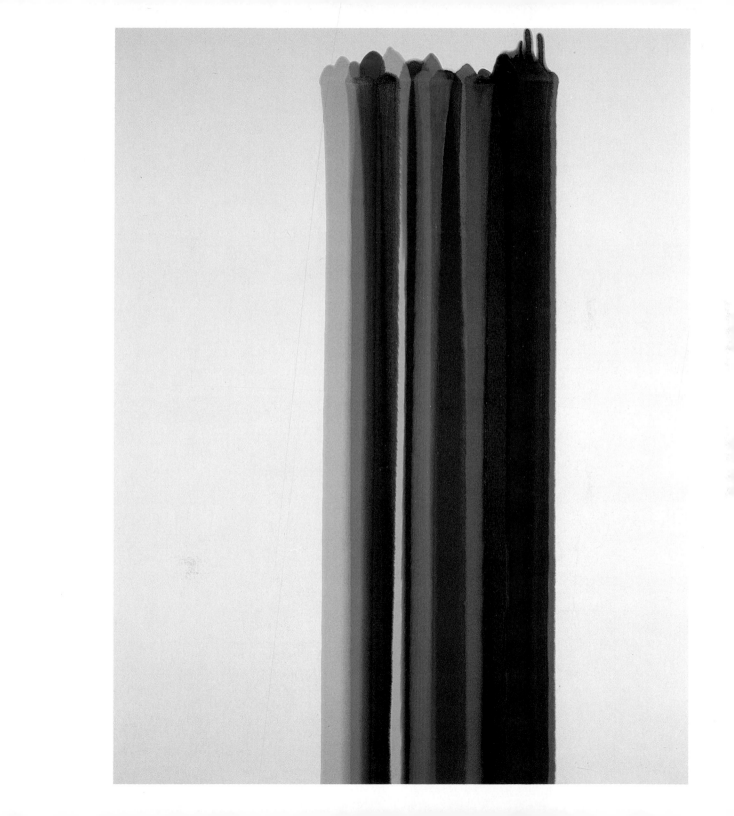

Brice Marden
American, 1938-

66. *Meritatio*, 1978
Oil paint and wax on canvas, 213.3 × 243.8 (84 × 96)
Signed on reverse, center panel upper right:
Meritatio 1978 B Marden
Virginia Museum of Fine Arts, Gift of
 The Sydney and Frances Lewis Foundation, 85.423

Brice Marden is a Minimalist in his reduction of painting to its purest form and color. Marden has been exploring monochromatic painting since 1964. He has also experimented with single panels as well as larger compositions made up of solid planes of several colors such in *Meritatio*.

To achieve his sleek, shining surfaces, Marden has developed a technique combining oil paint and the encaustic medium. After carefully sanding the surface of white-primed canvas and applying the paint, he uses painting knives to smooth out the surface, achieving a voluptuous richness. His paint medium is a liquid combination of oil paint, beeswax, and turpentine, which is layered in three to ten applications. The result is several series of exquisitely colored paintings devoid of representational subjects or textural variations in the surfaces. The quality of the colors and their interrelationships are Marden's most important concerns.

Although not apparent, the sources of *Meritatio* and the other four works in the same series are the five states of the Virgin during the Annunciation—Disquiet, Reflection, Inquiry, Submission, and Merit—as described in a fifteenth-century sermon by Fra Roberto Caracciolo of Lecce.[98] Of *Meritatio* (Merit), Marden

says, "In my mind, the small panels are the light and darkness. The idea of Christ as light and of Christianity as an evil religion... The one on the left is always dark. The painting is to move the light through. That's why the rhythm of the group seems to have jumped rather than flowed.

"The reason for changing the shape of one of the panels, cutting it in half, was to give it an extra rhythm, and it made the drawing much more complicated.... I just wanted more space, more acitivity in the painting. I think there is a way of working out different spatial situations within a framework. To talk about space is difficult because I don't mean one in front of the other, but I assume that if it's a yellow panel, that's a different kind of space than the red one."[99]

In this spatial relationship and the relationship of color, hue and tone, Marden creates a movement and tension in his painting not normally associated with Minimalist art. It is this concept of color relationship and the exploration of values that add communicative strength to Marden's paintings.

Provenance: Pace Gallery, New York, 1978.
Published: *Brice Marden: Recent Paintings and Drawings* (New York: Pace Gallery, 1978), no. 5 (illus.); *Brice Marden: Paintings,*

Drawings, Etchings 1975-80 (Amsterdam: Stedelijk Museum, 1981), no. 14 (illus.); *Brice Marden: Paintings, Drawings, and Prints, 1975-80* (London: Whitechapel Art Gallery, 1981), no. 31 (illus.); Brandt and Butler, *Late Twentieth Century Art*, p. 47, no. 40 (illus.).
Exhibited: *Brice Marden: Paintings Drawings Etchings*: Stedelijk Museum, Amsterdam, March 12-April 24, 1981. *Brice Marden: Paintings, Drawings, and Prints, 1975-80*: Whitechapel Art Gallery, London, May 8-June 21, 1981. *Late Twentieth-Century Art From The Sydney and Frances Lewis Foundation Collection*: The Anderson Gallery, Virginia Commonwealth University, Richmond, December 5, 1978-January 8, 1979; Institute of Contemporary Art, University of Pennsylvania, Philadelphia, March 22-May 2, 1979; The Dayton Art Institute, Dayton, Ohio, September 13-November 4, 1979; Brooks Memorial Art Gallery, Memphis, Tennessee, December 2, 1979-January 27, 1980; Dupont Gallery, Washington and Lee University, Lexington, Virginia, February 18-March 21, 1980; The Toledo Museum of Art, Toledo, September 21-November 9, 1980; Madison Art Center, Madison, Wisconsin, November 23, 1980-January 18, 1981. *Brice Marden: Paintings, Drawings, Etchings: 1975-80*: Stedelijk Museum, March 12-April 21, 1981. *Late Twentieth-Century Art From The Sydney and Frances Lewis Foundation Collection*: Gibbes Art Gallery, Charleston, South Carolina, October 15, 1981-January 10, 1982; Mississippi Museum of Art, Jackson, January 31-March 14, 1982; University of Tennessee, Knoxville, March 28-May 30, 1982; Worcester Art Museum, Worcester, Massachusetts, September 10-October 31, 1982; Allentown Art Museum, Allentown, Pennsylvania, November 14, 1981-January 16, 1983; University Memorial Gallery, University of Rochester, Rochester, January 30-March 13, 1983; Everson Museum of Art, Syracuse, New York, March 25-May 29, 1983.

98. Jean-Claude Lebenszteijn, *Brice Marden: Recent Paintings and Drawings* (New York: The Pace Gallery, 1978), unpaginated.
99. Ibid.

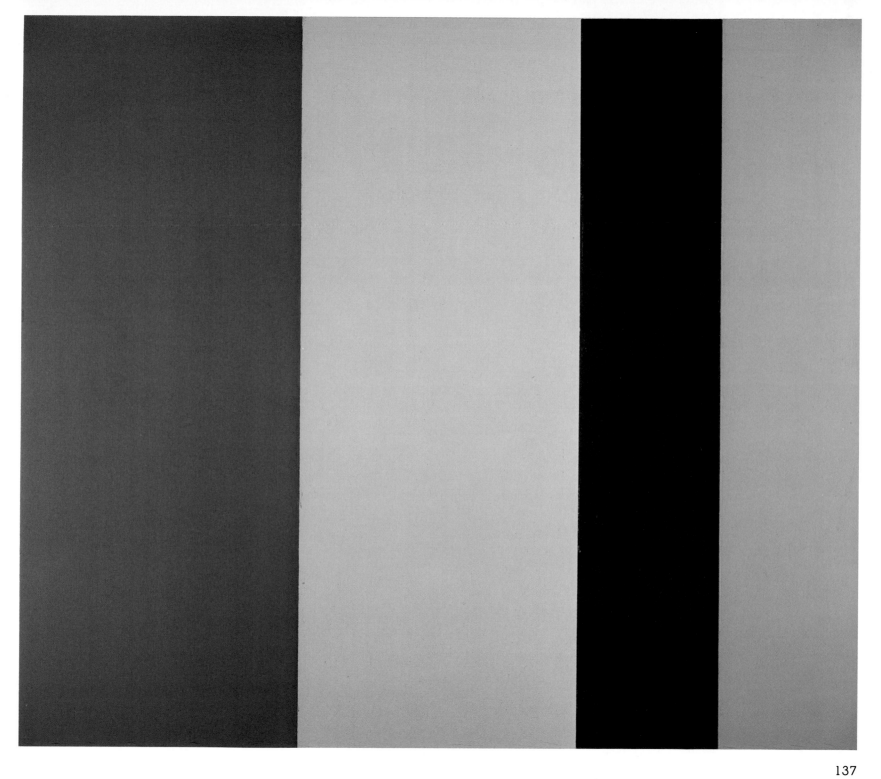

Richard McLean
American, 1934-

67. *Wishing Well Bridge*, 1972
Oil on canvas, 152.4 × 160.0 (60 × 63)
Signed on reverse: *Richard McLean Wishing Well
 Bridge 1972*
Virginia Museum of Fine Arts, Gift of
 Sydney and Frances Lewis, 85.423

Like other Photo-Realists, Richard McLean works from photographs. His subjects are horses and their environments. In this choice of content, McLean differs from his colleagues, who prefer urban landscapes. Until 1973 McLean used black-and-white magazine photographs. Although he basically copied the images, he changed the colors. In 1973 he began taking his own photographs and including more detail in the paintings. His recent works have a slightly more relaxed atmosphere; they resemble snapshots more than posed studies.

McLean assumes greater control over the pose of his subjects and their relationship to intense California light and shadow, which pervades all his paintings. He projects the photographic image and freely draws in the basic sketch. He often prepares preliminary watercolors to work out the contextual and color devices in abstract patterns.

Wishing Well Bridge derives from a photograph of the 1971 Miss Rodeo America pageant. Neither the emotions of the women nor their involvement in the contest are important. They are inanimate objects that can be replicated through various compositional devices. Unlike the majority of his paintings, no horse appears, though the pageant is a related context. In *Wishing Well Bridge*, McLean did not use colors arbitrarily but worked from a color photograph. Typically, the composition is very carefully balanced, the weight of the dominant image being centered in the canvas. In early works a dominant image also exists in the middle plane, although in his own photographs, the image moves to a more frontal plane and has a much reduced spatial depth.

Provenance: O.K. Harris Works of Art, New York, 1973.
Published: Wyrick, *Contemporary American Paintings*, p. 4 (illus.); Bernd Krimmel, ed. *Realismus und Realität* (Darmstadt: Kunsthalle Darmstadt, 1975), p. 169, no. 135 (illus.); Louis K. Meisel, *Photo-Realism* (New York: Harry N. Abrams, 1980), p. 342, no. 723 (illus.).
Exhibited: *Contemporary American Paintings from the Lewis Collection*: Delaware Art Museum, Wilmington, September 13-October 27, 1974. *Realismus und Realität*: Kunsthalle Darmstadt, Darmstadt, May 23-July 6, 1975.

Malcolm Morley
English, 1931-

68. *The Grand Bayonet Charge of the*
 Legionnaires in the Sahara, 1979
Oil on canvas, 182.8 × 274.3 (72 × 108)
Unsigned
Virginia Museum of Fine Arts, Gift of
 The Sydney and Frances Lewis Foundation, 85.424

The Grand Bayonet Charge of the Legionnaires in the Sahara, an early Neo-Expressionist work, is much different from Malcolm Morley's precisely painted portraits of cruise ships from the early 60s. This disparity illustrates the shift that has occurred throughout Morley's work in concept, technique, medium, and pictorialization.

Morley was born in the Highgate section of London. His house was destroyed by a bomb during World War II, and a ship model on which he was working was wrecked. This experience was the basis of his paintings of the warship and cruise ship series. Early in his career, he experimented with Pop Art and later Abstract Expressionism. The forays into Pop Art resulted from his studies at the Royal College of Art, at that time an important center for this movement.

After moving to New York in 1958, Morley soon abandoned his abstract painting and began creating oversized acrylics of cruise ships, which he meticulously replicated from advertising brochures and postcards. He carefully gridded the illustration and the canvas and worked on one square at a time. These paintings and others produced between 1958 and 1970 have been likened to Photo-Realism because of their precision. In 1971, Morley's style and medium changed. Using oil paints, he depicted various objects from his studio—telephone book covers, postcards, and other printed media—which were torn, folded, or wrinkled. By 1976 Morley was preoccupied with depicting catastrophes and military themes. He often incorporated images from earlier paintings such as toy boats and airplanes.

The Grand Bayonet Charge . . ., featuring the repeated motif of a small toy soldier, is a violent and intense painting. In their configuration the soldiers appear to be attacking one another. An abrupt shift in the position of figures on the right edge of the painting denotes a flat, pictorial plane and lessens the illusion.

In reviewing Morley's 1981 exhibition in New York, Hilton Kramer, art critic for the *New York Times*, called it "one of the best of the season . . . pictures with lively, sometimes bizarre images that have the look of something inspired and unexpected—and may become, at times, a little mad."[100] Because of his use of exaggerated imagery, brilliant coloration, and violent and rapid handling of paint, Morley is the predecessor of the Neo-Expressionist style of painting that has dominated the 80s.

Provenance: Nancy Hoffman Gallery, New York, 1979.
Published: Brandt and Butler, *Late Twentieth Century Art* , pp. 46-7, no. 41 (illus.); *Malcolm Morley: Paintings 1965-82* (London: The Whitechapel Art Gallery, 1983) pp. 15, 56 (illus.).
Exhibited: *Late Twentieth-Century Art From The Sydney and Frances Lewis Foundation Collection*: The Toledo Museum of Art, Toledo, September 21-November 9, 1980; Madison Art Center, Madison, Wisconsin, November 23, 1980-January 18, 1981; Allen Priebe Art Gallery, University of Wisconsin-Oshkosh, Oshkosh, January 27-March 15, 1981; Ulrich Museum, Wichita State University, Wichita, April 1-May 31, 1981; Gibbes Art Gallery, Charleston, South Carolina, October 15,1981-January 10, 1982; University of Tennessee, Knoxville, March 28-May 30, 1982; University Memorial Gallery, University of Rochester, Rochester, January 30-March 13, 1983; Huntington Galleries, Huntington, West Virginia, June 2-August 18, 1984. *Malcolm Morley: Paintings 1965-82*: The Whitechapel Art Gallery, London, June 22-August 21, 1983; Corcoran Gallery of Art, Washington, D.C., September 9-November 6, 1983; Museum of Contemporary Art, Chicago, November 19, 1983-January 22, 1984; The Brooklyn Museum, Brooklyn, February 18-April 15, 1984.

100. Hilton Kramer, "Art: Two Painters Explore New Wave," *The New York Times*, 17 April 1981.

Robert Morris
American, 1931-

69. *Table and Chair for Sydney Lewis*, 1973
Copper; table: 91.4 × 122. × 83.8 (36 × 48 × 33);
 chair: 91.4 × 47.6 × 40.6 (36 × 18¾ × 16)
Unsigned
Virginia Museum of Fine Arts, Gift of
 Sydney and Frances Lewis, 85.425.1/2

Robert Morris explores the relationships of the object to both the artist and the audience—the artist's conception and creation and the public's response. In the majority of his early work, Morris used industrial materials such as felt, steel, mirrors, lead, copper, and plywood. Effective communication is more important to Morris than technique.

In his preoccupation with "process," Morris has presented perplexing aspects of sound, scale, weight, and other concepts that necessitate a response in order to define the "art" of the particular object. Morris breaks down the distinctions between media. "There are . . . some activities that interact with surfaces, some with objects, some with objects and a temporal dimensionTo focus on the production end of art and to lift up the entire continuum of the process of making and find in it 'forms' may result in anthropological designations rather than art categories."[101]

These concepts carry over from Morris's Minimal work into soft, felt pieces, earthworks, and items such as *Table and Chair for Sydney Lewis*. Created in 1973, this copper table and chair, manufactured by the Lippincott Foundry of North Haven, Connecticut to the artist's specifications, bears a direct relationship to Morris's installation *Hearing* (1972), which represents "in debased form the power of the Tetragrammaton, the Hebrew four-letter word for God that embodies all the cycles of universal thought and creation."[102] Consisting of a copper chair, a zinc table, and a lead bed connected to six wet-cell storage batteries, *Hearing* had signs warning of dangerous electrical shocks. The inspiration comes from ancient Judaic belief. As the critic Jack Burnham has written, "In ancient times, the holiness of the Ark of the Covenant was so profound that touching it was considered fatal for a man."[103]

Hearing did not invite audience participation. The *Table and Chair* does. Morris requested that the set be left outside the Lewises' oceanfront house at Virginia Beach for three to four months. When the table and chair were brought inside, Sydney Lewis was to write a confidential passage in a notebook. According to Morris, "the subject of these entries (is) to be known only to S. Lewis and R. Morris. Date and time of each entry to be logged in book. This activity to occur only when table and chair are inside."[104] As Lewis sat at the table, a line was to be drawn around his arms and the notebook. Only the circumscribed portion, not the rest of the copper surface, was to be polished. As the copper oxidized in the sea air, the untouched polished area would preserve the "memory" of the event. The artist, the owner/audience, and nature all participate in the continuing process of the work of art.

In recent years Morris has produced more representational and almost traditional concepts of art. Works concerning the fire-bombing of Dresden and the atomic destruction of Hiroshima have been the subject of a series of drawings and castings. Through pictorial means Morris makes overt statements that again involve participation through association and memory.

Provenance: from the artist through Lippincott Inc., North Haven, Connecticut, 1973.

Exhibited: *Improbable Furniture* : Institute of Contemporary Art, University of Pennsylvania, Philadelphia, April, 1977; La Jolla Museum of Contemporary Art, La Jolla, California, May 20-July 10, 1977.

101. Robert Morris, "Some notes on the phenomenology of making: the search for the motivated," *Artforum* 8/8 (April 1970): 62.
102. "Voices from the Gate," *Arts Magazine* 46/8 (Summer 1972): 45; see also Burnham's "The Cabalistic Tree of Life (or Tree of Knowledge)" in *Arts Magazine* 46/5 (March 1972): 30-31.
103. Burnham, "Voices from the Gate," p. 45.
104. Instructions by Robert Morris, dated June 1972, on the drawings for proper use of *Table and Chair for Sydney Lewis*. The drawings are part of the Lewis Collection.

Don Nice
American, 1932-

70. *American Totem/Cornucopia Bear*, 1981
Oil on canvas, 243.8 (96) diameter
Signed lower center: *Nice*; reverse upper right: *Don Nice,
American Totem/Cornucopia Bear, 8' circle, 1981*
Virginia Museum of Fine Arts, Gift of
 Sydney and Frances Lewis, 85.426

Don Nice portrays flora and fauna, often juxtaposing seemingly unrelated objects. Although some of his subject materials are manmade and might seem nothing more than litter, most of the objects are natural. Nice combines disparate images by using a system of scale, color, and interrelationships.

Nice's early works of 1962 have been compared to Pop Art. He denies the validity of the association, however, claiming that he was only attempting to confront the relationship of the object to the environment and not to monumentalize the object.[105] In his later paintings he removes the object from the environment and depicts it as a singular item existing in space almost by itself. After selecting familiar images from wildlife, Nice works from the model, making endless sketches, which he keeps in neat, orderly notebooks. The sketches are often followed by watercolors, then large drawings, which are later transferred to the canvas.

Although Nice denies that there are ecological implications in his work,[106] his realistic portrayal may indeed evoke concern for wildlife. In *American Totem*, Nice focuses attention on the bear in the center by surrounding it with an abundance of eggplant, peppers, carrots, turnips, and other vegetables forming a framework similar to a Renaissance terra-cotta by Andrea or Luca della Robbia.

In 1974 Nice claimed, "A painting for me is a process of study, selection and projection. Beyond the work itself, there is no message. All we can experience is the reality of the external world. In order to create a modern image that will have some meaning for our time, each examination must transform not only the perceiver but also what is perceived. I select objects that I hope reflect a universal and not a specific culture . . . just objects which refer back to themselves."[107]

Provenance: Nancy Hoffman Gallery, New York, 1981.
Exhibited: *Don Nice*: Nancy Hoffman Gallery, New York, December 1981. *Contemporary American Realism Since 1960*: Virginia Museum of Fine Arts, Richmond, February 3-March 28, 1982.

105. Don Nice, "The Artist's Statement," in Dan van Golberdinge, *Don Nice* (Arnhem, The Netherlands: Arnhem Museum, 1974), p. 3.
106. Ibid., p. 5
107. Ibid.

145

Kenneth Noland
American, 1924-

71. *17th Stage*, 1964
Acrylic on canvas 237.5 × 204.5 (93½ × 80½)
Unsigned
Virginia Museum of Fine Arts, Gift of
 Sydney and Frances Lewis, 85.427

In 1960 the critic Clement Greenberg categorized Noland as a color painter. "His colour counts by its clarity and its energy; it is not there neutrally, to be carried by the design and drawing; it does the carrying itself.... Noland's art owes much of its truly phenomenal originality to the way in which it transcends the alternative between the painterly and the geometrical."[108] He claimed that Noland's geometric images defied the normal concepts and precepts of hard-edged geometric painting. The artist's hand was plainly discernible with uneven line, splatters, and unprimed canvas. His staining method also denied the characteristics of Abstract Expressionism.

Noland studied with Ilya Bolotowsky and Josef Albers at Black Mountain College in North Carolina. In 1948 he spent a year studying in Paris and returned to the United States, settling in Washington. During the subsequent years, he met Greenberg and became close friends with Morris Louis, whom he introduced to Greenberg. Greenberg acquainted both Noland and Louis with Helen Frankenthaler's *Mountain and Sea*, which led them to experiment with the staining technique. By 1956 Noland had developed his mature style of stained paintings in which he emphasized the central image.

A series of paintings featuring the chevron motif was developed in 1963. In this series, carefully placed stripes descending from the upper corners form a central motif. In 1964, when *17th Stage* was painted, Noland had moved the chevron away from the center of the canvas; the drama and tension increased not only by this shift in focal point but also by the variety of widths of the bands of color and the interrelationships of color. The asymmetrical chevrons logically developed into a series of long, narrowly compressed diamond shapes composed of a series of stripes. These, in turn, paralleled the large horizontally striped canvases developed by Noland at approximately the same time. Plaid compositions and irregularly shaped canvases dominated his work of the late 70s. He returned recently to the chevron motif through which he explores the luminosity and translucency of pearlescent paint.

In these works, as well as in his prints, sculptures, and handmade papers, Noland demonstrates his involvement with color and its relationship to shape and structure. Volume, density, shape, and scale are all important to him. Through color he communicates a wide range of mood and expression, as well as his personal experiences. He makes color accomplish different ends. The configuration of his colors and their respective quantities are as important to him as the colors he chooses. Through his wide experimentation with color and its relationship to shape and form, he has vindicated Greenberg's 1960 prediction that Noland was "a candidate for major status."[109]

Provenance: Carter Burden, New York; Anita Friedman Fine Arts Ltd., New York, 1982.
Published: L.C., "Reviews and Previews," *ARTnews* 64 (March 1965): 12 (illus); "Basel, Signale; Ausstellung in der Kunsthalle," *Werk* 52, suppl. 180 (August 1965): unpaginated; Michael Fried, *Three American Painters: Kenneth Noland, Jules Olitski, Frank Stella* (Cambridge, Mass.: Fogg Art Museum, 1971), no. 3 (illus.); Kenworth Moffett, *Kenneth Noland* (New York: Harry N. Abrams, 1977), no. 36 (illus.); Diane Waldman, *Kenneth Noland: A Retrospective* (New York: Solomon R. Guggenheim Museum, 1977), p. 83, no. 45 (illus.); Martha McWilliams Wright, "Washington," *Art International* 22 (January 1978): 65 (illus.).
Exhibited: *Kenneth Noland: A Retrospective*: Solomon R. Guggenheim Museum, New York, April 15-June 19, 1977; Hirshhorn Museum and Sculpture Garden and Corcoran Gallery of Art, Washington, D.C., September 29-November 27, 1977; Denver Art Museum, Denver, March 23-May 7, 1977.

108. Clement Greenberg, "Louis and Noland," *Art International*, 4/5 (25 May 1960): 28-29.
109. Ibid., 28.

Jim Nutt
American, 1938-

72. *Please!—This Is Important*, 1976-77
Acrylic on watercolor paper with hand-painted
 papier-mâché frame, 69.8 × 64.8 (27½ × 25½)
Unsigned
Virginia Museum of Fine Arts, Gift of
 Sydney and Frances Lewis, 85.428

A complex frame encloses a small opening in which Jim Nutt depicts a naked and grotesquely deformed female figure running across a shallow space. Her hair is like a Mickey Mouse cap, and her red pubic hair matches the red of her nipples and lips. Her right hand is a claw like appendage that glows with a green aura. Her left hand is a hook. She carries a petite pocketbook that also glows with a purple hue. Her left foot is enclosed in a glowing high-heeled shoe, and her right foot is merely a long slender line. Only her right foot touches the ground, casting a thin shadow. She is a hideous, strangely contoured "character" taken from Jim Nutt's endless repertoire of figures.

The elaborately painted handcrafted papier-mâché frame enhances the stagelike appearance of space. A looming, gridded face emerging from the left menaces the running female figure. A group of strange creatures, some humanoid, are oblivious to her flight. Others peer from the lower left border and from an opening in the rear wall. They all cast slight linear shadows emphasizing the shallow depth of the setting. In the creation of this obviously personal image, Nutt combines crude images with precise craftsmanship and exciting theatricality.

Nutt has been developing his strange characters since he first exhibited in 1966 with four other young Chicago artists, known as The Hairy Who. The group exhibited together at the Hyde Park Art Center until 1968. Singular images—mutilated, grotesque, and often vulgar—characterized Nutt's paintings on acrylic sheeting. Eventually, he began to depict a multitude of figures in small theatrical vignettes. *Please!—This Is Important* is a good example. The influence of comic strips and primitive art are evident, as well as the work of Karl Wirshum, one of the original Hairy Who members.

By placing his images in frames, Nutt creates "objects." His early work has more extremes of violence than his later and current work. A symbolic eroticism is also often present. At times his characters interact with one another and at other times they act independently to create separate dramas simultaneously. Nutt's titles are intentionally ambiguous, and he does not explain the personal symbols in his paintings, thus forcing the viewer to devise personal interpretation. "The idea of an image, an evocative image ... you create something which evokes more than it is. That, I think, runs through all my work. The punch of the pieces involves a compelling or evocative image the meaning of which is not quite clear. It doesn't represent anything specifically, but the nature of the image is demanding."[110]

The elaborate inner frame of *Please!—This is Important* emphasizes the theatrical quality and space of Nutt's painting. As he included more figures in his works, he thought of the frame as a stagelike space in which they were the actors. The inner, painted frame device serves as a proscenium and offers a glimpse of the private world of a highly imaginative artist.

Provenance: Phyllis Kind Gallery, New York, 1977.
Published: Russell Bowman, "An Interview with Jim Nutt," *Arts Magazine* 52 (March 1978): 134 (illus.).
Exhibited: *The 1970's: New American Painting*: Narodni Muzej, Belgrade, June 15-July 13, 1979; Narodni Musej, Zagreb, September 5-30, 1979; Moderna Galerija, Ljubljana, Yugoslavia, October 17-November 12, 1979; Fiera della Saidengna, Cagliari, Sardinia, December 15-January 13, 1980; Galleria Civica d'Arte Moderna, Palermo, January 19-February, 18, 1980; North Jutland Museum, Copenhagen, March 20-April 20, 1980; Geodesic Dome, Nepliget Park, Budapest, May 30-June 27, 1980; Geodesic Dome, Parcul Herastran Park, Bucharest, Romania, September 1-30, 1980; Biuro Wystaw Artystycrnych Gallery, Torun, Poland, November 16-30, 1980; Ministry of Culture, Lodes, Poland, December 18-January 9, 1981; Muzeum Narodowe w Warszawie, Warsaw, January 19-February 15, 1981.

110. Russell Bowman, "An Interview with Jim Nutt," *Arts Magazine* 52/7 (March 1978): 137.

Claes Oldenburg
American (born in Sweden), 1929-

73. *Typewriter Eraser*, 1976
Aluminum, stainless steel, and ferroconcrete
 243.8 × 218.4 × 170.1 (96 × 86 × 67)
Inscribed on rear: *Typewriter Eraser Copyright 1976 Claes
Oldenburg Oldenburg* (in script) *1/3 work executed by
 Lippincott North Haven, Conn;* inscribed on base: *Typewriter
 Eraser 1976*
Virginia Museum of Fine Arts, Gift of
 Sydney and Frances Lewis, 85. 429

Flashlights, baseball bats, clothespins, typewriter erasers, electrical plugs, and baseball mitts are all common objects taken for granted. However, a 45-foot high clothespin, a 38 ½-foot-tall flashlight, or a baseball bat more than 100 feet high take on an entirely different connotation and meaning. These huge objects force us to re-examine our world and to redefine the meaning of monumental sculpture. Re-evaluation is one of Claes Oldenburg's aims.

Although born in Sweden, Oldenburg grew up in Chicago. Early in his career, he abandoned representational painting for sculpture; commonplace objects became his repertoire. Much of his work in New York in the early 60s was related to "happenings" and environments. His 1961 environment, *The Store*, included brightly painted replicas of ordinary store merchandise fashioned in plaster and chicken wire. In other related works, the common objects bore direct relationship to various bodily parts. By 1964 he had developed his famous soft sculptures, which at first mimicked industrial products as they sagged, drooped, and bent in unrealistic fashion.

Since the mid 60s, Oldenburg has designed colossal monuments, many of which exist only as plans. Commissioned for a site on West 57th Street in New York, *Typewriter Eraser* fascinated Oldenburg because of the many shapes of erasers and their relationship to the human figure. Oldenburg arrived at the final form after extensive experimentation. The eraser sits on one edge at a slight angle, its bristles slightly bent and frayed from use. "At first I didn't know how to set the thing up. . . . You don't know what is up or down on a typewriter eraser, so I could stand it on its end, on its hairs. I experimented with cardboard models in different ways of positioning it."[111] Oldenburg did a watercolor, now in the Lewis Collection, of a typewriter eraser proposed as a monument for Alcatraz Island.[112]

The final version of the *Typewriter Eraser*, completed as gallery size, not a public, colossal monument, was fabricated by the Lippincott foundry in North Haven, Connecticut, which has manufactured all of Oldenburg's large-scale works. The Lippincott engineers worked closely with the artist to translate his sketches and scale models into working drawings to produce the final sculpture.

Oldenburg's sculpture suggests several interpretations. They are tributes to everyday, common objects; anti-art statements, poking fun at self-important municipal monuments bearing little relationship to their environment; and catalysts for changing and broadening our perceptions of the familiar.

Provenance: Leo Castelli Gallery, New York, 1977.
Published: Nancy Foote, "Oldenburg's Monuments to the Sixties," *Art Forum* 15/5 (January 1977): 56 (illus.); Willi Bongard, "Wall Stocks," *Across the Board* 14/11 (November 1977): 46 (illus.).
Exhibited: *Claes Oldenburg*: Leo Castelli Gallery, New York, January 1977.

111. Martin Friedman, *Oldenburg: Six Themes* (Minneapolis: Walker Art Center, 1975), p. 71.
112. Ibid., p. 70 (illus.).

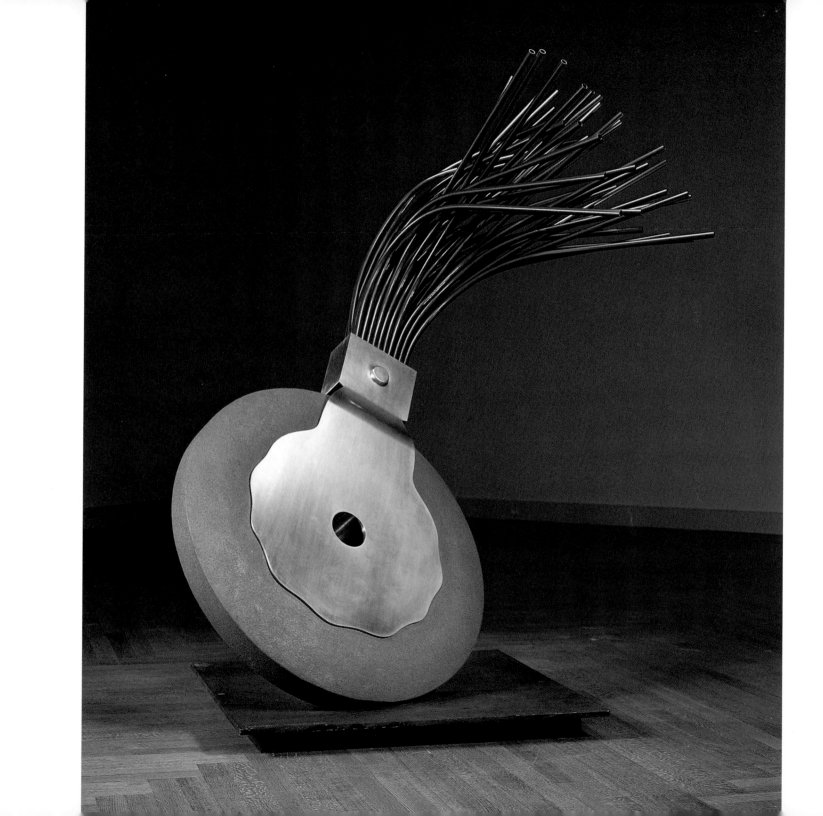

Jules Olitski
American (born in the U.S.S.R.), 1922-

74. *Isis Ardor*, 1962
Acrylic on canvas, 203.0 × 167.5 (80 × 66)
Signed on reverse: *Jules Olitski*
Virginia Museum of Fine Arts, Gift of
 Sydney and Frances Lewis, 85.430

Obsessed with pure color, Jules Olitski has attempted since the early 60s to present in his paintings the illusion of color alone. Supports or frames have no importance.

Although born in the Soviet Union, Olitski has lived in the United States almost all his life. He studied at New York University and the National Academy of Design, then studied two years in Paris under Ossip Zadkine at the Académie Grande Chaumière. In 1960 he abandoned his earlier, heavily painted work for lighter, colorful abstract paintings that were soaked and stained. The essential content of Olitski's work of this time, as in represented in *Isis Ardor*, consisted of circular shapes of color and their relationship to one another. In 1965 he produced spray paintings that brought him closer to a purer concept of color. "If only I could spray some color into the air and somehow it would remain suspended, that's what I would want. Just color by itself. I thought it was amusing and so did everyone else. But ... it occurred to me that it was a serious notion."[113]

Provenance: Poindexter Gallery, New York; Harry N. Abrams Collection, New York; Christie, Manson & Woods, New York, 1980.

Published: *Contemporary Art.* Sale catalogue, Christie, Manson & Woods, New York, May 16, 1980, no. 33 (illus.).

Exhibited: *Post-Painterly Abstraction:* Los Angeles County Museum of Art, April 23-June 7, 1964; Walker Art Center, Minneapolis, July 14-August 16, 1964; Art Gallery of Ontario, Toronto, November 20, 1964-January 3, 1965. *The Harry N. Abrams Family Collection:* The Jewish Museum, New York, June 29-September 5, 1966.

113. Valerie F. Brooks, "The Art Market: The Market For Pure Color," *ARTnews* 83/4 (April 1984): 22.

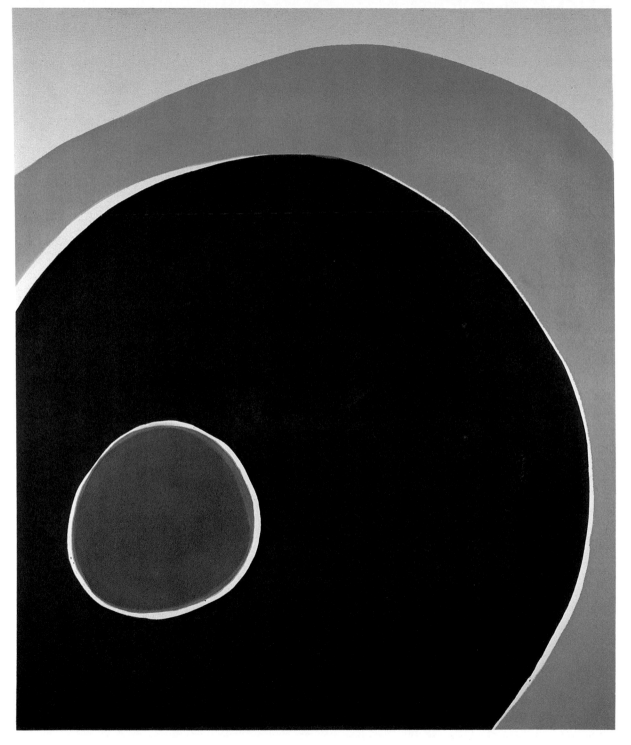

153

Edward Paschke
American, 1939-

75. *Duro-Verde*, 1978
Oil on canvas, 122.0 × 243.8 (48 × 96)
Signed lower right: *E Paschke 78*
Virginia Museum of Fine Arts, Gift of
 The Sydney and Frances Lewis Foundation, 85.431

The bizarre, garish, and often disturbing quality of fluorescent colors heightens the surrealistic effect of Edward Paschke's paintings. In addition, the facial coverings, resembling ski masks, depersonalize his figures even as their elaborate costumes give them a formal appearance. Their skin tone is unnatural, similar to that of a color television gone awry. Indeed electronics provide an important source for Paschke's images and conventions.

The circus and the theatre comprise another influence that is seen in his early works. Eerily colored and articulated objects such as shoes and accordians float across the canvases. Taken from magazines, these and other of his early images also relate to the darker side of urban life. The city at night appeals to Paschke.

In 1977 he began the series to which *Duro-Verde* belongs. In these works masked figures are shown in vibrant colors again derived from electronic images. The ghostlike persons are completely devoid of distinct human facial features. Their bizarre coloring and the background transmits an almost palpable energy.

Paschke's work has been likened to the Chicago Imagists school. His paintings derive from printed media, especially tabloids and other publications from the demi-monde of journalism. He projects his images onto the canvas and then renders them in distinctive, bright colors. The unusual images, distinctive energy, and rich colors, and allusions to violence and kinky sex have an unavoidable presence. The images are also theatrical, making them unreal. The drama of the figures in *Duro-Verde* and their interaction strengthens and raises voyeurism into fantasy.

Duro-Verde is a pivotal work in the artist's career. "The painting is significant for me because it is one of the first multiple figure compositions. It also represents a breakthrough for me in the use of complex light sources and the implications of narrative gestures."[114]

Provenance: Phyllis Kind Gallery, New York, 1978.
Published: Brandt and Butler, *Late Twentieth Century Art*, p. 51, no. 45 (illus.); Russell Bowman, "Ed Paschke," *Arts Magazine* 53/2 (October 1978): 14 (illus.).
Exhibited: *Late Twentieth-Century Art From The Sydney and Frances Lewis Foundation Collection*: The Anderson Gallery, Virginia Commonwealth University, Richmond, December 5,1978-January 8, 1979; Institute of Contemporary Art, University of Pennsylvania, Philadelphia, March 22-May 2, 1979; Brooks Memorial Art Gallery, Memphis, December 2, 1979-January 27, 1980; Dupont Gallery, Washington and Lee University, Lexington, Virginia, February 18-March 21, 1980; The Toledo Museum of Art, Toledo, September 21-November 9, 1980; Madison Art Center, Madison, Wisconsin, November 23, 1980-January 18, 1981; Edna Carlsten Gallery, University of Wisconsin-Stephens Point, January 27-March 15, 1981; Ulrich Museum, Wichita State University, Wichita, April 1-May 31, 1981; Morehead State University, Morehead, Kentucky, August 31-October 16, 1981; Museum of Art, Columbia, South Carolina, November 15, 1981-January 10, 1982; Mississippi Museum of Art, Jackson, January 31-March 14, 1982; University of Tennessee, Knoxville, March 28-May 30, 1982; Worcester Art Museum, Worcester, Massachusetts, September 10-October 31, 1982; Allentown Art Museum, Allentown, Pennsylvania, November 14, 1982-January 16, 1983; University Memorial Gallery, University of Rochester, Rochester, January 30-March 13, 1983; Everson Museum of Art, Syracuse, New York, March 25-May 29, 1983; Randolph-Macon Woman's College, Lynchburg, Virginia, November 6-December 17, 1983; Huntington Galleries, Huntington, West Virginia, June 2-August 18,.1984; Piedmont Arts Association, Martinsville, Virginia, February 27-March 27, 1985; Peninsula Fine Arts Center, Newport News, Virginia, April 5-May 1, 1985; The Athenaeum, Alexandria, Virginia, May 7-June 2, 1985.

114. Letter, dated October 25, 1984, from the artist to the author. The letter is part of the Lewis Foundation archives in the Department of 20th-Century Art, Virginia Museum of Fine Arts.

Philip Pearlstein
American, 1924-

76. *Two Female Models Reclining on a Cast-Iron Bed*, 1976
Oil on canvas, 182.8 × 182.8 (72 × 72)
Signed lower right: *Pearlstein '76*
Virginia Museum of Fine Arts, Gift of
 Sydney and Frances Lewis, 85.432

Since 1960 Philip Pearlstein has painted the nude female figure with an unrelenting realism. He depicts precisely what he sees before him, not allowing psychological or emotional symbolism to intrude. Despite the imagery, no sexuality or eroticism exists. Each composition is an exploration of the limitless, formal problems presented by the human body.

Pearlstein received national awards for his paintings while still in high school. After studying at the Carnegie Institute of Technology, he served in the Army and was stationed in Italy during World War II. He returned to Pittsburgh, where he designed industrial supplies and continued his studies at the Carnegie Institute. In 1949 he moved to New York to become a graphic designer and enrolled as a graduate student at New York University. His paintings during this time have an abstract quality and an Abstract Expressionist brushstroke. In 1962 he began painting directly from models. "I chose the artist's model, the naked person, as a subject of my re-education as a painter because of convenience.

It is a self-contained subject, offering forms of great complexity ever varying in their relationships, readily available in great variety. My selection of models has been dependent only on their willingness to come to my studio on schedule over a long period of time."[115] He applied what he had previously learned from abstract painting to representational painting.

Often possessing oblique angles thrusting back into the space of the canvas, Pearlstein's compositions are dense and complex. The interrelationship of the forms (if more than one figure is present) and their relationship to the studio furniture impart complexity. Pearlstein's works are large, often monumental, and drastic cropping increases the tension.

The nudes are usually painted in restrained colors. They are not the idealized sensual figures of men's magazines, but everyday persons, often wrinkled or overweight. He depicts old and young women. Through a complex system of lighting, Pearlstein carefully manipulates his images through light and dark and overlapping shadows.

Provenance: Allan Frumkin Gallery, New York, 1977.
Published: *Philip Pearlstein: A Retrospective* (New York: Alpine Fine Arts for the Milwaukee Art Museum, 1983), pp. 194–95, no. 86 (illus.); Thomas Styron, *American Figure Painting 1950-80* (Norfolk: Chrysler Museum, 1980), p. 86 (illus.).
Exhibited: *Representations of America*: Pushkin Museum, Moscow, December 15, 1977-February 15, 1978; Hermitage Museum, Leningrad, March 15-May 15, 1978; Palace of Art, Minsk, July 15-August 15, 1978. *American Figure Painting 1950-80*: Chrysler Museum, Norfolk, October 16-November 30, 1980. *Philip Pearlstein: A Retrospective*: Milwaukee Art Museum, Milwaukee, April 19-June 19, 1983; Brooklyn Museum, Brooklyn, July 14-September 15, 1983; The Pennsylvania Academy of Fine Arts, Philadelphia, December 15-February 26, 1984; Toledo Museum of Art, Toledo, March 18-April 29, 1984; The Carnegie Institute, Pittsburgh, May 19-July 15, 1984.

115. As quoted by Russell Bowman in "A Realist Artist in an Abstract World," *Philip Pearlstein: A Retrospective* (New York: Alpine Fine Arts Collection, 1983), p. 13.

157

Robert Rauschenberg
American, 1925-

77. *Coexistence*, 1961
Oil, fabric, metal, wood on canvas, 152.4 × 106.7 × 35.0
 (60 × 42 × 13¾)
Unsigned
Virginia Museum of Fine Arts, Gift of
 The Sydney and Frances Lewis Foundation, 85.433

Robert Rauschenberg is one of the most versatile and imaginative American artists to appear after World War II. Avoiding the traditional methods and theories of his colleagues, Rauschenberg has brought an unparalleled intellectual concept to painting, sculpture, theatre, and performance. Along with Jasper Johns, he directed the trend away from Abstract Expressionism, which had dominated American painting in the 40s and 50s, and influenced the return to the object and regard for the representational image. This renewed interest in representational works led eventually to Pop Art and New Realism.

Rauschenberg studied at the Kansas City Art Institute in 1947. In the following year, he enrolled in the Académie Julian in Paris. He studied next under Josef Albers in 1949 at Black Mountain College in Asheville and later at the Arts Student League in New York. For several years, he worked on a part-time basis designing department store window displays. In 1951 he had his first one-man show at the Betty Parsons Gallery in New York. At this time Rauschenberg became friends with the composer John Cage and dance-choreographer Merce Cunningham with whom he later collaborated in performance pieces and both set and costume designs for various dances. During the early 50s Rauschenberg developed his first major series of paintings. The works were either white, black, or red, and he achieved an Abstract Expressionist texture by applying the colors over collaged materials. Later, collage became the most important element, the paint being secondary. Between 1953 and 1955, while in New York, he developed what he called his "combine-paintings," which continued into the early 60s and which comprise the most important part of Rauschenberg's work.

He took seemingly unrelated three-dimensional objects and worked them into compositions, attaching them to the canvas plane in a manner not seen before. The relation of these objects to each other, to the paint and collage materials, and to the canvas plane create a totally different context, causing the objects to lose their identity and to take on an entirely new meaning. *Coexistence* is one of the last combines. The title is, typically, not simply a label for the combination of objects. It is purposefully left obscure and enigmatic. For his vaguely cross-shaped composition, Rauschenberg spans the longitudinal axis and part of the left side of the horizontal with a rusted metal fragment. To complete the left side and to form the right he uses other objects, among them a baton. From the bottom of the rusted metal piece on the long axis hangs a rag, and crossing the same piece at the top, running from central right to the upper left corner, is a police barricade segment. Rauschenberg has daubed on the upper left a patch of yellow paint, the color of a traffic caution sign. Both the yellow and the barricade-diagonal direct our attention to the extreme upper left corner where a rectangular and horizontal object juts out from the canvas and forms the support from which a small leather bag hangs. The three-dimensionality of the picture is expressed not only through the addition of the "real" elements of metal, rags, and wood, but also is extended past the boundary of the picture frame by the addition of the leather pouch and the rag. By interpreting the shattered police barricade as a symbol of violence and the red, white, and blue baton as an image of docility (drum majorettes?), the two elements "coexist."

For the last twenty years Rauschenberg has continued to experiment with painting, sculpture, printmaking, and collage. In addition to designing sets and costumes for theater productions, he has also actively participated as a performer. Recognized as one of the leading artists of our time, Rauschenberg has been honored by numerous museum exhibitions both in the United States and abroad.

Provenance: Leo Castelli Gallery, New York; private European collection; Christie, Manson & Woods, New York, 1981.
Published: *Robert Rauschenberg* (New York: The Jewish Museum, 1963), no. 38 (illus.); *Leo Castelli: Ten Years* (New York: Leo Castelli, 1967), unpaginated (illus.); Sam Hunter, *American Art of the 20th Century* (New York: Harry N. Abrams 1972), p. 263, no. 489, (illus.); *Contemporary Art*, Sale catalogue, Christie, Manson & Woods, New York, May 13, 1981, no. 47 (illus.)
Exhibited: *Robert Rauschenberg*: Leo Castelli Gallery, New York, November-December 1961. *Robert Rauschenberg*: The Jewish Museum, New York, April 1963.

Ad Reinhardt
American, 1913-1967

78. *Red Painting, 1952*, 1952
Oil on canvas, 152.5 × 203.0 (60 × 82)
Signed on reverse, upper right: *Ad Reinhardt Red Painting
1952*
Virginia Museum of Fine Arts, Gift of
Sydney and Frances Lewis, 85.434

Ad Reinhardt, a teacher as well as an artist, was a highly educated and especially articulate spokesman for the style of geometric abstract painting that he practiced throughout his entire professional career. He taught at Brooklyn College, Hunter College, Yale University, and the California School of Fine Arts in San Francisco. During his lifetime he was honored with numerous one-man exhibitions both in galleries and museums, and ultimately with a major retrospective at the Jewish Museum in 1966.

Red Painting, 1952 is aptly titled. Reinhardt's reductivist approach to painting, like Jules Olitski's, involved pure color. Emotional response or narrative content have no place in his work. Color alone is important. By skillful and subtle changes in the tonality of single color, Reinhardt creates a series of rectangles interacting to form a larger rectangle, which is the most significant element of the painting. The appearance of the artist's hand is minimal.

Much of Reinhardt's work is related to Eastern philosophies, as seen in its sense of rest, space, void, reiteration, elegance, and delicacy. It is also the legacy of the De Stijl and Constructivist painters of the early twentieth century. Reinhardt is the predecessor of the Minimalist philosophies and creations, especially the "cool" art of the 60s and 70s. Serving to reaffirm much of Reinhardt's philosophy of content, a reductive

mode appears in his work at the time when Abstract Expressionism and the artist's gesture were uppermost. Nonetheless, Reinhardt was diametrically opposed to the techniques of the New York School or Abstract Expressionists, while serving as a spokesman for abstract painting.

Reinhardt's bold but cool chromatic studies of the 1950s eventually led to the development of his famous black paintings, in which he not only reduced the form to minimal, geometric shapes but also simplified the color to varying tonalities of black. He thereby reaffirms his reductivist philosophy by keeping art to its simplest component. His works are indeed "ultimate paintings," as Reinhardt once called them.[116]

Provenance: Betty Parsons Gallery, New York; Estate of Ad Reinhardt, New York; Marlborough Gallery, New York; Mr. and Mrs. Sidney Kohl, Milwaukee; Christie, Manson & Woods, New York, 1979.

Published: Fred W. McDarrah, *The Artist's World in Pictures* (New York, 1961), p. 173 (illus.); Henry Geldzahler, *New York Painting and Sculpture: 1940-1970* (New York: E.P. Dutton, 1969), p. 102, no. 330 (illus.); Sam Hunter, *American Art of the 20th Century* (New York: Harry N. Abrams, 1972), p. 102, no. 336 (illus.); Jürgen Harten and Katharina Schmidt, *Ad Reinhardt* (Dusseldorf: Städtische Kunsthalle, 1972), p. 71, no. 46 (illus.); Lambert Tegenbosch and Dale McConathy, ed. *Ad Reinhardt* (Eindhoven, The Netherlands: Stedelijk Van Abbe Museum, 1972), no. 46 (illus.); Dale McConathy, *Ad Reinhardt: A Selection from 1937 to 1952* (New York: Marlborough Gallery, 1974), no. 54 (illus.); Lucy R. Lippard, "Ad Reinhardt: One Work," *Art in America* 62/6 (November-December 1974): 100 (illus.); Harold Spencer, *The Image Maker* (New York: Charles Scribner's Sons,

1975), p. 660, pl. 30 (illus.); *Contemporary Art.* Sale catalogue, Christie, Manson & Woods, New York, November 9, 1979, pp. 44-5, no. 19 (illus.); Margit Rowell, *Ad Reinhardt and Color* (New York: The Solomon R. Guggenheim Museum, 1979), pp. 40-41; Tom Armstrong, *Amerikanische Malerei 1930-1980* (Munich: Haus der Kunst und Prestel-Verlag, 1981), p. 72 (illus.).

Exhibited: *Ad Reinhardt*: Betty Parsons Gallery, New York, December 1953. *The New Decade—35 American Painters and Sculptors*: Whitney Museum of American Art, New York, May 11-August 7, 1955; San Francisco Museum of Art, San Francisco, October 6-November 6, 1955; Los Angeles Art Gallery, University of California, Los Angeles, November 20, 1955-January 7, 1956; Colorado Springs Fine Arts Center, Colorado Springs, February 9-March 20, 1956; City Museum of St. Louis, St. Louis, April 15-May 15, 1956. *Ad Reinhardt*: Graham Gallery, New York, March 1965. *The Responsive Eye*: Museum of Modern Art, New York, February 23-April 25, 1965; City Art Museum of St. Louis, St. Louis, May 20-June 20, 1965; Seattle Art Museum, Seattle, July 15-August 23, 1965; Pasadena Art Museum, Pasadena, September 25-November 7, 1965; The Baltimore Museum of Art, Baltimore, December 14, 1965-January 23, 1966. *New York Painting and Sculpture: 1940-1970*: Metropolitan Museum of Art, New York, October, 1969-February 1970. *Ad Reinhardt*: Städtische Kunsthalle, Dusseldorf, September 15-October 15, 1972; Stedelijk Van Abbe Museum, Eindhoven, The Netherlands, December 15, 1972-January 28, 1973; Kunsthaus, Zurich, February 11-March 18, 1973; Galeries Nationales du Grand Palais, Paris; Museum des 20 Jahrhunderts, Vienna, July 18-August 28, 1973. *Ad Reinhardt—A Selection from 1937 to 1952*: Marlborough Gallery, New York, March 1974. *Ad Reinhardt and Color*: The Solomon R. Guggenheim Museum, New York, January 10-March 9, 1980. *Amerikanische Malerei 1930-1980*: Haus der Kunst, Munich, November 14, 1981-January 31, 1982.

116. See Margit Rowell, *Ad Reinhardt and Color* (New York: The Solomon R. Guggenheim Museum, New York, 1980), p. 22.

Larry Rivers
American, 1923-

79. *Portrait of Daniel Webster on a Flesh Field, II*, 1975
Acrylic on canvas, 188.0 × 203.2 (74 × 80)
Signed, lower left: *Larry Rivers '79*
Virginia Museum of Fine Arts, Gift of
 Sydney and Frances Lewis, 85.435

In 1945 Larry Rivers began painting and studied with Hans Hofmann, eventually receiving his B. A. from New York University. Since the end of the 40s he has had many one-man shows in galleries and museums in the United States and abroad.

This work was first displayed in *Recent Works/Golden Oldies*, a one-person show at the Marlborough Gallery in New York. Many other works in the show also contained subject matter for which Rivers had already acquired an international reputation. Hence, the humorous exhibition title. They were not merely new versions of the same subjects but variations on earlier motifs such as cigar-box lids, cigarette packs, and family photographs, brought up-to-date through his then current stylistic treatment.

"What I'm doing," Rivers has said, "is taking subjects that became popular and identified with me and looking at them in the light of how I'm painting today."[117]

Rivers's usual technique involves production of a number of smaller studies in different media as referential material. His "trademarks" are quite evident in *Portrait of Daniel Webster on a Flesh Field, II*: muted tones of blacks, grays, browns and roses; incomplete and overlapping images; precisely painted segments contrasting with dramatic brushwork related to his earlier Abstract Expressionist paintings; stenciled letters associated with the Pop Art movement and finally, masterful draftsmanship.

Provenance: Marlborough Gallery, New York, 1979.
Published: *Larry Rivers: Recent Works/Golden Oldies* (New York: Marlborough Gallery 1979), p. 13, no. 22 (illus.).
Exhibited: *Larry Rivers: Recent Works/Golden Oldies*: Marlborough Gallery, New York, October 12-November 9, 1979.

117. John Ashbery, "Of Time and Rivers," *New York*, 29 October 1979, 92.

James Rosenquist
American, 1933-

80. *Early in the Morning*, 1963
Oil on canvas and plastic, 241.3 × 142.24 (95 × 56)
Signed on back: *James Rosenquist 1963*
Virginia Museum of Fine Arts, Gift of
 Sydney and Frances Lewis, 85.436.1/2

Style, technique, and imagery are often directly related to the artist's education, training, and environment. These influences are found in the work of James Rosenquist. Rosenquist's large, fragmented images of familiar objects and people are a direct reflection of his work as a billboard painter in New York's Times Square from 1958 to 1960. For billboards to be seen from a distance, they must be of huge scale, but the painter can visualize only one section at a time because of his proximity to the working area. This influence on Rosenquist's work is readily apparent in his large, monumental images, which are often fragmented and juxtaposed in seemingly unrelated circumstances.

Perhaps because of the familiar objects that Rosenquist uses as images, he has been grouped with the Pop artists of the 1960s. The validity of this comparison is questionable because Rosenquist uses everyday objects as symbols, not as images for veneration.

With its juxtaposition of sky, sliced orange, striding legs, and pocket comb, *Early in the Morning* is a typical work of Rosenquist's mature period. Because these images have been abruptly cropped, the image must be mentally completed outside of the picture plane. Some information is given. For example, the dotted circle in the orange is continued in the upper panel of the sky. However, the actual image of the orange is not. In addition, Rosenquist has applied painted plastic between the upper and lower panel to hang out over the painted teeth of the comb, adding a third dimension to the otherwise flat panel and further complicating the visual meaning of the comb.

Provenance: Green Gallery, New York; Robert C. Scull Collection, New York; Sotheby Parke-Bernet, New York, 1973.
Published: Allene Talmay, "Art is the Core," *Vogue* (July 1964): 118 (illus.); *The 1965 Pittsburgh International Exhibition of Con-*temporary Painting and Sculpture* (Pittsburgh: Carnegie Institute, 1965), no. 367 (illus.); Lucy R. Lippard, "James Rosenquist: Aspects of a Multiple Art," *Artforum* 4 (December 14, 1965): 44 (illus.); Henry Geldzahler, *New York Painting and Sculpture: 1940-1970* (New York: E.P. Dutton, 1969), p. 252, no. 340 (illus.); *James Rosenquist* (Ottawa: National Gallery of Canada, 1968), p. 55, no. 19 (illus.); Barbara Rose, *American Art Since 1900* (New York: Frederick A. Praeger, Inc., 1967), p. 220 (illus.); Gwen Swanson, "The Figure a Man Makes: James Rosenquist," *Art and Artists* 3/2 (May 1968): 44 (illus.); Marcia Tucker, *James Rosenquist* (New York: Whitney Museum of American Art, 1972), p. 22 (illus.); *James Rosenquist: Gemälde, Räume, Graphik* (Cologne: Wallraf-Richartz-Museum and Kunsthalle Köln, 1972), no. 37 (illus.); *A Selection of Fifty Works from the Collection of Robert C. Scull*. Sale catalogue, Sotheby Parke-Bernet, New York, October 18, 1973, no. 34 (illus.); Anna Maria Edelstein, ed., *Art at Auction, The Year at Sotheby Parke-Bernet 1973-74* (New York: Viking Press, 1974), p. 144; Judith Goldman, *James Rosenquist* (New York: Viking-Penguin, 1985), pp. 51, 112 (illus.).
Exhibited: *James Rosenquist Exhibition*: Green Gallery, New York, 1964. *Pittsburgh International Exhibition of Contemporary Painting and Sculpture*: Carnegie Institute, Pittsburgh, October 1964-January 1965. *James Rosenquist*: National Gallery of Canada, Ottawa, January-March 1968. *Painting & Sculpture: 1940-1970*: Metropolitan Museum of Art, New York, 1969. *James Rosenquist, 1972*: Whitney Museum of American Art, New York, April 12-May 19, 1972. Stedelijk Museum, Amsterdam; Wallraf-Richartz-Museum, Cologne, January 29-March 12, 1972.

Susan Rothenburg
American, 1945-

81. Untitled, 1980-81
Acrylic and vinyl on canvas, 289.6 × 289.6 (114 × 114)
Signed on reverse, center: *Susan Rothenberg*
 1980-1981 Head (Blue)
Virginia Museum of Fine Arts, Gift of
 The Sydney and Frances Lewis Foundation, 85.437

This untitled painting is one of five works that Susan Rothenberg completed as a single project in 1980 and 1981. Shown both in New York and Europe, these five paintings received great acclaim.

Rothenberg received her B.F.A. in 1966 from Cornell University, then studied at George Washington University and the Corcoran Gallery School, both in Washington, D.C. She currently works in New York.

For several years Rothenberg used only horse imagery in her work. She explains, "The interest in the horse image is because it divides right. Each half can hold its own, and I can get as much weight out of the back half as I can from the head half. It is important that on each side of the middle line there is good, solid form. Where divisions become more complex, it is a matter of making certain that each section has individual solidarity as well as a working contribution to the wholeness."[118]

She has abandoned such imagery in recent works for images that resemble heads and hands. The ghostlike specter of the face dominates the composition here but is equally a part of the overlapping hand. The vibrant quality of the paint surrounding the hand and the face gives it a sense of real space. Thus the floating quality of the images adds to the ethereal aspect of the whole.

Rothenberg has not divided this work with diagonal or vertical lines, as in her earlier paintings, which forced horse images to take various shapes in their spatial relationship to the geometric compositions. Here the head and the hand struggle for dominance without being forced to conform to any given space by the use of lines. Peter Schjeldahl has written of Rothenberg's work, "What distinguished them from other expressionists' art is the uncanny, disembodied control that rules their flurried strokes, the minute adjustments and impactions of their

violence—as if hysteria could be fine-tuned. Furthermore, the crude, glowering, panicky images are dumped right in the viewer's face."[119]

Provenance: Willard Gallery, New York, 1981.
Published: Brandt and Butler, *Late Twentieth Century Art*, p. 59, no. 51 (illus.).
Exhibited: *Susan Rothenberg*: Kunsthalle, Basel, October 3-November 15, 1981; Frankfurter Kunstverein, Frankfurt, December 18, 1981-January 31, 1982; Louisiana Museum of Modern Art, Humlebeck, Denmark, March 13-June 2, 1982; Stedelijk Museum, Amsterdam, October 14-November 28, 1982. *Late Twentieth-Century Art from the Sydney and Frances Lewis Foundation Collection*: Everson Museum of Art, Syracuse, New York, March 25-May 29, 1983; Randolph-Macon Woman's College, Lynchburg, Virginia, November 6-December 17, 1983; Muscarelle Museum, College of William and Mary, Williamsburg, February 4-April 14, 1984; Huntington Galleries, Huntington, West Virginia, June 2-August 18, 1984.

118. As quoted by Richard Marshall in *New Image Painting* (New York: Whitney Museum of American Art, 1978), p. 56.
119. Peter Schjeldahl, "Bravery in Action," *The Village Voice*, 29-April-5 May 1981.

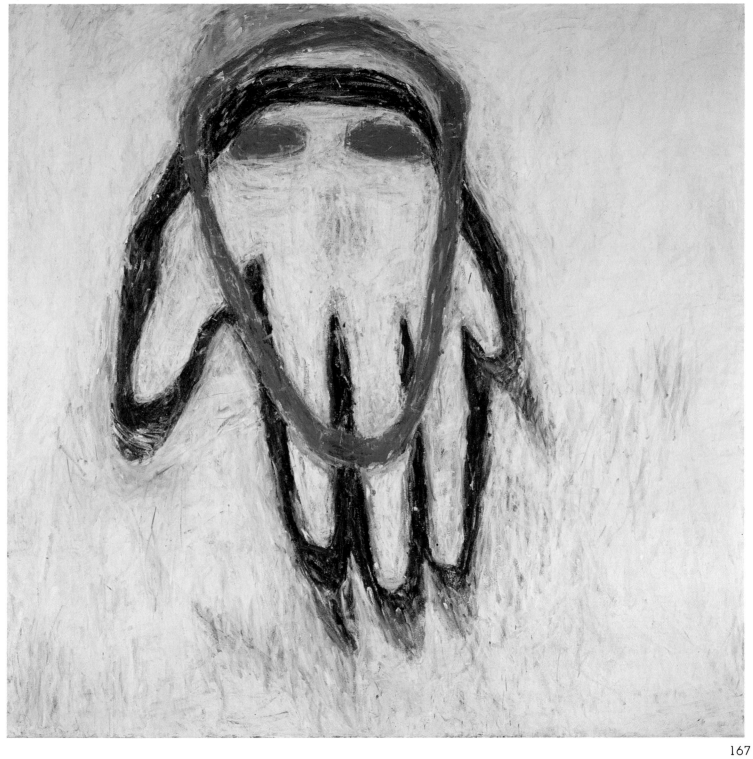

Mark Rothko
American (born in the U.S.S.R), 1903-1970

82. Untitled, 1960
Oil on canvas, 202 × 176 (79½ × 69¼)
Signed on reverse, upper left: *Mark Rothko 1960*
Virginia Museum of Fine Arts, Gift of
 Sydney and Frances Lewis, 85.438

From around 1949 until his death in 1970, Mark Rothko was preoccupied with the substance of color. In characteristically large paintings composed of related rectangular masses of color, he continually explored his experiences. His paintings became increasingly darker and tragic, often revealing a preoccupation with death.

Rothko emigrated to the United States from the Soviet Union in 1913, settling in Portland, Oregon. He studied at Yale University and, after moving to New York, attended the Arts Students League, where he studied under Max Weber. His early work is representational and shows the influence of Milton Avery, Weber, and the Surrealists. The exploration of Surrealist themes continued in the works of the 40s, as did his interpretations of Freudian philosophy and psychology. His work becomes increasingly abstract until the representational imagery disappears completely in favor of rectangles of saturated color. This mode continued for almost two decades.

Critics likened the abstract works of Rothko's mature style to those of the Abstract Expressionists (the New York School), but Rothko denied the connection. "I reject (any comparison) which classifies my work as 'Action Painting'.... To classify is to embalm. Real identity is incompatible with schools and categories except by mutilation. To allude to my work as Action Painting borders on the fantastic, no matter what modifications and adjustments are made to the meaning of the word action. Action Painting is antithetical to the very look and spirit of my work. The work must be the final arbiter."[120]

This statement is typical of Rothko's attitude toward his work. He not only refused to be categorized but also had a great concern for exactly where and how his paintings would be viewed. For example, he was given a major commission for murals to be installed in the Four Seasons restaurant in the Seagram building in New York. Upon completion of the work, how-ever, he refused to turn these over to the restaurant because he felt the space was not appropriate.[121] Toward the end of his life Rothko grew increasingly introspective and his work grew darker in color and more religious in intent, and eventually fulfilling his earlier premise that subject matter should be "only tragic and time-less."[122]

Provenance: Marlborough Gallery, Zurich; Sotheby, Parke-Bernet, New York, 1977.
Published: *Contemporary Art.* Sale catalogue, Sotheby Parke-Bernet, New York, May 12-13, 1977, no. 423 (illus.).
Exhibited: *Rothko*: Musée Nationale d'art Moderne, Centre Georges Pompidou, Paris, March 23-May 8, 1972.

120. Letter to the editor in *ARTnews* 56/8 (1958), as quoted by Diane Waldman in *Mark Rothko, 1903-1970: A Retrospective* (New York: The Solomon R. Guggenheim Museum, 1978), p. 276. Rothko was referring to Elaine de Kooning's article "Two Americans in Action" in *ARTnews Annual* 1958.
121. Waldman, *Mark Rothko*, p. 65.
122. As quoted by Eugene C. Goosen in "Mark Rothko," *The Britannica Encyclopedia of American Art*, p. 486.

Edward Ruscha
American, 1937-

83. *Noise, Pencil, Broken Pencil, Cheap Western*, 1963
Oil on canvas, 181.0 × 170.0 (71¼ × 67)
Signed on strip on reverse: *1963 E. Ruscha*
Virginia Museum of Fine Arts, Gift of
 Sydney and Frances Lewis, 85.439

Words are important subjects to Edward Ruscha, often becoming the primary content of his work. In *Noise, Pencil, Broken Pencil, Cheap Western*, the word becomes the image the noise might create. Ruscha sometimes combines words with symbols of California, particularly of Hollywood, as in his painting *Large Trademark with Eight Spotlights* (1962), where he depicts the Twentieth Century Fox logo in an exaggerated perspective. In the large screen print *Hollywood* (1968), Ruscha elicits many associations and images by his carefully drawn sign.

Southern California is an essential force in Ruscha's work. Upon his graduation from high school in 1956, he enrolled at the Chouinard Art Institute in Los Angeles. In 1960 he worked as a commercial artist, and in the following year he moved to Europe where he traveled, photographed, and completed small works incorporating words and photographs. Upon his return to the United States, his work was included in important exhibitions organized throughout California. At this time he also worked on major lithographs and completed *Large Trademark with Eight Spotlights*.

During his career Ruscha has published a number of books of photographs that document his travels and his interests in urban imagery. These include *Twenty-six Gasoline Stations, Some Los Angeles Apartments, Every Building on the Sunset Strip, Thirty-four Parking Lots in Los Angeles, Nine Swimming Pools*, and *A Broken Glass*. He has also experimented extensively with small works in nontraditional media. For example, he has used spinach, egg yolk, fruit stains, blood, shellac, zinc oxide, lettuce, and carrot juice, in combination with the traditional media of oil paint and pastel.

Noise, Pencil, Broken Pencil, Cheap Western can be linked with the Pop Art movement primarily because of its familiar imagery and broad planes of color painted as precious objects. By his inclusion of the word *noise* and the breaking of the pencil, however, Ruscha adds a conceptual essence to the painting that is not normally found in Pop Art. The pencils and the Western are not juxtaposed but exist as separate symbols. Any connection between the two is interpretative. Ruscha has claimed that this is his "best painting, for the following reasons: 1) it embodies all the issues in the works done since. 2) it is a technical success because of the use of wax mixed into the pigments. 3) in completing the painting I recall being completely awestruck and overwhelmed."[123]

Provenance: Ferrus Gallery, Los Angeles; Mr. and Mrs. Thomas G. Terbell, Jr. Collection, Pasadena; Locksley-Shea Gallery, Minneapolis; Christie, Manson & Woods, New York, 1979.
Published: Lawrence Alloway, *American Pop Art* (New York: Collier Books, 1974), pl. 3 (illus.); *Contemporary Art*. Sale catalogue, New York, May 18, 1979, no. 137 (illus.); Maurice Tuchman, *Art in Los Angeles: Seventeen Artists in the Sixties* (Los Angeles: Los Angeles County Museum of Art, 1981), pp. 95-96, no. 102 (illus.).
Exhibited: *The Fellows—A Selection*: Pasadena Art Museum, March-April 1969. *West Coast (1945-69)*: Pasadena Art Museum, November 1969-January 1970. *Pop Art*: Whitney Museum of American Art, New York, April 5-June 14, 1974. *Art in Los Angeles: Seventeen Artists in the Sixties*: Los Angeles County Museum of Art, July-October 1981; San Antonio Museum of Art, November 20, 1981-January 31, 1982.

123. Letter, dated October 22, 1984, from the artist to the author. The letter is now part of the Lewis Collection archives, Virginia Museum of Fine Arts.

David Salle
American, 1952-

84. *Goodbye D*, 1982
Acrylic on canvas, 284.4 × 218.4 (112 × 86)
Unsigned
Virginia Museum of Fine Arts, Gift of
 The Sydney and Frances Lewis Foundation, 85.440

In the few years he has been exhibiting, David Salle has received the extremes of critical comment. Sometimes accused of making derivative, sexist, and even pornographic work, he also has been lauded for his enigmatic combination of images with the philosophies of conceptual and minimal art.[124]

Salle has been involved in art for most of his life. Growing up in Wichita, he was encouraged by his parents through private tuition. He later received both his bachelor's and master's degrees from the California Institute of the Arts in San Francisco. The emphasis on conceptual art at the Institute was an important influence in his early work. In 1975 he moved to New York, where he exhibited large works on paper and created installations.

Since 1979, Salle has produced a large number of single- and multi-panel paintings consisting of a stained ground upon which he superimposes various images, often in a grisaille tonality.

Often there is no logical connection between the layering of images. Many of his earlier images derive from basic anatomical drawing books or from photographs from men's magazines. In fact, he worked for such a magazine during his early years in New York. Some of Salle's works are autobiographical. *Goodbye D* was painted during his separation from his wife, Diane. On a harsh, red-stained ground, Salle has superimposed two female images, one bikini-clad, the other nude. They meet on what appears to be a beach, and their interaction does not evoke confrontation. The ground color, the superimposed and expressionistically painted mass, and the half-kneeling nude figure, however, all convey emotion and drama to what is undoubtedly a very emotional statement by the artist about the ending of a relationship. The large-lettered title *Goodbye D.* overwhelms the composition and adds another layer to confuse further the visual reality of the images.

Salle continues to confound and irritate, at the same time bringing a visual excitement to his own personal statements. "People always want to look at my work as some mildly irritating stratagem. That's not how I see it. That kind of thing never had anything to do with good painting . . . my desire is to make work that couldn't have existed if I didn't make it . . . you have to transcend the situation . . . it's about grasping a moment, a feeling, and making it manifest."[125]

Provenance: Mary Boone Gallery, New York 1983.
Published: *1983 Biennial Exhibition*: Whitney Museum of American Art (New York: Whitney Museum of American Art, 1983), p. 47 (illus.); Michael Compton, ed. *New Art* (London: Tate Gallery, 1983), pp. 54, 71 (illus.).
Exhibited: *1983 Biennial Exhibition*: Whitney Museum of American Art, New York, March 24-May 29, 1983. *New Art*: Tate Gallery, London, September 14-October 23, 1983.

124. See Gerald Marzorati, "The Artful Dodger," *ARTnews* 83/6 (Summer 1984): 47-55.
125. Ibid., p. 55.

Lucas Samaras
American (born in Greece), 1936-

85. *Box #89*, 1974
Mixed media, 20.3 × 33. × 25.4 (8 × 13 × 10)
Unsigned
Virginia Museum of Fine Arts, Gift of
 Sydney and Frances Lewis, 85.441

A native of Greece, Lucas Samaras moved to the United States and settled in New Jersey in 1948. While studying at Rutgers University, he met Allan Kaprow with whom he later became involved in happenings. This association and the mixture of art and theatre provided the spark for some of his future works, many of which he considers a form of theatre. Since his first exhibition in 1959, Samaras has continually evolved a wide variety of works dealing with a highly imaginative group of non-traditional and traditional materials. His bright colors in pastel, wool, and other media are characteristic and are perhaps one of the few consistent elements throughout his vast corpus.

Samaras transforms traditional objects into extraordinary works that take on entirely different meaning. Boxes, normally innocuous storage items, assume fearful aspects when covered with pins and embedded with razor blades and knives. Chairs become non-functional objects. Flowers appear as broken shards of glass or limp balls of twine.

A very personal art, much of Samaras' work is not only autobiographical but also narcisstic and involves a continuing exploration of materials, concepts, and emotions that challenge traditional values and deeply probe the psyche of the artist.

Samaras has been much involved with photographic self-portraiture. Using Polaroid SX-70 film, he carefully manipulates his pictures to create images quite different from self-portraits. In many of them the image has been mutilated and destroyed by disturbing the emulsion of the film as the picture developed.

In the late 1970s Samaras produced a remarkable group of *Reconstructions* in which he sewed together small pieces of brightly colored fabric to form vibrant, abstract patterns on a large scale. The cloth and pins of these reconstructions, his earlier boxes, and his sculpture allude to his father's profession as a cobbler and furrier and to his cousin's dress shop.

Box #89 epitomizes Samaras' work. His use of found materials, pins, and colored wool undoubtedly relate to his childhood experiences in addition to his family's shops. He says that as a child, he made many of his toys out of found materials.[126] The self-portrait photograph brings us back to the present. Encased in plastic, peering out through an overlayered grid, the self-portrait focuses our attention on the center of the box, and a cast of his thumb occupies one of the compartments. Quite apart from being containers, Samaras' boxes are mysterious objects.

Palms, pocketbooks, packets of energy, coffins, conversations, rooms. We were conceived by boxes with boxes in boxes. We live in boxes, see and eat with boxes, travel in boxes, and even our days and nights are boxes. . . .

Whatever the beauties of the box form were, suggesting architecture and all sorts of satyric psychological complications, they provided me with a geometric structure that I could re-camouflage or with a category for which I could create a geometric structure. Rather than saying I am a sculptor I could have said I was a boxer.[127]

Provenance: The Pace Gallery, New York, 1975.
Published: Cynthia Jaffee McCabe, *The Golden Door: Artist Immigrants of America, 1876-1976* (Washington, D.C.: Smithsonian Institution Press for the Hirshhorn Museum and Sculpture Garden, 1976), p. 370, no. 184 (illus.).
Exhibited: *The Golden Door: Artist Immigrants of America, 1876-1976:* Hirshhorn Museum and Sculpture Garden, Washington, D.C., May 20-October 20, 1976.

126. Barbara Rose, *Samaras Reconstructions at the Pace Gallery* (New York: The Pace Gallery, 1978), unpaginated.
127. Lucas Samaras, *Lucas Samaras* (New York: Whitney Museum of American Art, 1972), unpaginated.

Julian Schnabel
American, 1951-

86. *Understanding Self-Hate*, 1981
Oil on velvet, 3 panels: 228.6 × 640.0 (90 × 252) assembled
Signed on right panel stretcher, upper right:
 Julian Schnabel, February-1981
Virginia Museum of Fine Arts, Gift of
 Sydney and Frances Lewis, 85.442.1/3

Julian Schnabel is one of the New Wave or Neo-Expressionist painters who have recently emerged. About 1980 there was a re-emergence of art based on emotions. The cool and calculated unemotional art of the 60s and 70s (Minimalism, Conceptualism, Photo-Realism, and Pop Art) gave way to Neo-Expressionism, a worldwide phenomenon, but particularly in the work of German, Italian, and younger American painters, including Julian Schnabel.

After his graduation from the University of Texas, Schnabel moved to New York. His early work is related to Abstract Expressionism, but he claims that the influential artists are Duccio, Giotto, and Van Gogh.[128] Having had a solo exhibition in New York in 1980, Schnabel was ranked in the forefront of the international Neo-Expressionist style. Vibrant and often violent, Schnabel's work is both narrative and emotive, and it has been characterized by dynamic brushwork and the use of unusual materials such as broken crockery, antlers, wood, linoleum, and, as a ground, black velvet. The ceramic shards, vigorous brushwork, and dark palette impart violence and brutality, but the imagery is obscure. Schnabel claims that death

is a frequent subject of his thoughts and that he thinks of his paintings in terms of death.[129] Bold, expressionistic, narrative, and melodramatic, his works often have religious overtones, also a sense of destruction. *Understanding Self-Hate* is a large three-panel painting combining oil paint and collage on black velvet, a most unconventional ground. But it is just this type of unorthodoxy that Schnabel has the daring to introduce, and he manipulates his paintings in a manner that makes highly successful compositions. By leaving his imagery unclear, he mystifies and opens up the possibility of many interpretations. Schnabel denies interest in emotionalism. "My paintings are about a state of mind, a state of mindedness. . . .We have been put in a position where we have to distinguish between things which are indistinguishable; so we reached a point where we have a fuller experience of reality. . . . painting is a synonym for truth, where all the mistakes are visible."[130]

The light-absorbent capacity of the luxuriously textured velvet tends to make it disappear and to contrast sharply with the glowing radiance of the paint, bringing to them an intensity of color they would not achieve on their own. The deep

rich black of the velvet causes the overlying images of faces and the vibrant brushstrokes to float in space. The images have no connection to the ground but exist almost in front of it, projecting beyond the surface plane. Only in the far right panel where much of the velvet has been obliterated through heavily and boldly brushed paint do the ground and figure become a more homogenous unit. The ambiguity of the imagery corresponds to the complexity established by the title.

Provenance: Mary Boone Gallery, New York, 1981.
Published: Erna Donkers, *Julian Schnabel* (Amsterdam: Stedelijk Museum, 1982), no. 14 (illus.); Russell Bowman, *New Figuration in America* (Milwaukee: Milwaukee Art Museum, 1982), pp. 102-103 (illus.).
Exhibited: *Julian Schnabel*: Mary Boone Gallery, New York, April, 1981. *Julian Schnabel*: Stedelijk Museum, Amsterdam, January 28-March 14, 1982. *New Figuration in America*: Milwaukee Art Museum, Milwaukee, December 3, 1982-January 20, 1983.

128. Grace Glueck, "What One Artist's Career Tells Us of Today's Art World," *The New York Times*, 2 December 1984.
129. Cathleen McGuigan, "Julian Schnabel: I Always Knew It Would Be Like This," *ARTnews* 81 (Summer 1982): 90.
130. As quoted by Dupuy Warrick Reed in "Julian Schnabel: The Truth of the Moment," *Arts Magazine* 54 (November 1979): 86.

Ben Schonzeit
American, 1942-

87. *Split*, 1981
Oil on canvas, 243.8 × 335.3 (96 × 132)
Signed on reverse, upper right: *Split Schonzeit 81*
Virginia Museum of Fine Arts, Gift of
 The Sydney and Frances Lewis Foundation, 85.443.1/3

Ben Schonzeit is a Photo-Realist. To create his imagery, he takes photographs and rearranges them for the final composition. Working from the photograph, he uses an airbrush to paint the images and a paint brush to create abstract images for the background. In *Split*, he reversed the photograph of the horse to create a mirror-image, a technique he has used often in his recent paintings.

Of his work, Schonzeit has said, "My drawings have their own life and their own progression, from one to the other. The paintings have their progression too, independent from the draw-ings. The sum of the drawings suggest the paint-ings."[131]

The final colors of the paintings are not neces-sarily those of the original photograph. His choice of colors depends on "how you choose to see it and what you want to pull out of it and how you want to interpret it or what reality you put together in what you think reality is."[132]

Provenance: Nancy Hoffman Gallery, New York, 1981.
Published: Brandt and Butler, *Late Twentieth Century Art*, p. 61, no. 54 (illus.).
Exhibited: *Selections from The Sydney and Frances Lewis Foundation Collection:* Gibbes Art Gallery, Charleston, South Carolina, October 15 1981-January 10, 1982; Mississippi Museum of Art, Jackson, January 31-March 14, 1982; Worcester Art Museum, Worcester, Massachusetts, September 10-October 31, 1982; Allentown Art Museum, Allentown, Pennsylvania, November 14, 1982-January 16, 1983; Everson Museum of Art, Syracuse, New York, March 25-May 29, 1983; Muscarelle Museum, College of William and Mary, Williamsburg, February 4-April 14, 1984; Huntington Galleries, West Virginia, June 2-August 18, 1984; Piedmont Arts Association, Martinsville, Virginia, February 27-March 27, 1985.

131. *Real, Really, Real Super Real: Directions in Contemporary American Realism* (San Antonio: San Antonio Museum Association, 1981), p. 51.
132. Ibid.

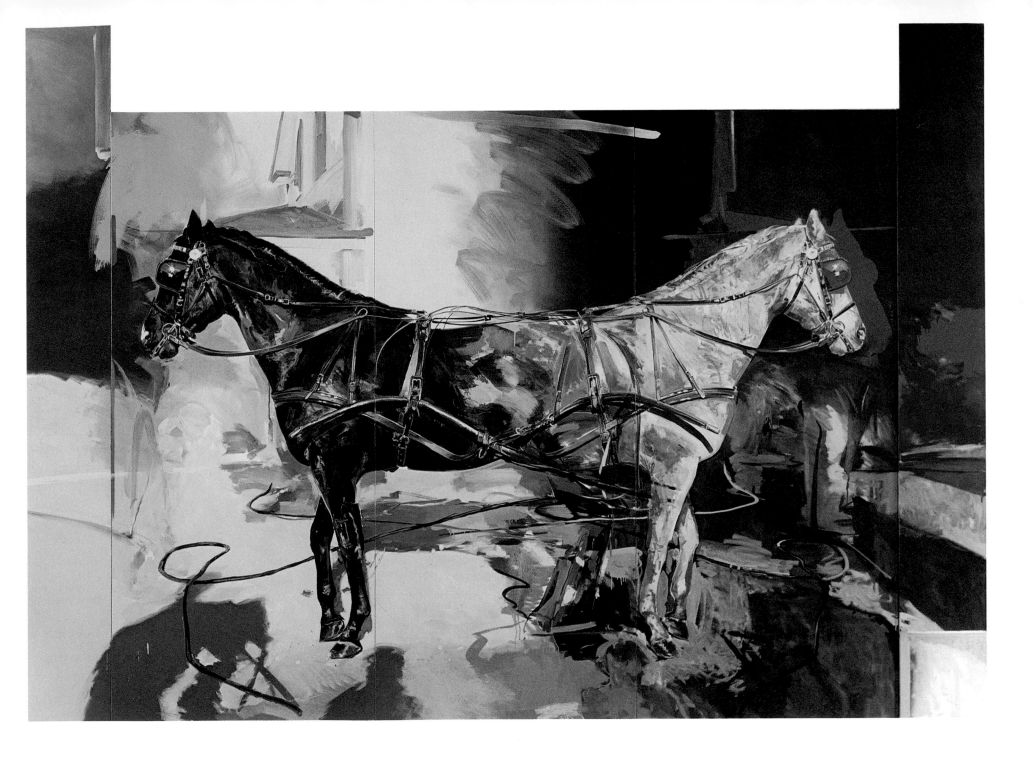

179

George Segal
American, 1924-

88. *Blue Girl on Black Bed*, 1976
Mixed media (painted plaster, wood), 111.7 × 208.3
 × 152.4 (44 × 82 × 60)
Unsigned
Virginia Museum of Fine Arts, Gift of
 Sydney and Frances Lewis, 85.444.1/2

Since 1961 George Segal has produced stark, white plaster figures through which he explores the intense isolation of human beings. Segal poses friends and models and wraps them in fast-drying plaster bandages, which he then removes and reassembles to form his rough-cast figures. The figures are then combined with real objects, to create vignettes or tableaux of life. In *Blue Girl on Black Bed*, Segal increases the emotion of the work through the addition of unrealistic color—intense blue and flat black. The reclining nude man and the bed are painted black and thus merge. The man thereby becomes an inanimate object. The female figure sitting on the edge of the bed is painted a vivid blue. She appears to be straining as if arising from the bed, but her downcast eyes and head stress immobility. The addition of color to this small vignette charges the images with an intensity not seen in Segal's white plaster figures. The use of different colors also points up the separation between the two figures. Although they may share the same bed, they are obviously two distinct personalities. The figures were modeled after two of Segal's friends, a photographer and his wife. Segal remembers "she was restless, twitchy, something seemed to be bothering her and he was in an oblivious state. I thought it was important to catch this quality, and their moods, so separate from each other's."[133]

Segal's sculptures capture his subjects in momentary action, almost as if they were stills from a movie. Their gestures, or in many cases their lack of gestures, tend to point up their personalities and experiences. Use of inanimate objects often provides a narrative, sometimes based on real life, sometimes fabrications. The separation and isolation of his figures recall the paintings of Edward Hopper, who places his figures in familiar environments, often stripped to their essentials. Unlike Hopper, Segal imparts no sense of sunlight to his subjects but a timeless light that conveys an infinite purgatory, where the figures are forced to hold their poses for an eternity.

Blue Girl on Black Bed illustrates Segal's later technique, which he refers to as "casting on the inside." His early, mummylike figures retained the roughness of the plaster bandages and the manipulation of the artist's hand as they were removed as casts from the models. In the early 70s, however, Segal changed his method to one by which he used one plaster cast to form the mold for another. The original cast had an accurate resemblance to his models' skin and clothing texture and therefore imparted a realistic surface to the inside of the mold made from the cast. The second and final figure made from the mold consequently had a smoother, more refined look in comparison with Segal's early works. Segal does not rework these second casts for even greater realism. Instead he makes use of the various faults of the plaster and thereby picks up all of the tiny details of the model's skin and clothing. The addition of real objects and environments gives a truer sense of "reality" to Segal's sculpture.

Provenance: Sidney Janis Gallery, New York, 1977.
Published: Mark Stevens, "Color Them Masters," *Newsweek* February 14, 1977, 80 (illus.); Donald P. Kuspit, "George Segal: On the Verge of Tragic Vision," *Art in America* 65/3 (May-June 1977): 85 (illus.); Martin Friedman and Graham W. J. Beal, *George Segal: Sculptures* (Minneapolis: Walker Art Center, 1978), p. 22 (illus.); Jan van der Marck, *George Segal*, rev. ed. (New York: Harry N. Abrams, 1979), pp. 222-23, fig. 161 (illus.).
Exhibited: *George Segal:* Sidney Janis Gallery, New York, February 1977. *George Segal: Sculptures:* Walker Art Center, Minneapolis, October 29, 1978-January 7, 1979; San Francisco Museum of Art, February 18-April 1, 1979; Whitney Museum of American Art, New York, May 16-July 8, 1979; *The Figure in Sculpture:* Institute of Contemporary Art, Virginia Museum of Fine Arts, Richmond, October 10-November 14, 1979.

133. George Segal quoted by Martin Friedman and Graham W. J. Beal in *George Segal: Sculptures* (Minneapolis: Walker Art Center, 1978), p. 19.

Theodoros Stamos
American, 1922-

89. *Corinth #3, Explorers of Space*, 1959
Oil on canvas, 177.8 × 203.2 (70 × 80)
Signed on reverse, upper left: *Stamos, Corinth # 3, Explorers of Space 1959*
Virginia Museum of Fine Arts, Gift of
 Sydney and Frances Lewis, 85.445

Theodoros Stamos is a first-generation Abstract Expressionist who has always relied on nature for ideas. Although Stamos was born in New York and still lives there, his work has never shown the urban influence expected from such a background.

Stamos achieved national recognition early in his career. He studied at the American Artists' School in New York and later under sculptors Simon Kennedy and Joseph Konzal. Having turned to painting, he soon became acquainted with the works of Arthur Dove, Milton Avery, and Paul Klee, and later met Arshile Gorky. Reflecting the influence of these artists, Stamos' early work also bore a close relationship to nature and surrealistically abstracted forms.

Stamos had his first one-man show in 1943 at the age of twenty-one. About this time he met Mark Rothko, Adolph Gottlieb, and Barnett Newman. Although his work was related to that of these Abstract Expressionists, Stamos turned to nature for inspiration. He studied the American Northeast coastline, particularly the shells, rocks, and other forms that characterize them. In paying tribute to his Greek heritage, he incorporated these forms into others derived from Greek mythology. Despite their abstract and non-narrative content, his paintings took titles from these myths, and their forms reflected the emotions of his ancient ancestors. In addition, the philosophies and the traditions of the Far East were of primary importance to Stamos and are reflected in his paintings in their spontaneity, spiritual harmony, abstraction, and space.[134]

His visits to Greece were also a source of inspiration, from the brilliant Mediterranean colors to the overwhelming expanses of land and sea, all immersed in the intense Greek sunlight. In a 1954 lecture he said that "... art becomes a memory picture based on past experience or on a series of such experiences."[135]

In his recent work, Stamos uses acrylic paints. He primes his canvas with acrylics because of their fast-drying quality. He works on only one painting at a time to capture the drama of the moment, since he feels that each canvas presents a different stage in mood or drama and thus requires different thoughts and techniques.

Provenance: from the artist, 1968.
Published: Wyrick, *Contemporary American Paintings*, no. 42 (illus.); Ralph Pomeroy, *Stamos* (New York: Harry N. Abrams, 1981), no. 145 (illus.).
Exhibited: *Selections from the Lewis Collection*: Richmond Artists Association Carillon Show, Richmond, March, 1969. *Selections from the Lewis Collection: 20th-Gallery Loan Exhibition*: Botetourt Gallery, Earl Gregg Swem Library, College of William and Mary, Williamsburg, April, 1970. *Contemporary American Paintings from the Lewis Collection*: Delaware Art Museum, Wilmington, September 13-October 27, 1974.

134. Kenneth B. Sawyer, *Stamos* (Paris: Editions Georges Fall, 1960), pp. 14, 20.
135. Ibid., p. 14.

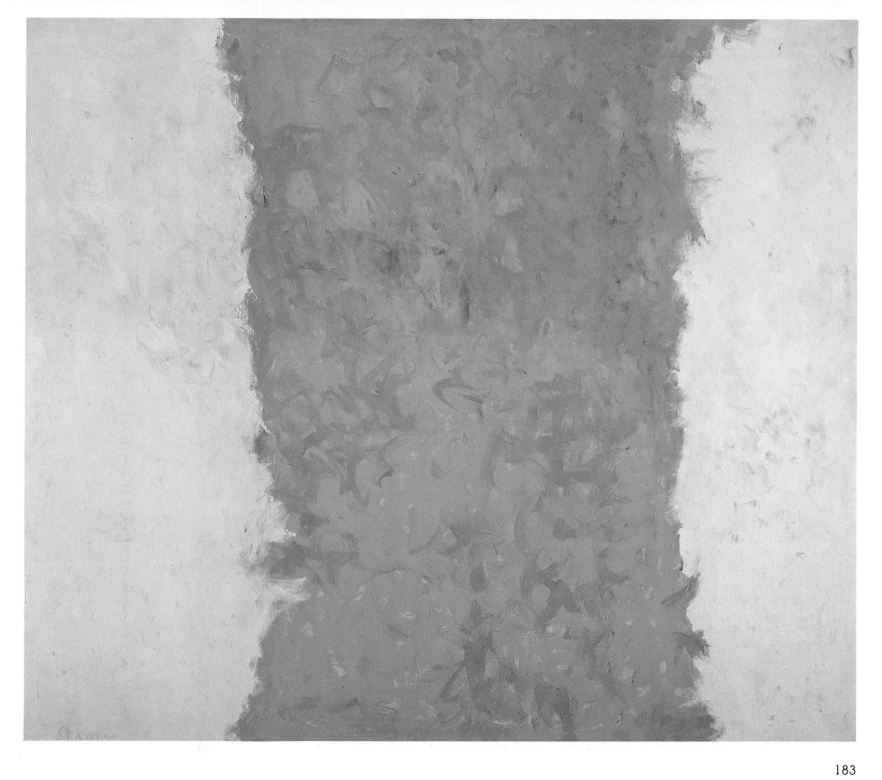

183

Richard Stankiewicz
American, 1922-1983

90. Untitled (*Big C*), #24, 1961
Iron and steel, 152.4 × 127. × 111.7 (60 × 50 × 44)
Unsigned
Virginia Museum of Fine Arts, Gift of
 Sydney and Frances Lewis, 85.446

Richard Stankiewicz created welded sculpture in the tradition of Julio Gonzalez and Pablo Picasso. Stankiewicz's work, as theirs, was witty and highly intellectual in the use of found objects.

In 1948 and 1949 Stankiewicz studied at the Hans Hofmann School of Fine Arts in Provincetown on Cape Cod, and in the following year he went to Paris to study under Ossip Zadkin. He moved to New York in 1952. "Before I came to New York (in 1952) I was in Hawaii and on the west coast and at the time I was painting more than I was sculpting. I was self-taught, but I wasn't satisfied with the reproduction of images, but had thought perhaps the idea of a bound-ary of a rectangular canvas as being a universe unto itself and that everything in that rectangle should relate somehow and I wanted to make something coherent out of this general no-tion."[136]

Upon his return to New York, he began experimenting with sculptures assembled from old machine parts and found objects.

The untitled work of 1961 is a very open work that combines a variety of pipes, small beams, angle irons, bolts, nuts, and plates to form an intricate sculptural whole in which the delicately fastened individual parts appear to float in space. When asked how he achieved the exact balance in this type of sculpture, Stankiewicz replied that he did not use a blueprint but simply welded one piece at a time in an improvisational manner, until he was fin-ished.[137]

Stankiewicz used corroded materials from the junkyard and gave them an impeccable order and design. Exuberant, vital, charming, and witty, his images sometimes evoke specific concepts of people or wildlife, and in other cases, exist as totally abstract entities.

Provenance: Zabriskie Gallery, New York, 1977.

136. Quoted by Virginia M. Zabriskie in *Richard Stankiewicz: Thirty Years Of Sculpture* (New York: Zabriskie Gallery, 1983), unpaginated.
137. Ibid.

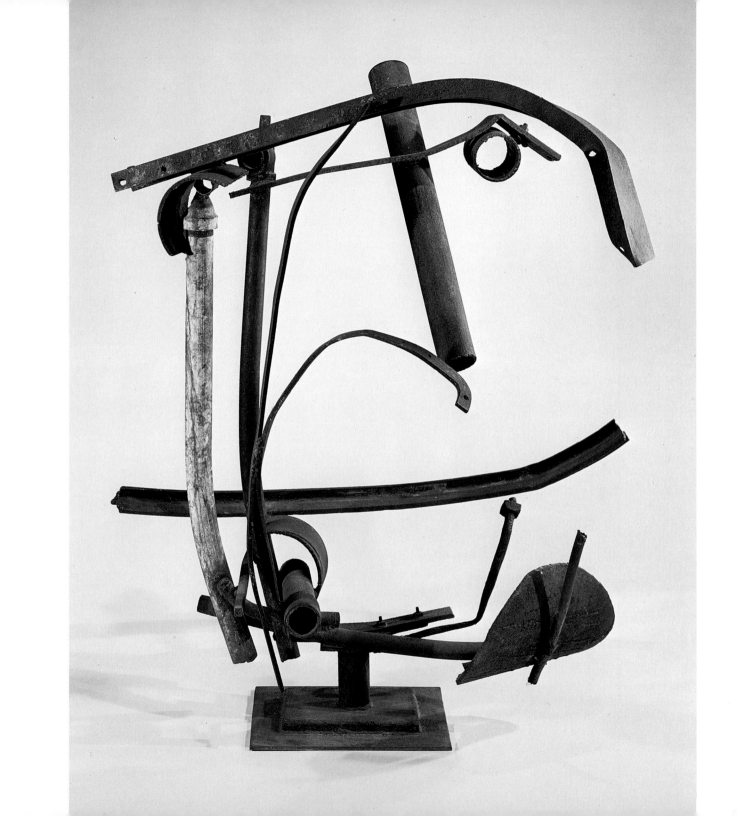

Frank Stella
American, 1936-

91. *Sinjerli Variation III*, 1968
Acrylic on canvas, 311.1 (122½) diameter
Signed on stretcher: *F. Stella, Sinjerli Variation III, 1968*
Virginia Museum of Fine Arts, Gift of
 Sydney and Frances Lewis, 85.447

Frank Stella is among the first generation of American artists to have created abstract paintings during their entire career. His predecessors all included some traces of realism before venturing into abstraction. Stella is a phenomenal artist who achieved recognition for his work soon after his graduation from college. His paintings have progressed through a number of series, the "Black Paintings," "Protractor," "Polish Village," "Brazilian," and "Exotic Bird."

In his earliest works Stella reaffirmed the flatness of the picture plane and refused to create illusionistic space. This anti-illusionism was denied, however, in his "Protractor series" of 1967-68, of which *Sinjerli Variation III* is a major part. Here, using polymer and fluorescent polymer paint, Stella structures his imagery through the repeated curves made by a protractor. As these various curves emerge and overlap one another,

some occupy a frontal space and the others merge into the illusionary space of the depth of the canvas. This illusion is intensified by the interrelationship of the colors. These curved shapes are further delineated and intensified by their outline in white and their unvarying modulation in texture.

Stella has carried this illusionism to a true three-dimensionality in his recent work. Again using forms derived from mechanical drawing instruments such as French curves, as well as from simple geometric shapes, Stella has assembled complex arrangements of brightly painted forms which literally thrust out from the wall and interrelate dimensionally. The three-dimensionality of these shapes and the use of paint has further served to break down the already thin boundaries between painting and sculpture. Through scale, optics, color, and intel-

lectually complex relationships of forms and materials, Stella has brought about a complete change in the concept of the pictorial plane.

Provenance: Leo Castelli Gallery, New York; Nelson A. Rockefeller Collection, New York; Parke-Bernet Galleries, New York, 1971.
Published: *Twentieth-Century Art from the Nelson Aldrich Rockefeller Collection* (New York: Museum of Modern Art, 1969), p. 119, no. 2 (illus.); *Important Post-War and Contemporary Art.* Sale catalogue, Parke-Bernet Galleries, New York, November 17, 1971, no. 38 (illus.); *Art at Auction 1971-1972* (New York: The Viking Press, 1972), p. 126 (illus.); Wyrick, *Contemporary American Painting*, p. 43 (illus.); William S. Lieberman, *The Nelson A. Rockefeller Collection Masterpieces of Art* (New York: Hudson Hills Press, 1981), p. 203 (illus.); *Story of America* (New York: Reader's Digest Press, 1975), p. 389 (illus. as *Sinjerli Variation I*).
Exhibited: *Twentieth-Century Art from the Nelson Aldrich Rockefeller Collection:* Museum of Modern Art, New York, May 28-September 1, 1969. *Contemporary American Painting from the Lewis Collection:* Delaware Art Museum, Wilmington, September 13-October 22, 1974.

187

Clyfford Still
American, 1904-1980

92. *1956 No. 1*, 1956
Oil on canvas, 264.1 × 236.2 (104 × 93)
Unsigned
Virginia Museum of Fine Arts, Gift of
 Sydney and Frances Lewis, 85.448

Sometimes likened to artists of the "New York School" (the Abstract Expressionists), Clyfford Still did not categorize himself as such and instead regarded himself as a visionary individual. "If at times in my personal rejection of the whole literary myth called Art History, and my determination to work out my personal and complete realization of my meaning, the imagery shows general parallels to past schools, it is of no real significance to understanding my purpose.

"I have not 'worked over' the imagery or gimmicks of the past, whether Realists, Surrealists, Expressionists, Bauhaus, Impressionists, or what you chose. I went back to my own idioms, envisioned, created and thought through and the insight gained and the momentum established altered the character of the whole concept of the practice of painting."[138]

Still grew up in Washington. He visited New York in 1925 but returned to Washington where he graduated from Spokane University and taught at Washington State College. In 1943, he moved to Richmond, where he taught at Richmond Professional Institute, now Virginia Commonwealth University, producing many works, including lithographs. In 1945, after he had moved to New York, he exhibited at Peggy Guggenheim's Art of This Century Gallery. From 1945 to 1949 he taught at the California School of Fine Arts in San Francisco and returned to New York in 1950. Thereafter, he had several important one-man exhibitions. A major retrospective of his work was held at the Albright Art Gallery, now the Albright-Knox Art Gallery, in Buffalo in 1959 and a second one at the San Francisco Museum of Modern Art in 1976. In 1979 the Metropolitan Museum of Art honored Still with an unprecedented exhibition of his work.

Developed in the 1940s and vigorously pursued throughout his career, Still's mature style featured heavy impasto paint in dramatic, vertical, jagged shapes, which set up dynamic tension between forms and their relationship to portions of bare canvas. The juxtaposition of color and form produces a rhythm in his paintings and demands that the work be looked at as a whole rather than for its individual parts. Forms interlock, producing an expansive image that seems to extend beyond the boundaries of the canvas.

Still often made careful recommendations to collectors interested in purchasing his works. In 1960 he wrote to Dr. Edgar Berman, the former owner of *1956-No.1* : "I should add a note about the painting you have. It is in reference to my choice of it for you.... It is simply to reassure you of my original intention when choosing the work and to hint at the meaning and reason behind that choice for you. I know its extensions are infinite, its exultation is without bathos or aggression, and that it will give back courage as freedom without arrogance or despair. For God knows I have had enough of what I have seen and known, so well set down by the Preacher of Ecclesiastes, of vanity and vexation of the spirit. And nowhere are they more rampant, explicit or prophetic, than the over-tensed world of the arts."[139]

Provenance: Dr. Edgar Berman Collection, Towson, Maryland; Marlborough Galleries, New York; Babette G. Cohen Fine Arts, New York, 1978.

138. Quoted in *Clyfford Still* (San Francisco: San Francisco Museum of Modern Art, 1976), p. 108.
139. Ibid., p. 123.

Wayne Thiebaud
American, 1920-

93. *Football Player*, 1963
Oil on canvas, 183.0 × 91.5 (72 × 36)
Signed upper left: *Thiebaud 1963*; on stretcher:
 Football Player 1963
Virginia Museum of Fine Arts, Gift of
 The Sydney and Frances Lewis Foundation, 85.449

A representational artist, Wayne Thiebaud has depicted landscapes, figures, and objects since the 60s when he had his first major exhibition at the Allan Stone Gallery in New York. There he showed paintings of pies, cakes, and pastries, depicted in a straightforward manner and using lush, sensuous paint. Critics equated these and the other works in the exhibition with Pop Art and saw them as social commentary.[140] Astonished, Thiebaud claimed that he had created these works as exercises in the interrelationship of simple geometric shapes, and an investigation of their formal problems of color, light, and dark.[141]

In producing his works, Thiebaud has no preconceptions for the design. He paints whatever has the right look and feel. Solitary and isolated, his figures are not dehumanized. *Football Player* shows a massive athlete in sharply foreshortened perspective and centered on the canvas. Typically, Thiebaud emphasized the figure against a white background, outlining it

in various, thick, multi-colored bands. The halation effect is the result of observing and painting the image under strong light. He attempts to reconcile the figure and the ground so that they merge, the figure receiving special energy.[142]

Thiebaud's early training as a commercial artist undoubtedly influenced his technique. Abstract Expressionism and the California figurative tradition have also left their marks. As in his earlier representational works and in his more recent cityscapes, Thiebaud works directly from observation, not from photographs; he makes hundreds of preliminary drawings either on location or from memory. He looks at each of his paintings as an exploration of problems of space and light. "If you're interested in light sources, you may paint subject matter that has a single light source or you may choose subject matter which somehow takes on a horrendous problem—that is, with unlimited light sources ... so you're constantly striving to confront yourself in the deepest way or the fullest

way relevant to whatever problems you are facing. If the problem is space, you may try to destroy or undercut that space. It's hard to describe, because it's a language unto itself and talking about it seems very strange.[143]

Provenance: Allan Stone Gallery, New York; The Harry N. Abrams Family Collection, New York; Christie, Manson & Woods, New York, 1982.
Published: Bruce Kurtz, "Interview with Harry N. Abrams," *Arts Magazine* 47 (September-October 1972): 50-51; *Contemporary Art.* Sale catalogue, Christie, Manson & Woods, New York, November 11, 1982, no. 159 (illus.).
Exhibited: *Sports Festival:* Loeb Student Center, New York University, New York, January 1965. *Harry N. Abrams Family Collection:* The Jewish Museum, June-September 1966. *Late 20th-Century Art From The Sydney and Frances Lewis Foundation Collection:* Piedmont Arts Association, Martinsville, Virginia, February 27-March 27, 1985.

140. Susan Stowens, "Wayne Thiebaud: Beyond Pop Art," *American Artist* 44 (September 1980): 46.
141. Ibid., pp. 48-50.
142. Ibid., p. 102.
143. Ibid., p. 103.

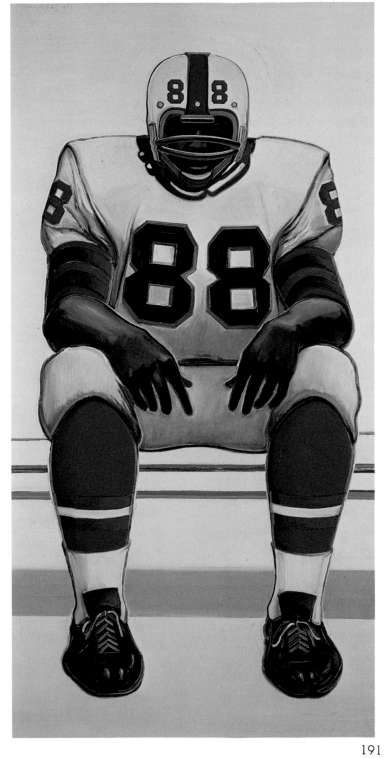

191

David True
American, 1942-

94. Untitled, 1984
Oil on canvas, two panels: 183.0 × 487.7 (72 × 192)
Signed on back, top: *David F. True, N.Y.C. '84*
Virginia Museum of Fine Arts, Gift of
　Sydney and Frances Lewis, 85.450.1/2

David True communicates with his viewers by supplying them with certain visual symbols and images so that they might be actively engaged in a poetical narrative with his work. These symbols reflect his experiences and emotions.

True studied at Ohio University in Athens before moving to New York in 1967. His early work was very much influenced by Minimalist sculpture but he began to add found objects to formulate narrative works. By 1977 he had returned to pure painting and produced his first ship paintings. This year marks the beginning of the mature phase of True's style and content.

Since 1977, his repertoire of images and symbols has expanded to include satyrs, automobiles, deer, and rocks and mountains. These images interact in fanciful landscapes formulated in True's imagination and subconscious. Despite his acknowledged debt to the works of

Giorgio de Chirico, True does not admit to working in the tradition of the Surrealists.[144] Much of True's work is apocalyptic and sensitive to ecological issues. The deer represents freedom, and the horse is a symbol for domesticity. The recurring theme of the satyr is a leitmotif for the duality of human nature and human control of nature.[145] His paintings reflect an ongoing struggle between these elements.

In this large untitled two-panel painting, True works with opposites. "There's a division within the painting. It includes a ship and a mountain of rock, emphasizing the opposites. It was one of the most difficult works, conceptually speaking, that I have ever attempted. It allowed me to find out what I can do in terms of expanding that notion of opposites within one work. When I did the rock or mountain, the mountain became more like the symbol or the idea of a mountain,

because it's a rock form that has rocks within it. It doesn't quite make sense as a strict pictorial representation of either a mountain or a rock. I knew it needed more information, something that would push it into a poetical realm. I've always been interested in anthropology, geology, and fossils. It's as if fossils were asleep and they referred to some kind of grand unconsciousness of the earth."[146]

Provenance: Edward Thorp Gallery, New York, 1984.
Published: Frederick R. Brandt, *David True: Paintings 1977-1984* (Richmond: Virginia Museum of Fine Arts, 1984), p. 14, no. 15 (illus.).
Exhibited: *David True: Paintings 1977-1984*: Virginia Museum of Fine Arts, September 11-October 7, 1984.

144. From an interview by the author with the artist, May 23, 1984.
145. Interview, May 23, 1984.
146. Interview, May 23, 1984.

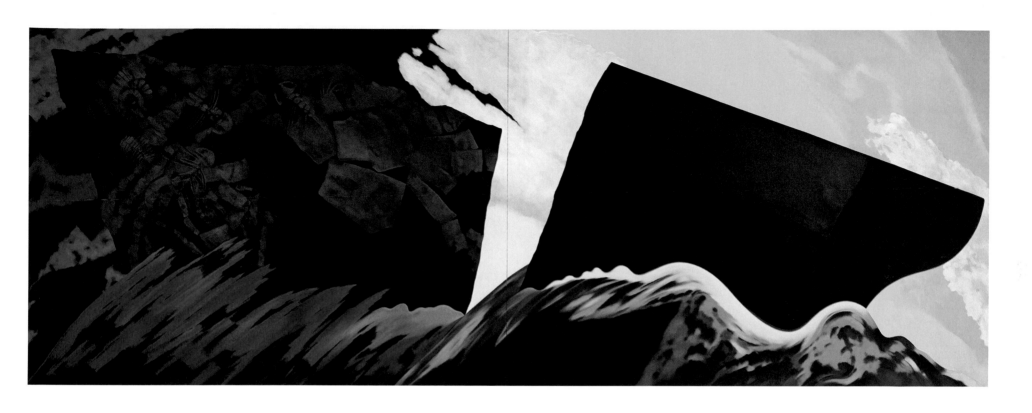

193

Cy Twombly
American, 1928-

95. *Synopsis of a Battle*, 1968
House paint, crayon on canvas, 200.0 × 262.0 (79 × 103⅛)
Dated lower right: '*68*; signed on reverse, lower right: *68*;
 upper left: *Cy Twombly*
Virginia Museum of Fine Arts, Gift of
 Sydney and Frances Lewis, 85.451

Cy Twombly studied at Washington and Lee University in Lexington, Virginia, the School of the Museum of Fine Arts in Boston, the Arts Students League in New York, and at Black Mountain College in North Carolina. He has lived in Rome since 1957.

Emphasizing drawing over painting and color, Twombly creates paintings that are distinctive for their unique markings that relate to classical history and mythology and to the automatic writings and drawing of the Surrealists. As a whole, his paintings are somewhat similar to those of Franz Kline and Jackson Pollock. Twombly's art is a contemporary continuance of the work of the Italian Futurists. Twombly's vibrantly drawn passages relate to paintings and drawings of other Italian masters such as Leonardo, particularly his drawings for the *Deluge*. *Synopsis of a Battle* is one of a 1968 series in which the paintings take on the appearance of chalky scrawls on large slate-grey blackboards. All these works seem to be messages left after an especially exuberant lecture in a classroom. The major compositional device is a small trapezoid that leads into a larger trapezoid occupying the center of the panel. This in turn is divided by a series of lines converging to a point somewhere at the top center of the canvas. Cryptic letters, words ("flank," "end"), and numerical equations completely cover the surface of the canvas, and together with the date of the painting in the lower right corner ("68"), they are the only parts of the canvas that read literally. Any attempt at deciphering is pointless; Twombly has created a pure abstract composition using familiar symbology in place of geometric or abstract shapes.

Synopsis of a Battle is a predecessor of the currently fashionable graffiti art by artists such as Toxic, Futura, and Jean-Michel Basquiat, and others. Their art, however, derives more from their daily experience and urban ambience than from the conceptual and art historical stimuli behind Twombly's work.

Provenance: Leo Castelli Gallery, New York, 1969.
Published: Wyrick, *Contemporary American Paintings*, p. 15 (illus.); Hiener Bastian, *Cy Twombly: Bilder Paintings 1952-76*, vol. I (Berlin: Propylaen Verlag, 1978); Roland Barthes, *Cy Twombly: Paintings and Drawings 1954-1977* (New York: Whitney Museum of American Art, 1979), p. 60 (illus.); John Bernard Myers, "Marks: Cy Twombly," *Artforum* (April 1982): 55 (illus.).
Exhibited: *The Lewis Collection*: Martha S. Grafton Library Gallery, Mary Baldwin College, Staunton, Virginia, April 6-10, 1969. *American Painting 1970*: Virginia Museum of Fine Arts, May 4-June 7, 1970. *Contemporary Painting from the Lewis Collection*: Delaware Art Museum, Wilmington, September-October 27, 1974. *20th-Century Art from Friends Collections*: Whitney Museum of American Art, New York, July 27-October 5, 1977. *Cy Twombly Paintings and Drawings 1954-1977*: Whitney Museum of American Art, New York, April 6-30, 1979. *William and Mary Collects*: College of William and Mary, Muscarelle Museum of Art, Williamsburg, October 1983-January 1984.

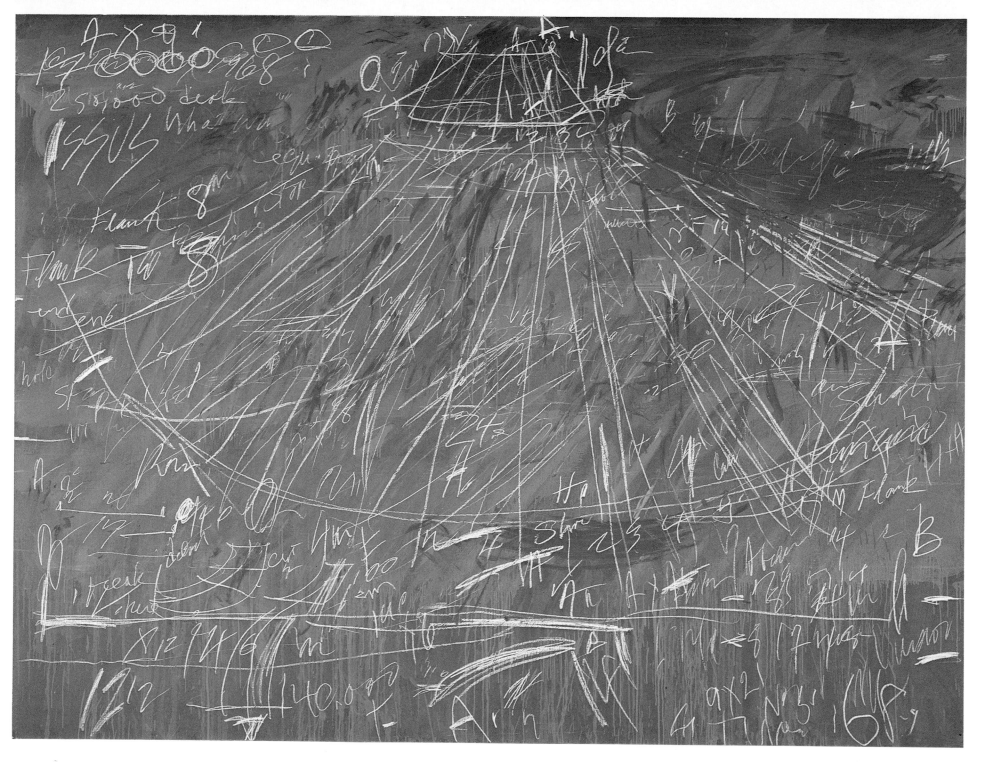

195

John Walker
English, 1939-

96. *Roundout Folly*, 1980
Oil on canvas, 243.8 × 304.8 (96 × 120)
Signed on reverse: *Walker 1980*
Virginia Museum of Fine Arts, Gift of
 The Sydney and Frances Lewis Foundation, 85.452

Originally an abstract painter, John Walker has more recently used representational images. Walker has said, "There is a desire now . . . let's illustrate it by saying that Matisse and Picasso, for example, took figurative painting almost to abstraction and then they stopped. I'd like to come the other way and stop, just this side of abstraction."[147]

Walker has achieved his aim in *Roundout Folly*. The extremely large geometric forms of the painting exist in a definite space within the picture plane. They recall still-life elements, such as those one might see in a Morandi painting. To identify these forms as real objects, however, is impossible. The rich paint and dark colors model the forms, which are given three-dimensionality and exist in ambiguous planes. The quality of space is very important to Walker. "I've never thought of abstract painting as being flat. It's often been a criticism of my work that there's too much in them. I think that people mean that there is space in them. But it's my desire to paint the air in paintings. For many years before I became an abstract painter, I always disliked the way everyone was trying to flatten everything. It seemed to me that air and space were essential to painting."[148]

Provenance: Betty Cunningham Gallery, New York, 1981.

Published: Brandt and Butler, *Late Twentieth Century Art*, p. 71, no. 62 (illus.).

Exhibited: *The Sydney and Frances Lewis Foundation Collection:* Morehead State University, Morehead, Kentucky, August 31-October 16, 1981; Columbia Museum of Art, Columbia, South Carolina, November 15, 1981-January 10, 1982; Mississippi Museum of Art, Jackson, January 31-March 14, 1982; Everson Museum of Art, Syracuse, New York, March 25-May 29, 1983; Huntington Galleries, Huntington, West Virginia, June 2-August 18, 1984.

147. "John Walker Interviewed By David Sweet," *Art Scribe* 12 (June 1978): 26.
148. Ibid.

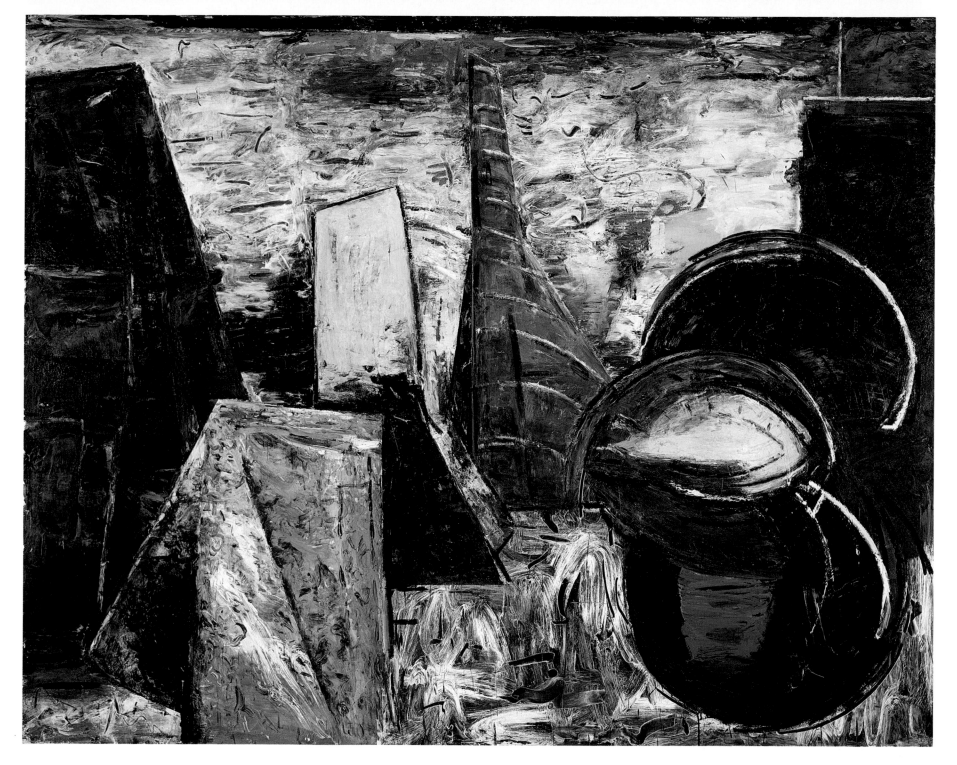

197

Andy Warhol
American, 1930(?)-

97. *Triple Elvis*, 1964
Aluminum paint, printer's ink silkscreened on
 canvas, 208.0 × 180.5 (81 × 71)
Unsigned
Virginia Museum of Fine Arts, Gift of
 Sydney and Frances Lewis, 85.453

Andy Warhol is the ultimate Pop artist. His name and his face are as popular as the celebrities he depicts. Perhaps because of his unabashed use of common imagery, the phenomenon of artist as superstar has arisen. By taking objects and images from everyday contexts and reproducing them in silkscreen, which emphasizes the black-and-white tonalities of newspapers and television, Warhol has documented the ordinary since the early 60s, raising it to a level of "high art."

Warhol moved to New York upon graduation from the Carnegie Institute of Technology in Pittsburgh and established himself as a magazine and advertising illustrator and designer. In the early 60s he emerged as the leading Pop artist. Like Roy Lichtenstein, he derived many of his early paintings directly from comic strips but he soon sought inspiration from the the commercial world: tabloid headlines, advertisements, commercial labels, postage stamp designs, and even dollar bills. He produced both single and multiple images. The Elvis portrait is an excellent example of the latter.

The earliest commercial images were painted by hand, but the later ones were rendered through silkscreening to simulate the look of mass production. Perhaps the most famous of the images to be developed in the early 1960s was the Campbell soup can, which he depicted both in singular and multiple images and in both paintings and silkscreens. In many cases the individual image in a series differed only in color. In 1962 Warhol produced serial images of celebrities such as Elizabeth Taylor, Marilyn Monroe, Troy Donahue, Marlon Brando, and Elvis Presley. His self-portrait became equally familiar, contributing in no little way to his fame as both artist and eccentric personality.

The silkscreen process was perfect for the repeated images of portraits and commercial products because it yields flat, sharply defined outlines. The silkscreen is basically a commercial technique in which a stencil is created by either a hand-drawn or cut process or, in Warhol's case, through photography. Ink or paint is applied through the stencil to print the image on the surface of the ground (paper or canvas or other materials). The stencil can be used to repeat the image endlessly. In recent years Warhol has vigorously and expressionistically painted the background of his portraits before screening in the details of the face.

Warhol overlapped three film frames in a direct, matter-of-fact manner, and the result is a dramatic portrait of a legendary superstar, Elvis Presley. The larger-than-life scale emphasizes the exalted status of such celebrities. Warhol glorifies and immortalizes both the image and the object or person, thereby asserting his role as the master of the Pop movement.

Provenance: Leo Castelli Gallery, New York; Locksley-Shea Gallery, Minneapolis; Christie, Manson & Woods, New York, 1980.
Published: John Coplans, *Andy Warhol* (Greenwich, Connecticut: New York Graphic Society, 1970), p.78 (illus.); *Contemporary Art.* Sale catalogue, Christie, Manson & Woods, New York, May 16, 1980, no. 42 (illus.); Thomas W. Styron, *American Figure Painting 1950-1980* (Norfolk: The Chrysler Museum, 1980), p. 96 (illus.)
Exhibited: *Andy Warhol:* Pasadena Art Museum, Pasadena, May 12-June 21, 1970; Museum of Contemporary Art, Chicago, July 4-September 6, 1970; Stedelijk Van Abbe Museum, Eindhoven, The Netherlands, October 9-November 22, 1970; Musée de l'Art Moderne, Paris, December 10, 1970-January 23, 1971; The Tate Gallery, London, February 17-March 28, 1971; The Whitney Museum of American Art, New York, April 26-June 6, 1971. *American Figure Painting 1950-1980:* The Chrysler Museum, Norfolk, October 17-November 30, 1980.

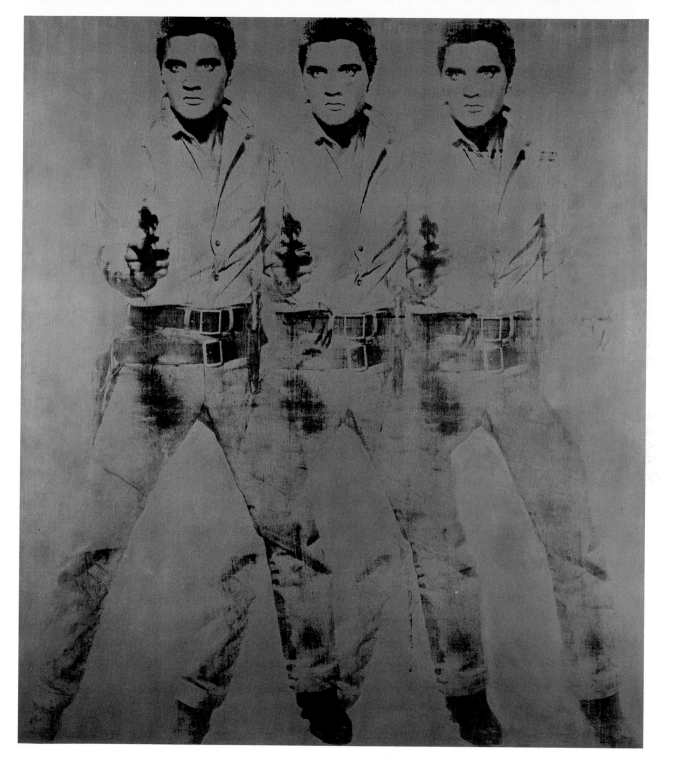

Tom Wesselmann
American, 1931-

98. *Great American Nude #35*, 1962
Enamel, polymer, and mixed media on board, 122.0 × 152.5 (48 × 60)
Signed on reverse, upper left: *GAN #35/4'x5' Wesselmann 62*
Virginia Museum of Fine Arts, Gift of
 Sydney and Frances Lewis, 85.454

Tom Wesselmann's work is often compared to Pop Art, and indeed it bears similarities in its depiction of common objects and use of flat, bright colors. There the similarity ends. Wesselmann's paintings transcend Pop aesthetics.

While studying at Cooper Union in New York in 1956, he was influenced by the Abstract Expressionists, particularly Robert Motherwell and Willem de Kooning. He realized, however, that his personality was not suited to the aggressiveness of Abstract Expressionism and instead developed a quieter and more restrained style.[149] In 1959 he began a series of portrait collages, and in 1961 they evolved into a larger format series of nudes, which he entitled *Great American Nude*. Wesselmann has worked on this series over the years, formulating principles that recur from one painting to another. His images are always in the immediate front of the picture plane, thrust forward in a shallow space. No one area is emphasized; all elements compete for space, struggling in the restraints of the pictorial plane and the perimeters of the canvas. Finally, there is an interplay between positive and negative spaces.

In 1962 Wesselmann began a still-life series featuring painted images and combined collage materials derived from billboards and advertisements. By eliminating shadows he retained a shallow pictorial space and continued to present the objects in a direct manner.

These earlier works have been followed by different series featuring collages, landscapes, seascapes, smokers, and, most recently, large-scale sculptures based on floral motifs and still-life elements. As each of these series has evolved and grown, Wesselmann's concept and treatment of scale has changed. He now presents the traditional small intimate still-life on a monumental scale, causing singular images such as cigarettes, ashtrays, lipsticks, and flowers to take on monumental proportions.

Great American Nude No. 35 is an important milestone in that series. As in the other works, the "patriotic" theme is stressed by red, white, and blue. In addition, he has collaged printed materials, including an image of the Mona Lisa, as part of the formal aspects of the composition. But what is most important is that this is the first nude where three-dimensional elements were introduced by the artist—the windows which he retrieved from a gutter, and the plastic soda and beer bottles on the shelf. "In 1962 I was just beginning to use 3-D elements, and I had a big push of projects using found materials and advertising props. Previously, I had insisted on staying with flatness. While I had just started using such things as plastic bottles, the windows were a big departure for me. I well remember the spatial decision to crop the Mona Lisa—it made the sense of the space of the other room more intense, the cutting of such a sacrosanct and special image."[150]

Wesselmann continues to depict household objects and rooms, particularly the bedroom. The interrelationship of images in the bedroom paintings impart eroticism. By compressing the composition, cropping, and pushing the major images to the front part of the picture plane, Wesselmann creates a tension between the still life and the body parts, and he forces us to share the intimacy of the scene.

Provenance: Pace Gallery, Boston; Sotheby Parke-Bernet, New York, 1972.
Published: *Important Post-War and Contemporary Art.* Sale catalogue, Sotheby Parke-Bernet, New York, October 26, 1972, no. 43 (illus.).
Exhibited: *Selections from the Lewis Collection:* Richmond Public Library, Richmond, April 1976; *A Bicentennial Exhibition: American Art Today:* University of Virginia Bicentennial Exhibit, Charlottesville March 9-April 30, 1976. *Art about Art:* Whitney Museum of American Art, New York, July 15-September 24, 1978; North Carolina Museum of Art, Raleigh, October 15-November 26, 1978; The Frederick S. Wight Art Gallery, University of California at Los Angeles, December 17, 1978-February 11, 1979; Portland Art Museum, Portland, Oregon, March 6-April 15, 1979.

149. See Slim Stealingworth, *Tom Wesselman* (New York: Abbeville Press, 1981).
150. Letter, dated October 13, 1984, from the artist to the author. The letter is part of the Lewis Collection archives in the Department of 20th-Century Art, Virginia Museum of Fine Arts.

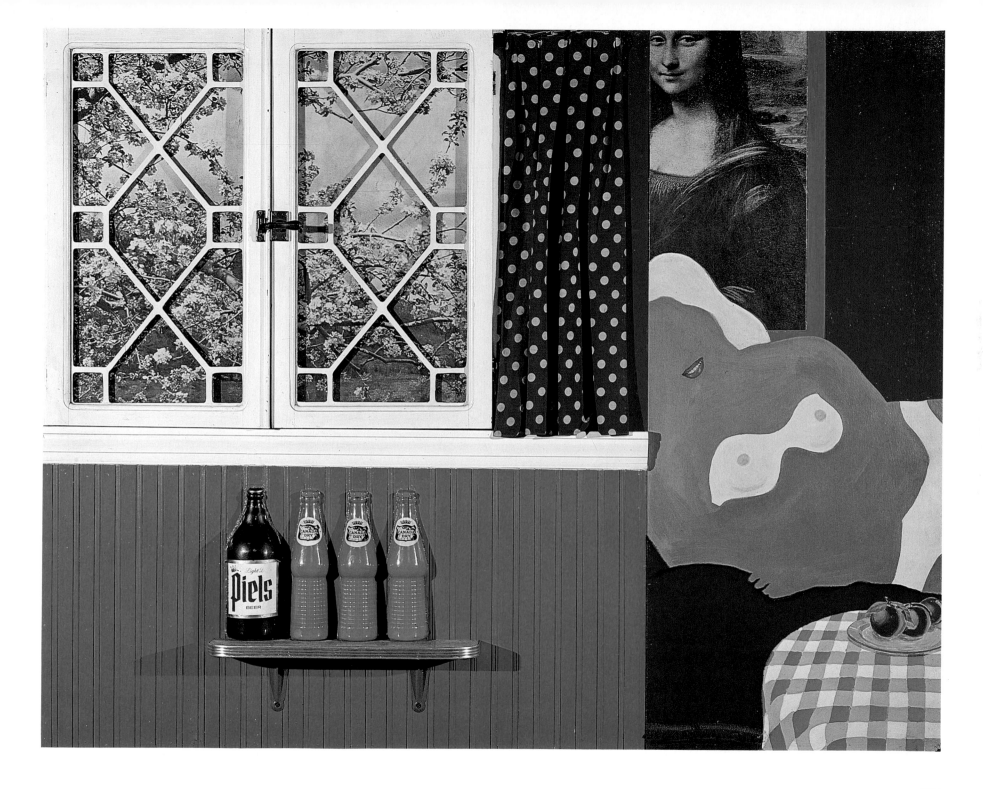

Christopher Wilmarth
American, 1943-

99. *Orange Delta for A.P.S.,* 1973
Glass, steel, 241.3 × 108.0 × 119.3 (95 × 42½ × 47)
Unsigned
Virginia Museum of Fine Arts, Gift of
 The Sydney and Frances Lewis Foundation, 85.455

Christopher Wilmarth has pioneered the use of glass as a sculptural medium. The interplay of glass and light is one of the most important elements of his work because it defines volume and space. "Light gains character as it touches the world, from what is lighted and from who is there to see. I associate the significant moments of my life with the character of light at the time. The universal implications of my original experience have located in and have become signified by kinds of light. My sculptures are places to generate this experience compressed into light and shadow and returned to the world as a physical poem...."[151]

Wilmarth studied at Cooper Union in New York from 1960 to 1965. His early wood sculptures were gradually transformed by the addition of glass. Fascinated by the possibilities and properties of glass, he soon abandoned the wood sections and began to use sheets of glass and steel, two very different materials, and to use them in contradictory ways, as in *Orange Delta for A.P.S.* Wilmarth explored the process for bending, cutting, and fitting glass to bring out its sensitive and delicate qualities. Although in some of his sculptures he worked solely with sheets of glass, nonetheless he often defined and delineated them with black metal cables.

Wilmarth treats his sculpture as a painting. He colors the glass with acids and shapes and cuts it, often letting the black and aluminum wire act as a drawing line to demarcate certain areas of the glass. The acid treatment roughens the glass and gives it an opacity that denies its fragility, brittleness, and reflective power. He bends the steel, making its strength and weight much less obvious. The surfaces of both steel and glass absorb light, and give little reflection. Our attention is drawn into the sculpture.

The title of this work refers to Anthony (Tony) P. Smith, the late sculptor, who was Wilmarth's friend and mentor. The orange of the title alludes to Orange, New Jersey, where Wilmarth lives. Of the sculpture, Wilmarth says "the work is of emerging and release, longing and reverie; of the psychological reference of a certain kind of light; of fragility and strength and the ambiguous position of poetry in a spiritually conforming society."[152]

Provenance: André Emmerich Gallery, New York, 1978.
Published: Brandt and Butler, *Late Twentieth Century Art,* p. 75, (illus.).

Exhibited: *The Sydney and Frances Lewis Foundation Collection:* Institute of Contemporary Art, University of Pennsylvania, Philadelphia, March 22-May 2, 1979; The Dayton Art Institute, Dayton, Ohio, September 13-November 4, 1979; Brooks Memorial Art Gallery, Memphis, December 2, 1979-January 27, 1980; Dupont Gallery, Washington and Lee University, Lexington, Virginia, February 18-March 21, 1980; The Toledo Museum of Art, Toledo, September 21-November 9, 1980; Madison Art Center, Madison, November 23, 1980-January 18, 1981; Allen Priebe Art Gallery, University of Wisconsin-Oshkosh, Oshkosh, January 27-March 15, 1981; Ulrich Museum, Wichita State University, Wichita, April 1-May 31, 1981; Morehead State University, Morehead, Kentucky, August 31-October 16, 1981; Columbia Museum of Art, Columbia, South Carolina, November 15, 1981-January 10, 1982; Mississippi Museum of Art, Jackson, January 31-March 14, 1982; Worcester Art Museum, Worcester, Massachusetts, September 10-October 31, 1982; Allentown Art Museum, Pennsylvania, November 14, 1982-January 16, 1983; University Memorial Gallery, University of Rochester, Rochester, January 30-March 13, 1983; Everson Museum of Art, Syracuse, New York, March 25-May 29, 1983; Randolph-Macon Woman's College, Lynchburg, Virginia, November 6-December 17, 1983; Huntington Galleries, Huntington, West Virginia, June 2-August 18, 1984.

151. *Matrix 29: Christopher Wilmarth* (Hartford, Connecticut: Wadsworth Athenaeum, 1977), unpaginated.
152. Letter, dated November 1, 1984, from the artist to the author. The letter is part of the Lewis Foundation archives in the Department of 20th-Century Art, Virginia Museum of Fine Arts.

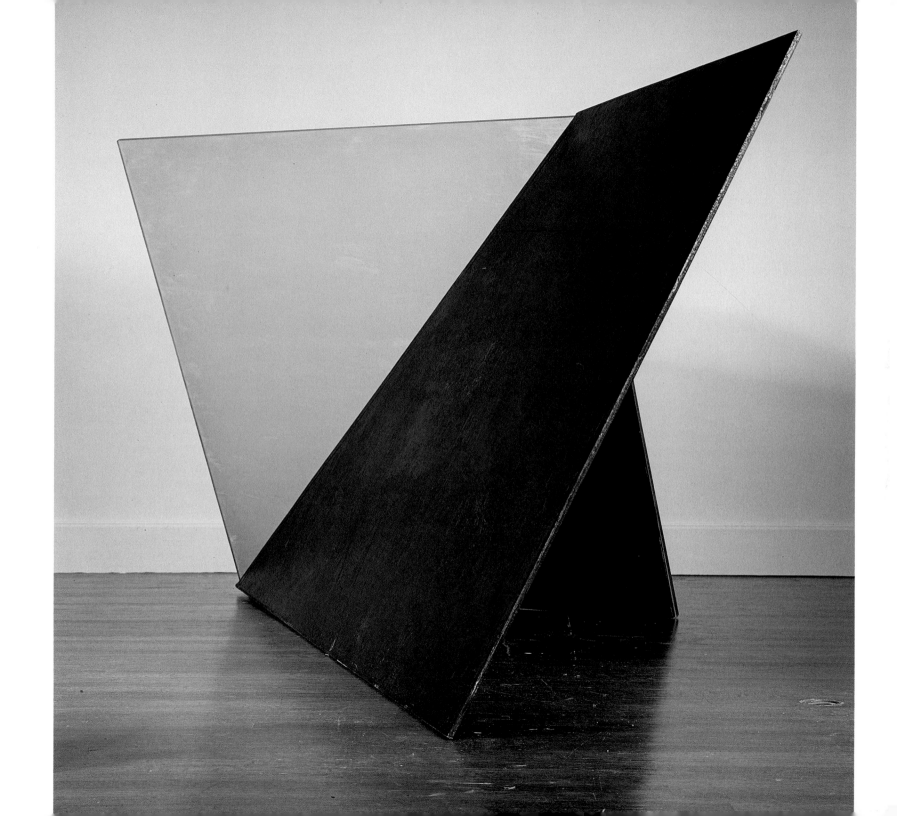

James Wines
American, 1932-

100. *Yahoo*, 1965
Iron, cement, 188.0 × 94. × 55.8 (74 × 37 × 22)
Signed lower right: *Wines 65*
Virginia Museum of Fine Arts, Gift of
 Sydney and Frances Lewis, 85.456

In 1959 James Wines's sculpture *Child in a Web* was included in the Museum of Modern Art's exhibition *Recent Sculpture U.S.A.* A figurative work, it related to the renewed interest in the human figure, but Wines rejected realistic and symbolic style for a more abstract approach. Relying on pure forms and tensions, he imparted greater evocative powers than in his earlier harshly symbolic pieces. As a result, in the early 60s he relied heavily on shapes from natural materials such as rocks and trees. He also made bronzes that exist as environments or fragments of environments.

He then made a complete break with natural imagery and shifted to a Constructivist approach that implied a dependency between architecture and the machine. In 1966, Wines wrote "Considering the architect as a kind of master of assemblage I have been influenced by him on a number of levels. I am involved with sculpture as an architectural experience, and this not only includes the intention to use works in buildings or create sculpture environments, but also to capture the spirit, sensation,

and space of architecture. For intrinsic pieces I try to create the sensation of passing through a building by using dense forms or walls which cut off completely the various different views of a sculpture."[153]

The complexity of spatial arrangements of *Yahoo* presents visual surprises. The sculpture is at once both a two-dimensional, linear work and a three-dimensional object. The apertures imply architectural windows and give a spatial orientation to the surrounding area. The use of both steel and reinforced concrete implies architectural construction and lends interesting textural qualities to the surface. Further, the play of graphic line against modeled shape presents fascinating detail.

Wines's interest in architecture culminated in 1970 when he became one of the charter members of the New York architectural firm SITE (Sculpture in the Environment). Wines abandoned sculpture to devote his energies to this organization, which was founded for creating new concepts of commercial and municipal architecture. He attempted to fuse art and ar-

chitecture in a process that he prefers to call de-architecturization," a method, or perspective, for examining the conventions of the built environment and expanding their meanings. By shifting the concerns of architecture from traditional formalism to information and commentary, it is intended that a heightened level of public communication may be achieved."[154] Through SITE, Wines has fulfilled his earlier desire to create works and spaces that would become total sculptural environments.

Provenance: from the artist, 1968.
Published: *The One Hundred and Sixty-Third Annual Exhibition of American Painting and Sculpture* (Philadelphia: The Pennsylvania Academy of the Fine Arts, 1968), unpaginated (illus.).
Exhibited: *The One Hundred and Sixty-Third Annual Exhibition of American Painting and Sculpture*: The Pennsylvania Academy of the Fine Arts, Philadelphia, January 19-March 3, 1968.

153. As quoted by David Sellin in *James Wines: Recent Sculpture, 1963-66* (Hamilton, New York: Dana Creative Art Center, Colgate University, 1966), p. 4.
154. C. Ray Smith, *SITE: Buildings and Spaces* (Richmond: Virginia Museum of Fine Arts, 1980), p. 4.

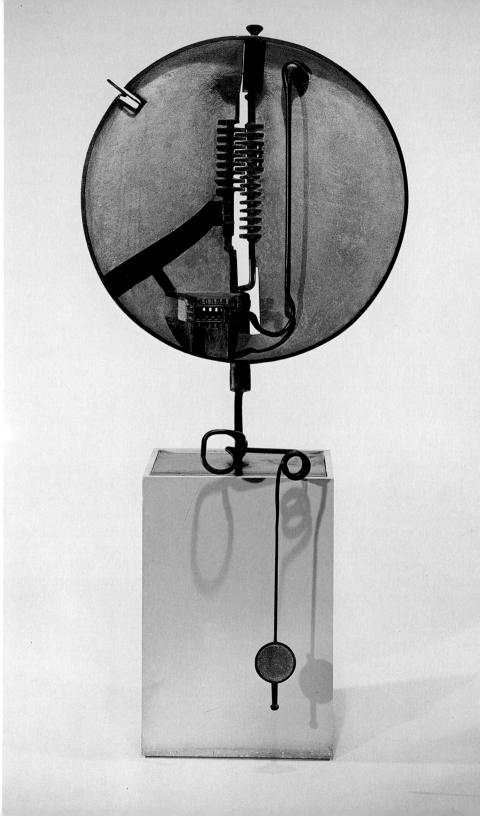

Other Catalogues of the Collection of the Virginia Museum of Fine Arts:

Fabergé: A Catalog of the Lillian Thomas Pratt Collection of Russian Imperial Jewels (1960; rev. 1976)

European Art in the Virginia Museum (1966)

Ancient Art in the Virginia Museum (1973)

Treasures in the Virginia Museum (1974)

The Sydney and Frances Lewis Contemporary Art Fund Collection (1980)

Eighteenth-Century Meissen Porcelain from the Margaret M. and Arthur J. Mourot Collection in the Virginia Museum (1983)

Oriental Rugs, The Collection of Dr. and Mrs. Robert A. Fisher in the Virginia Museum of Fine Arts (1984)

British Sporting Paintings, The Paul Mellon Collection in the Virginia Museum of Fine Arts (1985)

French Paintings, The Collection of Mr. and Mrs. Paul Mellon in the Virginia Museum of Fine Arts (1985)

Late 19th- and Early 20th-Century Decorative Arts, The Sydney and Frances Lewis Collection in the Virginia Museum of Fine Arts (1985)

This book was composed in Lubalin Book by William Byrd Press, Richmond, Virginia, and printed on Warren luster offset enamel dull paper by Progress Printing Co., Inc., Lynchburg, Virginia.